DADDY-O'S
BOOK OF
BIG-ASS ART

DADDY-O'S
BOOK OF BIG-ASS ART

BOB WADE

WITH W. K. STRATTON
& RACHEL WADE

Foreword by Kinky Friedman

TEXAS A&M UNIVERSITY PRESS

COLLEGE STATION

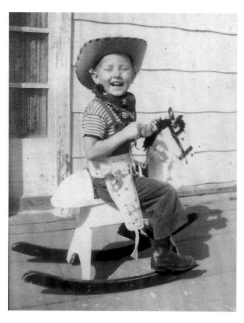

Cowboy Bob with Hobbyhorse, 1950,
Galveston, Texas. Bob's father,
Chaffin, made the hobbyhorse.

This paper meets the requirements
of ANSI/NISO Z39.48–1992 (Permanence of Paper).
Binding materials have been chosen for durability.
Manufactured in Canada by Friesens

LIBRARY OF CONGRESS CATALOGING-IN-PUBLICATION DATA

Names: Wade, Bob, 1943–2019 author. | Stratton, W. K., 1955– editor.
Title: Daddy-O's book of big-ass art / Bob Wade; with W.K. Stratton.
Description: First edition. | College Station: Texas A&M University Press,
 [2020] | Includes index.
Identifiers: LCCN 2019058012 | ISBN 9781623498696 (cloth) | ISBN
 9781623498702 (ebook)
Subjects: LCSH: Wade, Bob, 1943–2019 | Wade, Bob, 1943–2019—Catalogs. | Wade,
Bob, 1943–2019—Themes, motives. | Artists—Texas—Biography. | Texas—In
art. |
 Texas—Social life and customs—Pictorial works.
Classification: LCC N6537.W218 A4 2020 | DDC 700.9764—dc23
LC record available at https://lccn.loc.gov/2019058012

Endsheet photography courtesy Scott David Gordon

This book is dedicated to my parents,

Pattie and Chaffin,

who encouraged me to do what I wanted

(MOST OF THE TIME).

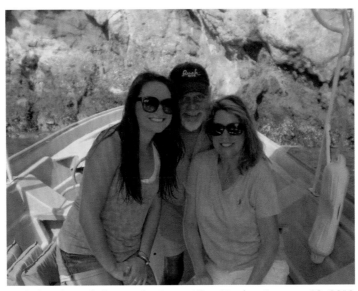

Rachel, Bob, and Lisa Wade, Punta Mita, Mexico, January 10, 2010

To say Bob "Daddy-O" Wade was excited about this book would be an understatement. He threw himself into this project. Among other things, he decided which written pieces and photographs would appear in its pages, carefully edited copy to ensure its accuracy, and was involved with the book's format and design. To people close to him, he confided that he considered this book to be a legacy for his children. He had a sense of urgency about getting it finished. Bob had essentially completed his pre-publication work on *Daddy-O's Book of Big-Ass Art* when he died unexpectedly just past midnight on Christmas Eve 2019. While many of the following pieces refer to Bob in present tense as a living, working artist, we refrained from making changes to reflect his passing. What you have before you is the book as the Daddy-O wanted it to be.

LISA WADE
RACHEL WADE

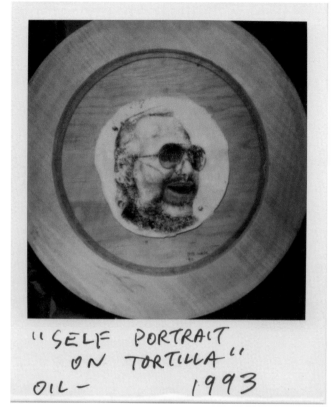

Self-Portrait on Tortilla, 1992. Oil on tortilla with clear coat, 8.5″ diameter. Collection of the artist.

If you can't make it good, make it big; if it's still not good, paint it red.
—*graffito from men's room, Kansas City Art Institute,*
1970s, as reported by Bob Wade

Robert was taught right from wrong, but sometimes he prefers wrong.
—*Bob's mother to his middle school teachers, 1950s*

I don't want to change you; just don't get any worse.
—*Lisa Wade*

CONTENTS

CONTENTS ☆ ix

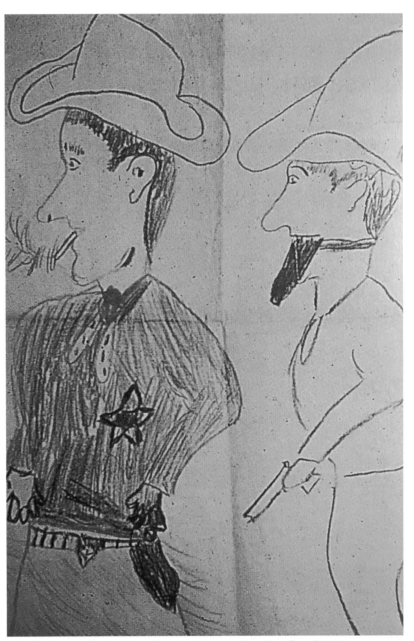

**Bob Wade, age 7, *Bad Guy Gets the Drop on the Sheriff*, Fall 1950.
Crayola on Paper, 18"x 24".**

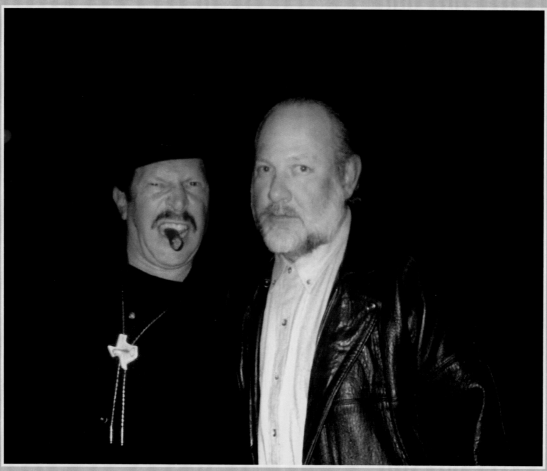

Kinky Friedman and Bob Wade at the Broken Spoke, Austin Texas, 1992.
Photo credit: Lisa Wade

FOREWORD

Kinky Friedman

Texas culture, in which Bob "Daddy-O" Wade is certainly a leading, not to say Olympian, figure, has long been regarded by some pointy-headed intellectuals as an oxymoron. This jaundiced, jaded view flies in the face of truth, beauty, and everything—well, at least some of the things—we hold dear in America. Like the freedom to create weird shit and make it bigger and better than anybody else. This, after all, was basically the approach that God had in mind when He worked for six days and created the earth and all that is on it. There are, of course, those of us who feel that He might've taken just a little more time.

All that notwithstanding, Bob Wade almost had to be a Texan. Not for him to spend a lifetime perfecting masterpieces in miniature. Not for him to reside in coffeehouses on the Left Bank of Paris or New York or L.A., embroidering and vampirizing the thinking of the day. Daddy-O needed a little more spiritual elbow room. For it is out of this aching expanse of emptiness that is sometimes called Texas that now and again is born that rarity of rarities, a truly creative and original idea.

Though Bob Wade's work takes many forms, gracing everything from postcards to shopping malls to art museums, the creation of his that I'm the most familiar with is the Giant Iguana that once seemed to live and breathe on the rooftop of the old Lone Star Café in New York. Andy Warhol, John Belushi, John Matuszak—all of whom have subsequently stepped on a rainbow—and multitudes of others from all walks of life have experienced a personal communion with this mystical child of Daddy-O's in the midst of the madness of the city. Part of Wade's genius, of course, was making that monster look like many of us felt at that particular time in our lives, which was usually moderately amphibious as well.

It's never easy for an artist to create. It's even harder for the artist to tell you how in fact he did it. This fifty-year survey is Bob Wade's latest attempt to share his strange and wonderful things (with a little help from his friends). But just as the Iguana has finally found a home in the country, the innovative talent of Bob Wade has certainly found a home, too, in the eyes, hearts, and sensibilities of the legions of Americans who love his art, even if he deliberately makes it sometimes a little difficult to collect.

Oscar Wilde once observed: "No great artist ever sees things as they really are. If he did, he would cease to be an artist." There's very little danger, of course, of Daddy-O's ever seeing things the way they really are, and that's a blessing for us all.

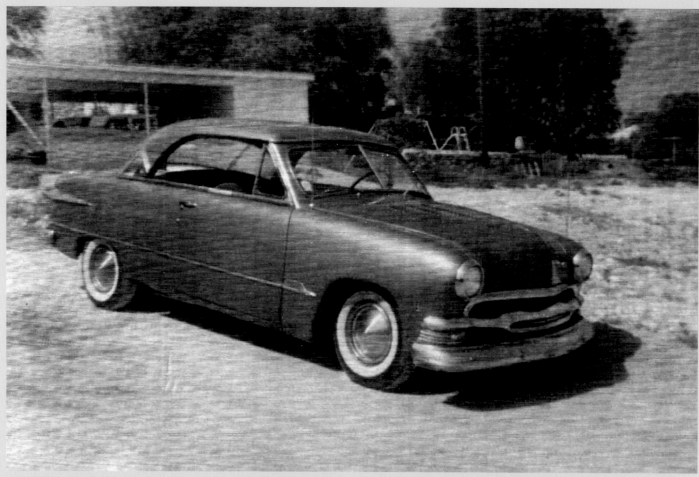

Bob's high school car, 1951 Ford, Crown Victoria hardtop. Nosed and decked, raked, three-quarter race cam flathead with dual carbs. Hurst shifter with Coors beer knob. Traction bars, lakes pipes, rolled and pleated interior, with *Ravisher* pinstriped on dashboard by Von Dutch. Painted Chevrolet Sierra Gold. Won numerous trophies for racing F-gas at quarter-mile drag strip.

PREFACE

In 1976, after having put a taxidermized horse, a two-headed calf, a jukebox, and giant photo canvases in museums around the USA, I decided to assemble 150 color-photocopied pages that reproduced most of my projects from childhood to the present. A hand-tooled leather cover and back with silver saddle studs held the pages together. I made fifty copies of *Bob Wade's Texas,* and many ended up in book art exhibits and in the permanent collection of universities and museums, including the Pompidou Centre in Paris and the Center for Creative Photography in Tucson, Arizona.

Almost twenty years later my book *Daddy-O: Iguana Heads & Texas Tales* was released by St. Martin's Press, concentrating on unbelievable but true stories about my better-known projects and photo works: Giant Iguana, Boots, Frogs, and Cowgirls.

Twenty-four years later, this new publication—created with the help of more than thirty contributors who were either familiar with the projects or just took the facts and "created a page"—is an attempt to add more information about my over fifty years of making stuff. I'm hoping the responses of the contributors will add entertainment and head-scratching to the reproductions and create more myths than already exist.

My coauthor W. K. "Kip" Stratton and I have arranged some of the projects by subject matter, and while this book concentrates mostly on sculpture, many photo works are included to act as 2-D sidekicks.

Kip has also written an essay from the viewpoint of a writer of Western sensibility as it relates to my work with similar Tex-Mex subject matter. And Jason Mellard, who has written about me in catalogs, has contributed an essay that provides insight and context to my career in general.

In addition, my first "abbreviated chronology" is included at the end for those of you who care about more information than you needed to know.

I consider this book one of my best projects, and a legacy for my daughters and grandkids.

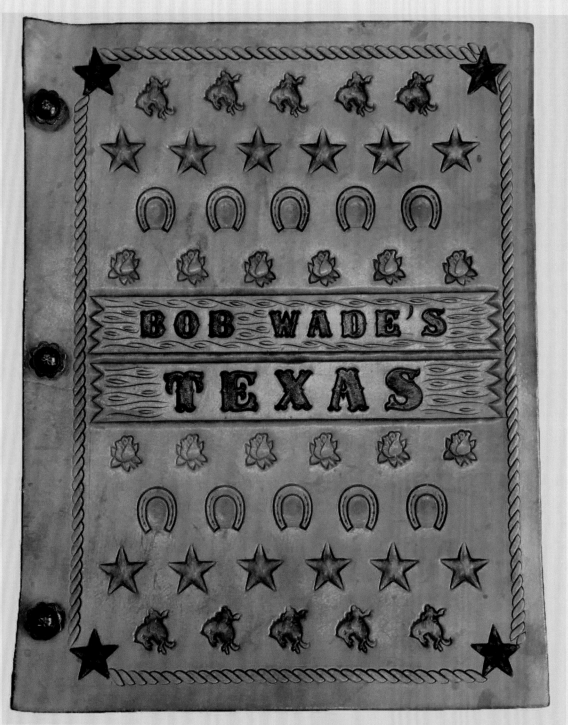

Bob Wade's Texas, 1976. Hand-tooled leather cover, 150 color Xerox pages, edition of 50. 11.5" × 9".
Collection of the Centre Pompidou Library, Paris, France.

ARTIST'S STATEMENT
From *Bob Wade's Texas,* 1976

I have always been interested in cultural manifestations in the anthropological sense. I drove all through Florida in summer 1971, saw the southernmost point in the United States, lots of wax museums, including one which had "Kennedy's car" and "Oswald's room" and NASA's "Outdoor Space Museum," not to mention dozens of bird and monkey zoos, alligator farms, and reptile gardens. Two summers later, 1973, I was "researching" the Lone Star State of Texas on a National Endowment for the Arts "special projects" grant. This book is a chronological presentation of my projects about Texas, defined in this context as ideas and attitudes about scale, culture, myths, symbols, artifacts, history, customs, food, animals, experiences, kitsch, machismo, cross-fertilization, sign systems, tourism, country-western music, the picturesque, cowboys, boundaries, life and death. In Texas, there still exists a thin line between cynicism and humor. In the wax museum between Dallas and Fort Worth, "The West in Wax" has two extra-good displays: "Jack Ruby Shooting Oswald" and "The Last Supper." The projects documented in this volume are mainly static works: photographic murals and three-dimensional "displays": most were part of gallery and museum shows, 1971–1976. The color Xeroxes are translations from slides and photographs printed on a Xerox 6500 color copier by Clare Frost. The color quality and photo resolution are especially well suited to the easy conveyance of the "Texas information." Simultaneous cultures will eventually crisscross to the extent that "Earth culture" will be a hodgepodge of all previously "exotic" and related phenomena. The whole planet will probably become a "display": a museum memorial to the history of the Earth through the present. The interesting thing about places like Texas is that the myths are perpetuated by cultural curiosity and perhaps a universal interest in being a real cowboy. Maybe Earth will be a spherical movie lot, with the tourists as extras.

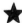

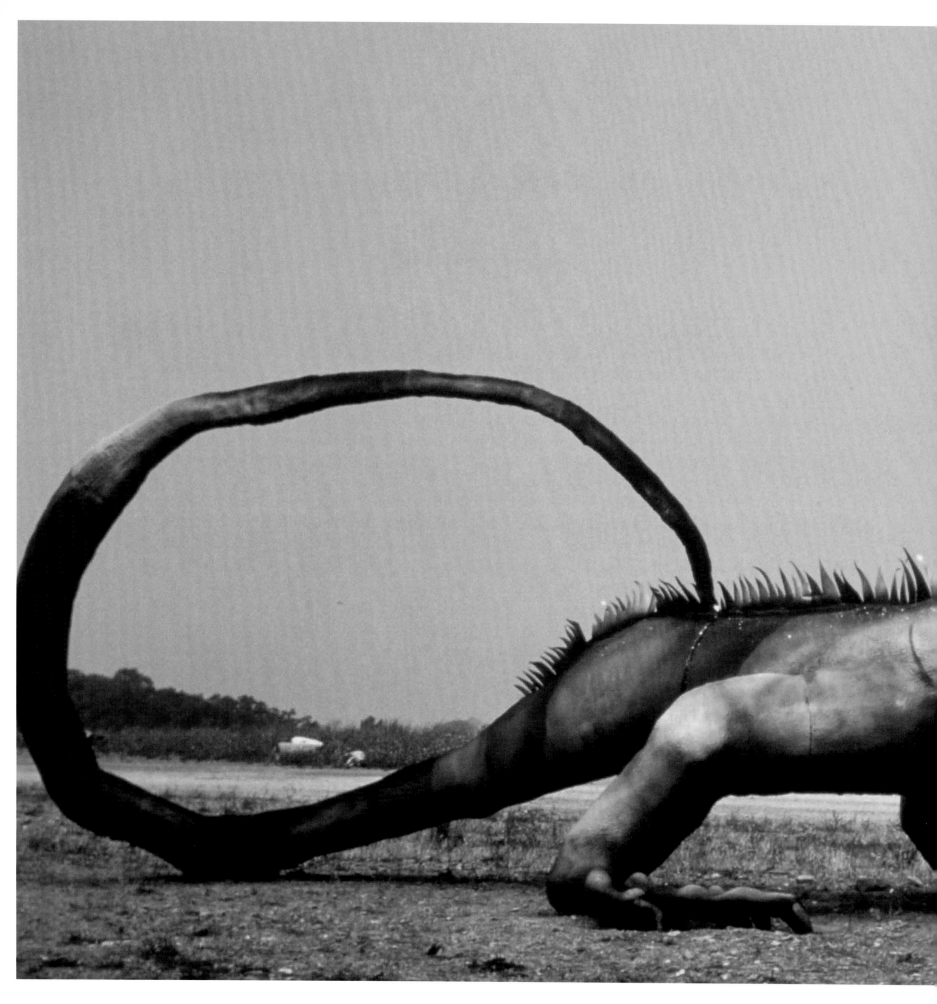

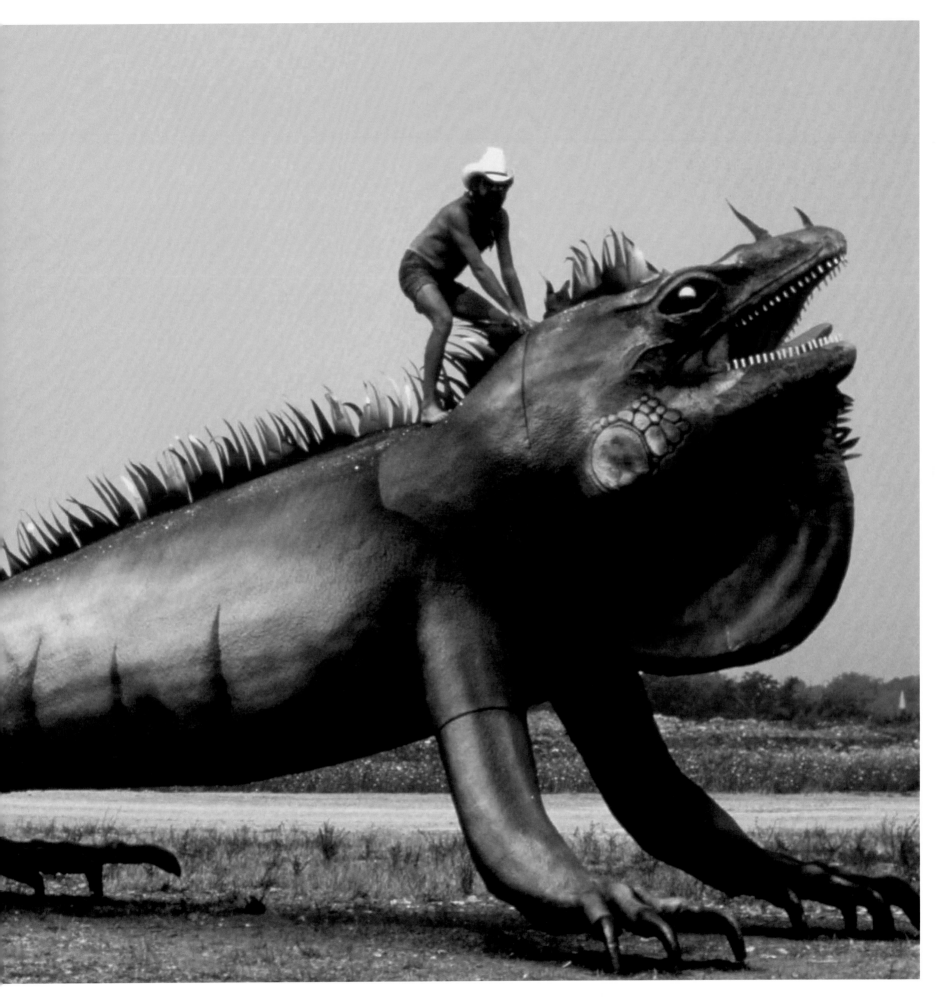

Ridin' It on Out, 1969. Wade performance in Waco, Texas. WWII rubber pontoon, saddle, and rope. 25′. Photograph: Tommy McGee.

BOB WADE
Projects and Photo Works
Lisa Sherman

Bob Wade's work, be it a painting, photograph, or sculpture, has consistently resulted in memorable imagery reflecting the cultural manifestations of the contemporary American West. The strong, straightforward work, further emphasized through scale, oddity, site, or color, forces the viewer to confront the social implications of the imagery. These images can be overpowering and conceal the technical and formalistic skills and expertise of Wade as an artist. And all the pieces of work have a relationship to and an influence on one another, despite Wade's seemingly varied career.

The early paintings such as *Floating Weenies No. 2* featured hot dog shapes derived from a "Texas funk," surreal, organic sensibility of the late 1960s. Working purely as a painter, Wade was involved with the idea of a three-dimensional object illusionistically existing within the painting framework. Airbrushed shadows and theoretical color schemes enabled the weenies to advance out into the viewer's space, hovering in a way that draws upon the theories of formalistic abstractions. Similar concerns would later be manifested in his hand-tinted photo pieces.

By 1971, in an attempt to achieve more variety through out-of-focus backgrounds for the floating weenies, Wade began researching photographic processes. He projected negatives of suitable textures onto pieces of canvas he coated with photosensitive emulsion. *Sweet Little Floater* is an early developed photo-canvas combining paint and photography. This involvement with the photographic process led to pure photo-canvases without paint or weenie subject matter.

Turning to Texas culture as it relates to photographic parameters, Wade began collecting and taking photos of ironic weird roadside scenes and people, such as coyotes on a fence (*Texas Picturesque*), cattle mating, and hunters and their trophies. Drawing upon these images for his first photographic works, Wade created life-size (six to ten feet wide) peripheral experience presentations, which brought everyday scenes into the realm of art and questioned the ironic attitudes toward hunting, criminals, good guys, bad guys, Western myths, folklore, and heroes.

Colorations appeared on these loose canvases due to the emulsion process; the results presented appealing tonalities. Wade always had an interest in color statements and started to experiment with applying photo dyes to the canvas. He moved away

Weenie [detail from squadron of weenies]. Acrylic on canvas. 5′ × 5′. Collection of the artist.

from the earlier technical processes to the use of a pre-primed photo linen, and the brushy, process quality began to disappear.

He became more aware of photography in terms of color and conceptual content, such as in *Autobiography*. The conceptual as opposed to the process presented a shift in emphasis in terms of statement, impact, color, design, and balance. The unstretched works like *Johnny Stewart* were pinned loose to the wall, presenting the canvas as a large object, whereas the photo-linen work was stretched, creating a picture-plane context and demanding the manipulation of color to create forward-backward interaction. Also, the majority of the photo-emulsion images were so striking that food plates, *Juarez at Nite,* and desert landscapes needed coloration in order to express the dialogue of the painting. Wade's fascination with border-town culture (he lived in El Paso as a child) began showing up in much of his work. It would remain a continuing inspiration for both his paintings and his sculptures.

As Wade the photographer improved, he developed more sophisticated images, with attention to placement and design in a contemporary advertising direction. He created elegant images of cactuses, stuffed iguanas, Texas boots, and other Texana objects enlarged to emphasize the sculptural qualities of single objects as opposed to scenes and situations. Many of these photo images would later become the catalyst for some of his large public sculptures, such as Giant Iguana and The World's Biggest Cowboy Boots. Recurring themes employed throughout the artist's career in a variety of mediums show the consistencies and differences in emphasis and concern. He has simultaneously explored the possibilities of images and painting and the relationship between the two.

The intriguing ambiguity of the photo work as both painting and photograph creates an interesting dialogue and a visual appeal. The work appears more real than real, as Wade manipulates the photograph to create an added depth to the image. It is his skill as a painter, not as a photographer, that creates certain illusions of reality in his photo works.

Perhaps the strength in Wade's art comes from his innate technical flexibility and consuming compassion to constantly redefine his work. He draws upon every experience and perception to create provoking, sometimes startling, and surprisingly well-thought-out work. Wade creates the illusion of spontaneity and real-time experience in his art that works in reverse, demanding one ponder his statement and question the artificially imposed limitations of art.

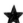

TEXAS, DADDY-O, AND BIG-ASS ART

W. K. Stratton

And so, Austin: where it's never supposed to get cold. Outside, the sky is the color of duct tape, and the wind fairly howls from the north. I've scooted along from my parking spot a block away as fast as my Lucchese boots will move me. Inside Shoal Creek Saloon, things are toasty enough as I await Bob "Daddy-O" Wade's arrival. Usually we sit out back on a porch overlooking the flood-prone stream for which the saloon is named. But none of that today—too damned cold. I sit down at what Daddy-O and I have come to call the Power Table. It's a two-seater at the head of the shuffle-board table. A waitress saunters past. "Waiting for the Daddy-O?" she says. I nod. Everyone here knows Wade. He is a fixture, as much as as the giant New Orleans Saints Helmet out front, which he created from an abandoned Volkswagen Beetle body. A good thing, too: Better that an old car blossom into a piece of art than rust away in a junkyard.

Presently Wade arrives. Through most of the year, his uniform is made up of shorts, flip-flops, and well-faded Hawaiian shirts. His clothes come from the Goodwill Central Texas Lake Austin Store, located approximately at the intersection of Lake Austin Boulevard and Exposition Boulevard in a small strip center that also houses a Twin Liquors and Maudie's Café. Daddy-O's wife, Lisa, tells me he's an easy husband to shop for: gift cards from Goodwill and Shoal Creek Saloon are all the presents he needs. Today, though, Wade is bundled up. Relatively speaking, at least. He agrees that the Power Table is a good choice. He takes his chair, and after we order, we get down to work on the book before you.

You need to understand from the get-go that I'm no artist. I fail at even drawing stick figures. Yet I've always loved paintings, sculpture, drawings, and photographs. There wasn't much of it around when I was a kid growing up in the place I sometimes refer to as Dog Lick, Oklahoma. Every so often I'd make it over to Tulsa, where if fate smiled kindly on me, I could avoid the Prayer Tower at Oral Roberts University and go to a museum like the Gilcrease or the Philbrook. I'd be amazed by the art I'd see and wonder how in the hell someone could make something like that. But those pieces all seemed to be about a hundred years old or more and were hardly relevant to what I dealt with in my day-to-day life. I mean, up there on museum walls I'd see buffalo

hunts, towering mountains, grand waterfalls, cattle drives, huge rivers, Indians! Stuff far removed from Dog Lick. Then I'd go home and look around at the trailer parks, gas stations, tire recapping shops, backyard chicken coops, and oil field tool yards. I'd wonder: Why doesn't anyone make art from the world I know?

Well, we were pretty cut off from the rest of the world up there in Dog Lick, except for the regular arrival by mail of *Reader's Digest* and the appearance of syndicated Lawrence Welk shows on TV. So I had no idea that a revolution was going on in the art world. I didn't know that someone like Andy Warhol had been making art from the label of a Campbell's soup can or the image of Elvis Presley on television. Or that Eduardo Paolozzi was fashioning collages from confessional magazine covers (just like the ones they sold down at the Dog Lick bus station!), postcards, and Coca-Cola ads. Or that Robert Rauschenberg of Port Arthur, Texas (by way of the University of Texas), had done his famous Combine paintings incorporating all kinds of found stuff, from newspaper clippings to patches of clothing. Or that Ed Ruscha from Oklahoma City (just thirty miles from Dog Lick!) had created an artist's book called *Twentysix Gasoline Stations* that included, well, twenty-six black-and-white photographs of gasoline stations between Los Angeles and Oklahoma City. Or that Mason Williams, also of Oklahoma City, had made this life-size silk screen of a Greyhound bus, which turned up at various museums since its 1967 debut.

I certainly didn't know anything about Bob Wade back then.

Daddy-O was born in Austin, Texas, in 1943. It was fitting that he drew his first breath here, just blocks from the Shoal Creek Saloon. Austin is the state capital, and it sits pretty much in the middle of the huge landmass that is Texas. Images of Texas are at the foundation of most of the work that Wade has created. His dad was a hotel manager. Wade explained that hotels changed hands with some frequency in those days. A new owner would come in and fire the staff already in place, then bring in new people. As a result, Daddy-O's youth was nomadic. He grew up in Galveston, Waco, San Antonio, and Marfa, where his dad was employed by the Hotel Paisano shortly before Rock Hudson, James Dean, and Elizabeth Taylor finished up filming George Stevens's *Giant* there. For a time, he lived in Beaumont in far East Texas, birthplace of the state's fabled oil and gas industry. He went to high school 828 miles west and a little north of Beaumont in El Paso, the westernmost point of the Texas. During all this moving around, the Daddy-O was absorbing Texas and Texans.

But Wade was also filing away the iconography of the West itself. His mother's cousin was Leonard Slye, a guitar-playing, golden-voiced yodeler who found success with his vocal group, the Sons of the Pioneers ("Tumblin' Tumbleweeds"), and then, rechristened as Roy Rogers, became the Saturday-afternoon-serial "king of the cowboys." And more. The serials Rogers made for Republic Pictures found a home on television in the 1950s, and Roy Rogers action figures, lunch pails, and adventure novels, as well as a comic book series and a daily newspaper comic strip, followed. As much as anyone, Daddy-O's cousin forged the mythic image of the cowboy for millions of American baby boomers. Wade was there

to take it in, not just the adventures of Roy Rogers, but also the nighttime Westerns, such as *Gunsmoke* and *Have Gun—Will Travel*. He was primarily an urban kid, living in heart of those Texas cities. He never rounded up cattle on a ranch, never did much in the way of horseback riding, never rode the rodeo. He knew the mythic icons, though—Matt Dillon, Paladin, Cousin Roy, and the rest. He loved what he saw. "There was little Bob Wade in the hotel manager's suite, watching it all on TV," he told me.

The move to El Paso proved fortuitous. It certainly had its connections to both the real and the mythic West. John Wesley Hardin is buried there. Legend holds that Marty Robbins was inspired to write his legendary hit, "El Paso," while stopped in the city for a smoke break en route to Los Angeles on the old two-lane highways. El Paso is not far from Pat Garrett and Billy the Kid country. It's also on the Mexican border, with the lively metropolis of Ciudad Juárez just across the Rio Grande.

At the time Wade moved to El Paso, the "Sun City" was a happening place. The best anyone can tell, the whole pachuco thing got rolling there and across the river in Juárez at about the same time. El Paso became so well known for its pachucos that it got the nicknames Chucotown and El Chuco in Texas and northern Mexico. Pachucos had been around for a few years by the time Wade showed up, and they made an impression on him. Pachuco was, in part, about style: clothes, of course, but also cars. Wade was like a lot of boys coming of age in the late 1950s and early 1960s. He was car crazy. He was especially interested in hot rods, and El Paso boasted a nonpareil hot-rod culture. (Wade's fascination with hot rods began when he was just a tyke. He had a metal

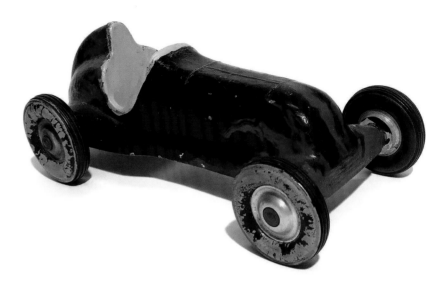

Childhood toy race car, altered by Wade circa 1953. Enamel and mother's fingernail polish on cast aluminum Indy race car. 8.5″ long. Collection of the artist.

toy car that he customized by painting the interior blue and the exterior black, using his mom's fingernail polish. He also added red flames to the front.) "El Paso was all about cars," he said, "a huge automotive phenomenon that was around long before I got there in the fifties. Though we were a hell of a long way from L.A., where the custom-car craze was happening big." No one below a certain age (except maybe the soldiers stationed at Fort Bliss) drove a car that looked like it did when it rolled off the factory line. Some were souped up into racers. Others were just tricked up inside and out. Your car was your personal statement. Everything was fair game, from the suspension to the roof to the front grille (or lack thereof) to the tuck-and-roll upholstery. In short, a whole bunch of people roaming around El Chuco were creating art.

The same was true across the river in Juárez. As a teenager, Wade went back and forth between the cities often, usually to get into mischief at Juárez's bars and whorehouses. There were hot rods aplenty, of course, but even more. Daddy-O was exposed to all sorts of tourist-trade items—everything from playing cards emblazoned with pictures of naked women to stuffed lizards to mass-produced black velvet paintings. He took these images all in and filed them away in his creative consciousness. The El Paso experience was key to his development as an artist, just as it was for his contemporaries Luis Jiménez (a major Mexican American sculptor and painter) and Boyd Elder (best known for album covers for the rock band the Eagles).

Wade was nicknamed Daddy-O by Kappa Sigma fraternity members while he was attending the University of Texas in Austin in the early 1960s. He showed up in Austin wearing long(ish) hair, jeans, and desert boots. Urged to stop by the Kappa Sigma house, known to be one of the wildest on campus, he encountered a bunch of young men from places like the Park Cities in Dallas who wore starched high-water khakis. The crew cut seemed to be their favored hairstyle. At the urging of a frat member named Machine Gun Kelly, the Kappa Sigs voted him in. The crew cuts from places like Dallas thought he sounded and looked like a pachuco. One thing led to another, and he became the Daddy-O. He joined company with guys with nicknames like Pig Pen, Doc, Spot, Cowboy, Monk, Skate Key, Blanco, and Mellon Head.

The Kappa Sig experience turned out to be important for his development as an artist. For one thing, it provided him with a world of connections he would never have had otherwise. More than one Kappa Sig has purchased his art over the years. The Kappa Sigs were wild and crazy boys without question—Daddy-O describes them as "high-class *Animal House* types"—but a number of them went on to important roles in business, education, the legal community, politics, and journalism. The road trip was an important aspect of Kappa Sig tradition. Typically, it would involve logging a lot of miles between Austin and the border cities to the south, usually either Nuevo Laredo or Villa Acuña (nowadays Ciudad Acuña). Plenty of high jinks took place during those journeys, but as the highway miles rolled away, Wade was stockpiling more and more images of his native state—those from la frontera, for sure, but also from those miles and miles of flat mesquite country.

After graduating from UT, Daddy-O headed to one of the highest of highbrow universities on the West Coast—Cal Berkeley—where he received an MA degree. He arrived just as the days of the Beat Generation were winding down and the counterculture that flowered in the late 1960s was getting under way. In most ways, the bohemian spirit was different from anything he'd experienced in either El Paso or Austin. But there were also elements that reminded him of the "rough, organic, visceral quality" he was accustomed to back in Austin. He fitted in at the art department, where important professors included Peter Voulkos, Jim Melchert, George Miyasaki, Harold Paris, and Elmer Bischoff. Voulkos in particular impressed Daddy-O with his "free-form attitude."

Back in Texas, Wade became an academic and spent a decade teaching at colleges and universities. He also steadily became known as one of Tex-

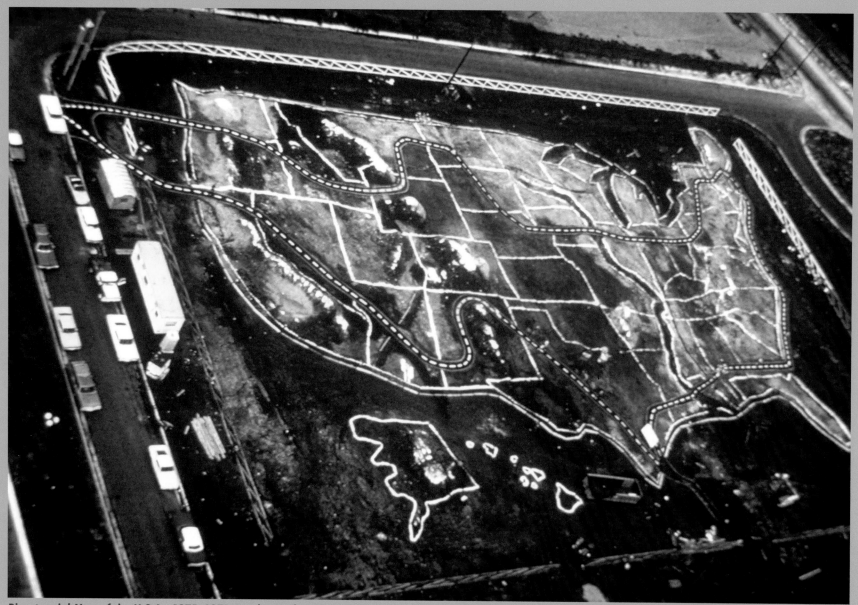

Bicentennial Map of the U.S.A., 1975–1976. Landscaped areas and displays representing American culture. Route 66, cars, miniature billboards, white gravel, wood fence, viewing tower. 400' × 250'. Temporary installation for the bicentennial on Trammell Crow property—North Dallas, Texas.

as's best young artists. Not long ago, I stopped by Daddy-O's place in the Northwest Hills section of Austin. (You can tell which house is his by the B-52 nose cone in the driveway.) I spent a couple of hours looking at Wade's own artist's book called *Bob Wade's Texas,* which in recent years has become highly collectible; the last one I saw for sale was listed at $7,500. Daddy-O produced fifty of them in 1976, each signed, numbered, and hand-assembled, with a tooled leather cover (stars, horseshoes, bucking broncs, and roses with a rope border) and held together by silver saddle studs. Anyway, I sat down at a table in Wade's studio, and assiduously avoiding spilling any of my Tecate on a copy he let me examine, I looked through the incredible collection of photos inside. Most were of installations he'd done at museums during his first ten years back in Texas. They were large, impressive works, and like all installation art, temporary. The photos are the only evidence they existed. Most (maybe all) dealt with Texas, and they were constructed out of Texas found material: dirt from here, chicken wire from there, a couple of galvanized stock tanks from the ranch and farm supply store, a small travel trailer, pairs of Justin boots from a Western wear store, and so forth. As I thumbed through the pages of the book that nowadays costs about thirty-five times more than the first car I bought, I formulated some thoughts about Daddy-O's media and just where his art shows up.

I'm sort of a half-assed student of Zen, have been for decades. One thing I've come to learn is that the Buddha resides as comfortably in a sewage treatment plant as it does in the grandest temple in Kyoto. Likewise, the godhead of art is just as present in barbed wire and wrecked VWs as it is in the finest oil paints and most expensive canvases. Real art is as much on display in the design of lowrider cars on display in, say, Española, New Mexico (the Lowrider Capital of the World), as it is in the works of all those dead Italian guys hanging on the walls of the Louvre in Paris. I remember I began to figure that out when I was in my twenties and guys like the Daddy-O became artistic heroes of mine.

I first heard of Daddy-O when I was still in Oklahoma and accomplishing my higher education at a state college that prided itself on its mortuary science department. One day I picked up a copy of *People* magazine lying around in the student union (fifty-cent sloppy joes!) and opened it to a two-page layout concerning America's bicentennial. The headline read: "Eat Your Heart Out, Rand McNally, Bob Wade Is Building a Map Bigger Than a Football Field." It was a giant rendering of the United States, and indeed, it was wider than the length of the Dog Lick High School gridiron. People described the installation thusly: "The giant earthwork is located outside Dallas at a freeway intersection where 100,000 cars pass each day. Though still under construction, the map already has the major mountain ranges installed. The Mississippi River and Great Lakes, when filled with water, will contain the equivalent of two huge swimming pools."

All right! I thought at the time. *This is my kind of art.* The Daddy-O told me at Shoal Creek Saloon nearly a half century later, "I'm just not the sort of guy to wander around Provence wearing a beret and painting watercolors." Thank God he's not. Otherwise we would not have the treasures that appear in this book: giant cowboy boots, dancing frogs, a saxophone longer than an eighteen-wheeler, and

so on. About three years after I read about Daddy-O in *People,* I encountered one of his big-ass pieces of art while I was making my virgin voyage to New York City. I'd been told that the Lone Star Café was the hip place to be at the time, and desiring above all else to be cool, I made a stop there. Much can be said about the music I heard and the waitress I met there, but I digress. The important thing was Wade's iguana perched there on top of the building, huge it was, above the legendary sign (lifted from Billy Joe Shaver): TOO MUCH AIN'T ENOUGH. The lizard, named Iggy by the locals, became a bit of controversy back in the day, as you'll read in the book. It now has a peaceful home at the Fort Worth Zoo. When I glimpsed it back in '79 (or thereabouts), it blew me away. I became a Daddy-O fan for life.

Within these pages, you will find observations on the Daddy-O's art from other fans, along with various writers, tycoons, critics, journalists, scholars, and wheeler-dealers. The latter is important when considering the whole of Wade's achievements. Daddy-O is in part a performance artist, though that typically goes unrecognized. The Texas wheeler-dealer is a Lone Star stereotype. Think Lyndon B. Johnson muscling and cajoling legislation through a divided US Senate back in the 1950s. Think the Cadillac-driving fast talker scooping up mineral rights leases by the score in the Texas Panhandle. Think maybe even of Jett Rink his own self . . . When Daddy-O is gathering material for an installation or a sculpture or whatever he's working on, he'll slip into wheeler-dealer mode. He'll be talking his way into borrowing, say, a dozen pairs of Justin cowboy boots from a Western wear store just down the block from the art

museum. He's good at it. He gets what he wants and needs.

Part of this has to do with an ethos Wade embraces. To be sure, he is at home at art museums and universities, and he's received his share of acclaim from them. But he also feels a strong connection to the world of the rodeo cowboy—in particular, rough stock riders. If you ride a saddle bronc or a bull, either you make the eight-second buzzer or you don't. Everything is clean and clear. There's no room for vagaries in the rodeo arena. There's also no time for deep reflection or any form of soul-searching for a rodeo cowboy. A few summers ago, I was hanging out in Prescott, Arizona, when a rider I knew, Jesse Bail, roared into town with his traveling partner. They jumped out of the pickup, stripped down to their underwear in front of God and everyone, put on their riding grodies, exchanged a few pleasantries with me, and then hustled off to the chutes, where they each rode a bronc and a bull. Then it was back to the pickup, out of the grodies, and into their traveling jeans and boots, and hit the highway for the next rodeo, which happened to be in Window Rock, 281.9 miles away. Get it on, get it done, then move on. This kind of gonzo approach to life (and art) works for the Daddy-O as much as it does for Jesse Bail. It's a tenet much appreciated by old-school Texans.

Those same old-school Texans will appreciate how Wade has made it through his personal and artistic life on his own, taking his own risks, paying his own way. He's made it work splendidly, as the works in this book demonstrate.

P.T. BARNUM MEETS ROBERT SMITHSON

Or, Claes Oldenburg Speaks with Mark Twain's Accent

Jason Mellard

It is tempting to start a book on Bob "Daddy-O" Wade with comparisons, to say that the art of Daddy-O is what happens when P. T. Barnum meets Robert Smithson, or when Claes Oldenburg speaks with Mark Twain's accent. Daddy-O is Davy Crockett gone to MoMA. He invites such comparisons; they will appear throughout this book. The truth of the matter, though, is that no one comparison will pin Daddy-O down. It might be safely said that he is an American artist, and not just in the museum signage sense—ROBERT WADE, AMERICAN, BORN 1943—but in the ways his career evokes something of the nation's sense of self: its optimism and inventiveness, its irreverence and humor, its populism and find-a-way pragmatism. These core characteristics enliven the pages to follow. It is a book about the art Bob Wade has made, and how that art has affected the world around it.

Wade closed the first chapter of his 1995 memoir with the advice: "don't look back, I never do."[1] The years have a way of circling back on you, though, and two further decades of Daddy-O doing what Daddy-O does have made the time ripe for retrospective. To look back now is not just timely but necessary, and the reason our examination is essential is something of a paradox. Taken as a whole, Wade's wide and wild body of work—rendered in oversize critters and roadside attractions, cowgirl canvases and hot rods gone feral—maps American sensibilities, and not just in a metaphorical sense. Daddy-O's work is everywhere, but many people may not realize it. His creations roam the countryside and stalk city streets, staggering in their scale and also in their ubiquity—forty-foot iguanas sunbathing atop zoos, Volkswagens-turned-football-helmets above a bar, Godzilla-sized boots standing sentinel at a mall. Yet that same ubiquity, the fact that so much of his work winds its way into the public realm of commerce and leisure, often leaves viewers unaware that all these creations sprung from a single, fertile, mischie-

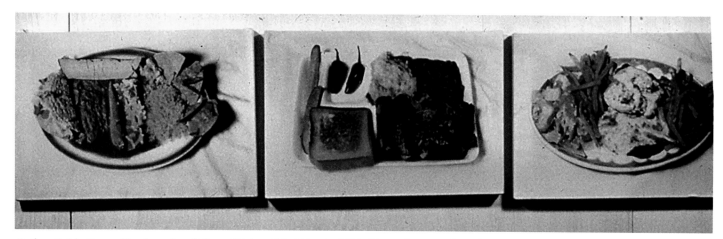

Eating Out in Texas Mexican, Bar B Que, Chicken Fried Steak, 1974. Photo dyes on photo linen. Each 14" × 20". Collection of the Meadows Museum at Southern Methodist University, Dallas, Texas.

vous artistic mind. Such is Daddy-O, and this volume serves as an introduction to his work to those who have not formally met it before, as well as a review, a "retrospectacle," as his 2009 South Austin Museum of Popular Culture, or SouthPop, exhibition termed it, for those who have long followed this particular patron saint of Americana.

Born in 1943 in Austin, Texas, Bob Wade spent his early years all across the Lone Star State due to his father's peripatetic career as a hotel manager. Among other things, this made young Wade an early artist on the Marfa scene, closer in time to James Dean at the Hotel Paisano than Donald Judd at the Chinati Foundation, but it was an El Paso adolescence that left the deepest marks on his aesthetic sensibilities. His arts education sparked somewhere between El Paso and Ciudad Juárez, in the border-town subversion of aesthetic hierarchies and legal niceties, its embrace of bold colors and frenetic hustle, its ceaseless movement and contagious optimism amidst want. Wade has often taken

on these themes explicitly, but they have also lent to the whole of his art a boundary-crossing quality. He knows well, but does not honor, the lines between high and low, art and commerce, the gallery and the honky-tonk. If the border shaped his world view, El Paso also developed his technique. The sculptural improvisation of his teenage hot-rod club the Road-runners introduced him to the art of customizing, taking the products of American mass production and making them unique objects: faster, brighter, louder, and bigger than the original design, sure to attract attention.

The El Paso borderlands, then, lent Wade the populist nature of his craft and an eye for vernacular creativity. He first found his academic footing at the University of Texas at Austin in the early 1960s, training under William Lester, Everett Spruce, and Charles Umlauf. Such formal art training by day found its complement in the nocturnal prankishness of the Kappa Sigma fraternity. It was there that Wade's border hipsterism earned him the moniker

Daddy-O, as well as friends who would serve as lifetime patrons and partners in crime. Austin academe next launched Wade to Berkeley, where Daddy-O dove headfirst into the zeitgeist while pursuing a master's in painting at the University of California in 1965 and 1966. Berkeley helped fuse the academic and anarchic sides of Wade's Austin years through Bay Area curator Peter Selz's Funk Art movement. Selz's Funk sought to claw back figurative painting from sterile abstraction, and foregrounded emotion, humor, and an earnest appreciation of folk art.

If Berkeley was one origin point of Wade's irreverent funk, Waco was another. Post-California, teaching brought Daddy-O home to Texas, with stops at McLennan Community College in Waco (1966–1970), both the Northwood University and Richland College in Dallas (1972–1973), and the University of North Texas in Denton (1973–1977). In Waco, Wade began what he called his "weenie" paintings of the period, with long, squiggly cylinders floating across the space of canvases to create the Op Art illusion of depth. The figures evoked the sixties in their echoes of the rockets of Buck Rogers and the space race, the missiles of the arms race, and the dizzy joy of sexual revolution and psychedelia. Waco hosted some of Wade's first public sculptures, including Funny Farm Family (1968), which took Wade's "weenie" canvases into the third dimension. McLennan County also reminded Wade what a weird place Texas could be. He encountered a cross section of good ol' boys, outlaws, and countercultural regionalists who would help thrust his Berkeley funk into overdrive. The synthesis came into full view with the Dave Hickey–curated South Texas Sweet Funk exhibition of 1970 at St. Edward's University in Austin. There, Wade's work appeared alongside armadillo artiste Jim Franklin, Chicano sculptor Luis Jiménez, and Gilbert Shelton of *Fabulous Furry Freak Brothers* fame, among others.

In Dallas, Wade joined forces with some likeminded surreal regionalists dubbed the Oak Cliff Four. Daddy-O, George Green, Jack Mims, Jim Roche, and Mac Whitney together came off as something like the Depression-era Dallas Nine gone gonzo.[2] If painters Jerry Bywaters and Alexandre Hogue had offered earnest critique of class and capital in the 1930s, in the 1970s Wade and his compatriots held up a funhouse mirror to the expressive exaggerations of their Texas home in a moment when the state drew outsize attention. Wade's efforts both fed and furthered a national hunger for Texas Chic in these years, as the oil economy and popular culture of the 1970s rendered Texas an island of swagger in a sea of American malaise.

Wade came naturally to the cowboy pose. Roy Rogers was his mother's cousin, giving Daddy-O early insight into the ways that Western myth and reality played tag with one another. Like the reporter famously said to Jimmy Stewart's character in *The Man Who Shot Liberty Valance,* "This is the West, sir. When the legend becomes the fact, print the legend." Daddy-O lived the words, quick to spin a tall tale when asked by those abroad to explain some product of Texas. Once Daddy-O transported a taxidermied bucking bronco cross-country to an exhibition in Los Angeles, upside down in the back of an El Camino. A dead horse hauled thusly is a bit macabre, but Funeral Wagon, the world's deadliest bronco, took on heroic dimensions as Daddy-O spun his biography out bit by bit. To cap it off, Wade wrote out the story longhand on the wall of the L.A. gallery.

Wade's art took monumental form in the Texas Chic years through sculptures that playfully incarnated the state's braggadocio. Perhaps his most iconic piece was born of this impulse. First developed at Artpark in Buffalo, New York, in 1978, Wade's forty-foot polyurethane neon iguana on a metal frame soon found its legendary perch atop Manhattan's Lone Star Café. From there, the giant lizard served as a beacon of weird for Texas Chic. While Kinky Friedman, Waylon Jennings, and Doug Sahm graced the venue's stage, the iguana visually embodied the slogan emblazoned across the club's front: "Too Much Ain't Enough." As with Liberty Valance, the words could well serve as a Wade mantra.

Such gargantuan installations were one element of Wade's Texana turn. Another involved photo-emulsion canvases through which Wade made some of the most vibrant explorations of his absurdist strain of regionalism. In searching for new techniques to create backdrops for his early "weenie" paintings, Wade had struck on the idea of photo emulsion, developing photographed backgrounds on canvases and linens. Eventually, the cylindrical abstractions withered away entirely as Wade began to enlarge and hand-tint photographs he found or took himself of bizarre scenes surrounding him in North Texas—rows of dead coyotes, groups of gun enthusiasts and tattooed ladies, and greasy-spoon gastronomy. Over time, photo linens of cowgirls, often lined up for formal portraits at early twentieth-century rodeos, would become Wade's calling card and develop a large popular audience. The offbeat canvases also quickly drew attention in the art world. The black-and-white photo-emulsion canvas *Gettin' It Near Cedar Hill,* of two heifers quixotically making the beast with two

backs, appeared in *Artforum* in 1971, reviewed by Robert Pincus-Witten. The photo canvases have proliferated in scale and subject matter since, remaining a cornerstone of Wade's practice. They hang in the collections of the Pompidou Centre in Paris, the Menil Collection in Houston, the New Mexico Museum of Art in Santa Fe, and the Prince's Palace of Monaco, bringing new life to old rodeos, scenes of the Mexican Revolution, Western cantinas, and images of otherwise forgotten Americana exotica.

Wade's canvases brought him renown as early as the Whitney Museum of American Art annual of 1969, but he unleashed his full Texas pastiche on the art world with an installation at the Paris Biennale in 1976. There Wade filled a Spartan trailer with a taxidermized two-headed calf, plastic bluebonnets, a tooled leather saddle, stuffed rattlesnakes and armadillos, and the legendary Funeral Wagon himself, accompanied by a Waylon Jennings soundtrack. Wade has consistently shown a capacity to both exploit and explode Texas stereotypes by rendering the state's culture through such odd ephemerata. Much as T. S. Eliot tried to define Britishness through the homology of all the characteristic activities and interests of a people—"Derby Day, Henley Regatta, Cowes, the twelfth of August, a cup final, the dog races, the pin table, the dart board, Wensleydale cheese, boiled cabbage cut into sections, beetroot in vinegar, 19th century Gothic churches and the music of Elgar"—so has Daddy-O decanted Texas. In an essay from this period Wade described his attempts to capture Texas in "ideas and attitudes about scale, culture, myths, symbols, artifacts, history, customs, food, animals, experiences, kitsch, machismo, cross-fertilization, sign systems, tourism, country

western music, the picturesque, boundaries, life and death."[3] He crafted Texas installations of this Whitmanic scope not just in Paris but also in New York, Los Angeles, San Francisco, and even Fort Worth and Houston. Texans, too, crave an understanding of the mythic folk others hold them to be.

Now, the art world's appropriation of popular culture, its usage of objects and ideas from the commercial and vernacular worlds, was nothing new. On the surface, Wade speaks the language of 1960s pop art, of Andy Warhol, Roy Lichtenstein, and fellow Texan Robert Rauschenberg. He swims in some of the same waters as the later masters of the postmodern like Jeff Koons. Wade was well aware of these critical contexts, the attempts to tear down the walls between "high" and "low" culture. In the 1975 film *Jackelope,* Wade references Clement Greenberg's influential 1939 essay "Avant-Garde and Kitsch," in which Greenberg hoped to buttress those walls, defending the seriousness of the avant-garde project against the celebratory gestures of popular culture.[4] When Greenberg spoke of kitsch, his words aimed to dismiss it, to dethrone the Popular Front regionalists of the Depression in favor of more cerebral abstraction. When Wade muses over kitsch while on his *Jackelope* road trip across Texas, though, he instead pays homage to American populism. Kitsch, he says, is "just good material to talk about—and that's all we're doing is talking about it." Commercial kitsch informed sixties pop art, but its practitioners still implied that their appreciation came from a distance, that they reframed the material when they brought it into the gallery setting.

Wade does not affect such cool distance. He appreciates and echoes and seeks to amplify the original authors of kitsch in a very different way.

Like Robert Venturi, Denise Scott Brown, and Steven Izenour's contemporaneous manifesto *Learning from Las Vegas,* Wade looked to the flotsam and jetsam of midcentury Americana to make the case that the world of common folk—the commercialized landscape through which they moved and the cornucopia of plasticized commodities that they consumed— was not a perversion or a coarsening of American culture, but rather that culture's throbbing, loud, messy essence. Wade's boundary crossing proves boldest here. Rather than bringing advertising into the museum to challenge patrons to appreciate it, Wade took his sculptural forms out into the world in such a way that several pieces—the Lone Star Café's Giant Iguana (1978) in New York, the dancing Six Frogs Over Tango (1983) in Dallas, the monumental Smokesax (1993) at Billy Blues in Houston—ran afoul of the law. Authorities claimed they were signage. Wade said they were art. The struggles that ensued— in which the law, always, determined that Daddy-O was indeed an artist who made art—themselves seemed like performance, rituals that Wade forced on the city to debate the very nature of artistic expression.

In the late 1980s, Daddy-O decamped from Dallas to Santa Fe. New Mexico's desert environs, regionalist art tradition, and gallery representation served as draws, but the real magnet was the development of his most meaningful collaboration. It was Santa Fe that brought his wife, Lisa, into the picture, and she soon became his indispensable partner, adviser, and steward. The Wades have since settled in Daddy-O's birthplace of Austin.

The twenty-first century has shown no signs of Daddy-O's slowing down. New exhibitions, new

works, and new frontiers continue to beckon. He devised a chicken-themed miniature golf hole for an artist-designed course at Laguna Gloria just down the hill from his home studio, installed an animatronic fish swimming in Lake Austin, and let loose a Harley-Davidson morphed into its namesake animal, Hog. The new century even brought another chapter for an old friend in the refurbishing of Daddy-O's iconic iguana. Wade and frequent collaborator Stylle Read gave the lizard a new coat of paint and lease on life, complete with a ceremonial helicopter airlift to the Fort Worth Zoo.

Wade's artworks can still hide in plain sight. In a way, they reverse Marcel Duchamp's readymades. Instead of signing a urinal and dropping it in a museum like a grenade, Wade crafts examples of roadside Americana so meticulously that they can be indistinguishable from the "real thing." For example, Wade once modified a twenty-five-foot fiberglass statue of a soda jerk from along the Pacific Coast Highway in Malibu into El Salsero (1987) for a new Mexican restaurant. The late actor and sometime Wade associate Dennis Hopper so admired the highway figure that he had it replicated for his exhibitions as an anonymous piece of folk art without even realizing it was a Daddy-O original. This misrecognition is understandable with pieces such as the New Orleans Saints Helmet atop the Shoal Creek Saloon in Austin, Dino Bob peering over a roof line in downtown Abilene, or the Bonnie and Clyde Mobile run aground alongside the Lost Horse Saloon in Marfa. "I didn't even know that was art" has often been the response of people passing by each of these well-loved landmarks. It is a compliment, really, that runs both ways. Wade successfully creates roadside Americana while also drawing attention to the his-

toric artfulness of such work, even if made by anonymous hands. He treats the genre seriously as an expressive art form and thus honors it by participating in the tradition. In the process, Bob Wade of the Whitney and the Pompidou shifts seamlessly into the Daddy-O whose fine art camouflages its pedigree as it enters public space.

The twentieth-century avant-garde long held that the power of art lies in its ability to be in and of the world, rather than occupying an elevated, separate sphere for aesthetes. Wade often treats such boundaries as if they do not exist to begin with, giving him the ability to straddle them with ease, to blend in from Monaco to the rodeo, as he says. All the world's his stage, or in the words of Wade, maybe "earth will be a spherical movie lot, with the tourists as extras."[5] I have invited Wade to speak to my history classes at Texas State University, and inevitably students approach him afterward who have very personal connections to his art, who take annual family Christmas portraits with the San Antonio boots or have marked time on I-35 road trips by spotting the wooden nickel at Carl's Corner. Place-making and the notion of a museum without walls have enjoyed a great deal of currency in recent discussions of public art, but Daddy-O intuited them long ago and has been forging places for community for most of his working life. He galloped ahead of the curve, and there may now be a need to wrangle his efforts back into the critical conversation.

In his memoir, Wade describes how the making of his art can be as much a public spectacle as the finished product itself. While originally constructing the world's largest boots on a street corner in Washington, D.C., he says, the "first thing I learned was that the minute you walk into a chain-link

fenced area with a bucket of junk, wood, and pieces of steel, within minutes of dumping the stuff on the ground, you have twenty people hanging on the fence watching. Not only are they watching, they're yelling things like 'Hey, mister! What's this going to be?'"[6] He has elicited the "What's that, mister?" question on many installation sites over the years, and he is always ready with an answer. More than that, he is as likely to pass the curious inquirer a shovel or a ladder or a list of supplies. Wade's public works, in other words, are participatory not just in their reception but also in their production. The elements of getting the thing built—the collection of materials, the permits, the puzzled stares, the invitations to collaboration—are key to the artwork. Wade has had a penchant for taking on the impossible and, through extensive collaboration and public relations, rendering a task merely improbable.

The goal is reminiscent of Christo and Jeanne-Claude's wrapping or reframing of public spaces such as the Reichstag or Central Park. Whole documentaries have captured their vision of art as civic process, where engaging, activating, and negotiating with the community are integral to the work. A high-profile example of how Wade's process echoes theirs is the Bicentennial Map of the U.S.A. (1976), conceived just as Christo and Jeanne-Claude's Running Fence (1976) was finally coming to fruition in California. Wade proposed an enormous earthwork American map off a freeway outside Dallas. This would be a sort of real-life version of the illustrated diner place mats depicting the flora, fauna, people, and economic activity you might find at any particular geographic spot. Wade had already accomplished a Texas-only version of this with a large installation at the University of St. Thomas in Houston. The Dallas project enlisted the aid of schoolchildren, chambers of commerce, street people, businesses, and the National Endowment of the Arts in creating a topographical map that you could walk in and even theoretically drive through, complete with entire boats, flags, roads, statues, and patriotic detritus.

Perhaps no acquaintance took to the task more than Willard Watson, aka the Texas Kid. Watson first came to Wade's attention through his over-the-top yard decorations. Daddy-O invited the Texas Kid as a collaborator, and along with other curator and artist friends, also helped him make connections to present his own folk art in more formal settings. Wade does this because he believes the folk/formal divide should not be a barrier to recognizing artistic vision. Daddy-O amplified the Texas Kid's voice, and Watson also informed Wade's practice. "Art is something you see in your imagination" was a Texas Kidism that struck at the heart of Wade's work.[7] Daddy-O could see that map take shape, and so it did. He could also see the community that the map created as being a tribute to the bicentennial in its own right. In the artistic tradition of social practice, people, too, are a medium through which Wade works, as much as paint or canvas or hubcaps or jukeboxes or surfboards or airplane fuselages.

In other words, Wade is a craftsman working from the flotsam and jetsam of American commerce, using stuff to make bigger and better and cooler stuff, but he is also a conductor of a raucous orchestra of Americans themselves. I am reminded of Lilly's, a bar in Lockhart, Texas, that Daddy-O had warmed to in the early 2000s. In 2011, Wade was also preparing an exhibition at Texas Lutheran University in Seguin that turned the school's art space into a simulation of a honky-tonk, centered on an

antique Wurlitzer jukebox. He took Lilly's bar as his model, in part due to the proprietor's daring design choices, with armies of tchotchke elephants donated by customers and chockablock neon signs. Lilly's coup de grace was walls covered in a very artful installation of aluminum foil, making that neon dance across the surfaces of the darkened bar. Lilly Serna had blanketed her walls in such a fashion for decades, and she meticulously taught Wade her foiling technique on the pool table one afternoon amidst the dense swirl of the bars' regulars.

In small moments like this, Wade's work does not simply pay tribute to American folk art, but reflects an earnest interest in harnessing the collective creativity of the many characters he has met along the way. He shows a delight in the vernacular that does not keep its distance from the creative work of everyday people, but invites their collaboration. This extends from originals like Lilly Serna to truck stop mogul Carl Cornelius of Carl's Corner or Waco taxidermist Byron Jernigan. They are not blank vessels or mere "inspirations" for Wade. They are colleagues, theorists, and often aesthetic pranksters who are in on the joke. Of the taxidermist Jernigan, Daddy-O once said, "he's selling deer heads and armadillos to the Japanese. That's the funniest thing I've ever heard, and I know that he knows it's funny."[8] Wade's appreciation of absurd inventiveness runs throughout his work, and few concepts prove as central for him as the Texas humor Jernigan embodies, a quality Daddy-O has defined as "garish, resilient, disorderly, perverse, and [helping] perpetuate the idea of the 'Professional Texan.'"[9]

To be enlisted in a Daddy-O art moment is a special kind of adventure. Recently, for example, he called me to ask if I'd like to ride along to Waco because he had to "see a guy about a skunk." And off to Jernigan's shop in Waco we went, that same spot he had been visiting since the *Jackelope* days, to procure a stuffed skunk to be incorporated into a mobile sculpture. Such social relationships, nurtured over time, are in some ways just as much Wade's masterwork as his monumental sculptures. Daddy-O has crafted an anarchic and enthusiastic menagerie that spans Texas, America, and the world. His sculptures, taken together, map the highways and byways of an alternate Texas and a carnivalesque America, and these sculptures are also, always, signposts to social networks just as lovingly constructed. His is a web that has spun so far that it has included, in time, Tommy Allsup, Kinky Friedman, Larry Hagman, Ed Koch, Larry Mahan, Willie Nelson, Ann Richards, Ed Ruscha, Julian Schnabel, Sam Shepard, and Prince Albert of Monaco, to name a few. Wade's weird world contains multitudes. This book is a testament to that fact. Like Daddy-O's art, it draws on an extensive and enthusiastic group of artists, critics, musicians, journalists, designers, academics, entrepreneurs, friends, family, and just about every brand of do-well and ne'er-do-well there is. Each of their paths has intersected with Wade or his art, and having done so, has never been quite the same. Their individual essays speak to a specific work or period from Wade's career, mapping Daddy-O's rich oeuvre and remembering what it means to all of us. And it has meant quite a lot. When it comes to Bob Wade's art, after all, too much, surely, ain't enough.

NOTES

1. Bob Wade with Keith and Kent Zimmerman. *Daddy-O: Iguana Heads and Texas Tales* (New York: St. Martin's Press, 1995), 4.

2. Brendan McNally, "The Oak Cliff 4 (or 5): When Funky Art Ruled Dallas—And Beyond," Art & Seek, May 31, 2013, http://artandseek.org/2013/05/31/the-oak-cliff-four-or-five-when-funky-art-ruled-dallas-and-beyond/.

3. T. S. Eliot. *Notes Toward a Definition of Culture* (London: Faber and Faber, 1948), 31; Bob Wade, *Bob Wade's Texas* (Maastricht: Agora Studio, 1977), 1.

4. Clement Greenberg, "Avant-Garde and Kitsch," *Partisan Review* 6, no. 5 (1939): 34–39. *Jackelope*, film directed by Ken Harrison (1975; Dallas: North Texas Public Broadcasting Foundation). Access the documentary at the Texas Archive of the Moving Image: http://www.texasarchive.org/library/index.php?title=Jackelope.

5. Wade, *Bob Wade's Texas*, 1.

6. Wade with Keith and Kent Zimmerman, *Daddy-O*, 117.

7. Ibid., 71.

8. *Jackelope*.

9. Annette Carlozzi, *50 Texas Artists: A Critical Selection of Painters and Sculptors Working in Texas* (San Francisco: Chronicle Books, 1986), 105.

Let'er Rip, 2012. Acrylic on digital canvas, 40" x 72".

FUNNY FARM

Carl Hoover

Funny Farm Family, 1968. Painted bomb casings, transformers and pipe. 7' tall × variable dimensions. Collection of the Waco Arts Center, Waco, Texas.

They converse in gaudy silence, the Funny Farm Family, grouped under the cedars outside the Art Center of Waco, four metal bodies from an industrial past jacketed in playground colors. The name raises questions. Who's the father? The mother? Why are they funny?

They once were metal transformers, ventilation piping, and bomb casings, sitting in Melvin Lipsitz's Waco salvage yard. In 1968, Bob Wade, an art instructor at Waco's newly established McLennan Community College, resurrected them. He welded them, painted them, and arranged them as art for a sculp-

ture exhibition at the HemisFair in San Antonio. The Funny Farm Family. It was Wade's first public art installation, already with the hallmarks of what would characterize much of his artworks for half a century. Implausible. Whimsical. Provocative. Controversial, even if mildly in this case: Wade's addition of *Funny* to the sculpture title had some wags wondering if he was commenting on the mental state of his fellow MCC faculty.

After the HemisFair, the Family settled back on the MCC campus and later was donated to the adjacent Waco Art Center. They stood there for decades, weathering Texas climate, the contemplative looks of art fanciers, and glances of students rushing to class.

Time proved to have not healing but corrosive hands, and by the turn of the twenty-first century, the Funny Farm Family had lapsed into a sad pile of happy junk. Wade, now an established artist with international reputation, returned to his Waco work in 2015 for some restorative family therapy. With the help of friends and MCC personnel, he repainted and revitalized them at a new site near Robert Wilson's Open Door on the Art Center grounds. Rededicated in 2018 on its fiftieth anniversary, the Funny Farm Family looks forward to new generations of observers pondering and wondering: Who's the father? The mother? Why are they funny?

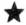

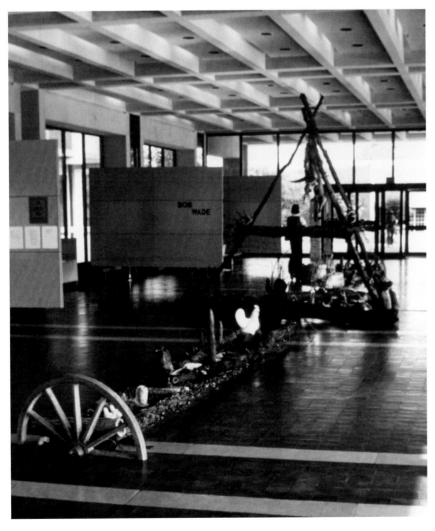

▲ Bob Wade (left) with welder Charles White, who assisted with the fabrication of Funny Farm Family. Collection of the artist.

◀ Waco, 1973. Regional objects and artifacts. 10' tall × variable dimensions × 75' long. Temporary installation in the library of Baylor University, Waco, Texas.

EL PASO

Ricardo "Rick" Hernandez

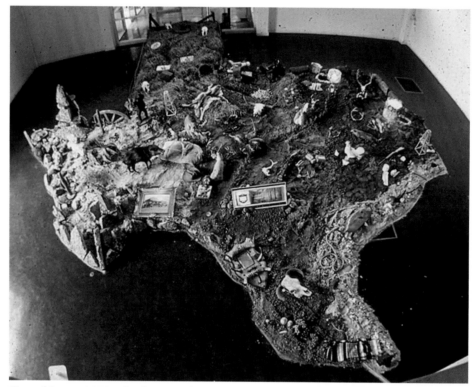

Map of Texas, 1973. Dirt, hay, sand, rocks, plastic bluebonnets, stuffed critters, beer signs, and miscellaneous Texana objects. 40' × 40'. Temporary installation at the University of St. Thomas, Houston, Texas. Photo: Robert Smith.

"Hey, Rick, there's this sculptor I know that's coming to town and he asked me to turn him on to someone that can get him anything he wants," said Dennis Evans, my sculpture prof at the University of Texas at El Paso. "I told him you were the dude, so help him out however you can."

That innocuous intro led to what would become a lifelong friendship and collaboration. Bob Daddy-O Wade had spent part of his youth in El Paso and graduated from El Paso High. He was coming home

to do a piece. The new Fox Fine Arts Center had just been completed at UTEP, and the main gallery was primed for its first installation.

An assistant professor at North Texas University, Bob had gotten a grant from the National Endowment for the Arts, and El Paso was to be the third in a series of four pieces created with the funds. The first two were a map of Texas at the University of St. Thomas and another of Central Texas created for Baylor University.

Bob wanted to build something that would

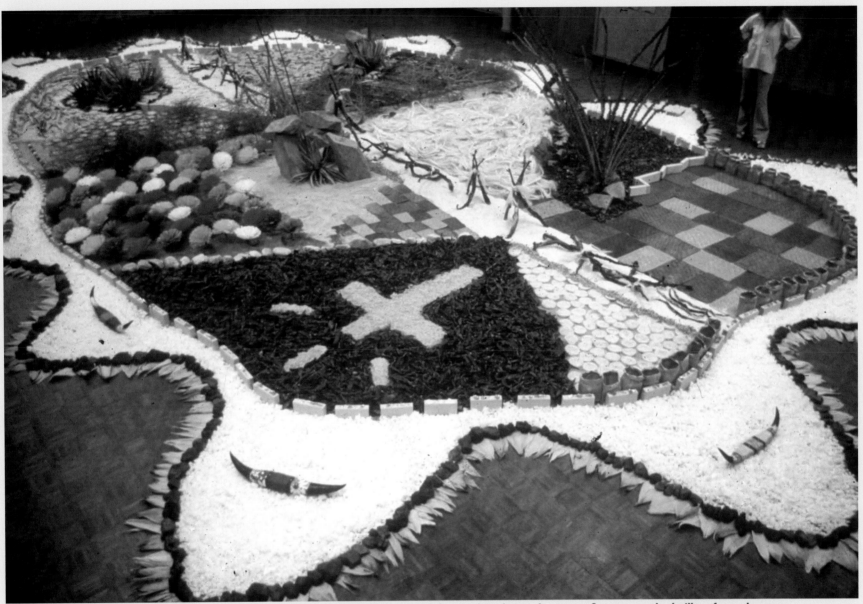

El Paso, 1974. Velvet paintings, Mexican steer horns, chili peppers, yuccas, corn husks, smelter slag rocks, paper flowers, crushed pillow foam, banana stalks, Fritos, tortillas, and various border-town artifacts. 30' × 45'. Temporary installation at the University of Texas, El Paso.

resemble an Aztec calendar, a cactus garden, or a Mexican combination plate, all familiar iconography in the El Paso Southwest and in the psyche of its population. Where better to harvest materials than Juárez, El Paso's sister city across the Rio Grande. We climbed into his old Chevy "Courtesy Van" and went into the depths of Juárez to gather the "stuff" that continues to be a part of his arsenal of objects and iconography to this day.

Haggling with mercado merchants and street vendors was commonplace for me, as was stopping off at Curly's Club for a cold beer and some flirting and Fred's Rainbow Bar for a ham and cheese torta. A new wrinkle was haggling for banana stalks that had no bananas. To his keen artist eye they appeared to have aesthetic value, so after a little negotiating we were led to a basement, where we found ourselves knee-deep in festering water, wrestling rats and rot stench for the best of what was to become a central element in the piece.

Once the Courtesy Van was filled, we had to get our bounty across the border. The agents weren't easily convinced that we were making "art" and weren't instead in the curios business and in need of paying a hefty tariff. In classic border patrol fash-

ion, they pulled us over and instructed us to unload the velvet paintings, corn husks, chili peppers, tortilla shells, hemp, sisal rope coasters and trivets, and mounted bull's horns on the ground.

To this day I believe that it was the rotting banana stalks, not the silver-tongued Daddy-O waxing on about the benefits of engaging community and place that are inherent in "this kind of material gathering and installing" that makes his approach to art making "more dynamic than being in the studio," that convinced them to let us go on without charge or arrest. Also, as is typical, they didn't help us put the stuff back in the van!

A few more materials were easily found on this side of the river—tumbleweeds, cactuses, and Asarco slag—and Daddy-O was ready to create. With additional help from my fellow students Pamela Leighton and Jim LaSalandra, we followed Bob's lead to complete El Paso, which was installed and on public view through November of 1974.

The gallery was christened and El Pasoans were treated to a celebratory view of themselves and the place in which they live through the creative eye and vision of expat Bob Daddy-O Wade!

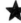

PANCHO AND FRIENDS/ SOLDADERAS

Carla Ellard

Texas is full of larger-than-life stories and legends, including the art of Bob "Daddy-O" Wade.

Growing up all over Texas, Wade went to high school in El Paso, where he embraced the border-town milieu. Years later, his appreciation for border culture would play a major role in his art—both sculpture and photography.

Since 1971, Bob has been creating photo works of subjects ranging from Texas cowgirls to bandidos to oil gushers. He is a collector of vintage and real photo postcards, and his photo process is unique. Both famous and rare photographs are cropped according to his design and enlarged digitally onto canvas. He then reinvents the photographs by airbrushing transparent layers of acrylic paint over the surface, utilizing his academic training as a painter. His photo works are sought out by individual collectors and major museums around the world.

The Wittliff Collections at Texas State, mostly

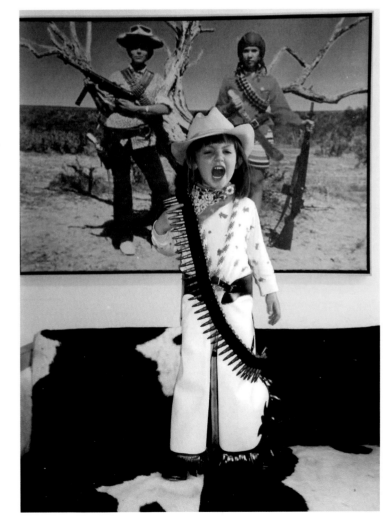

Rachel Wade with *Waco Girls*. Santa Fe, New Mexico, 1994.

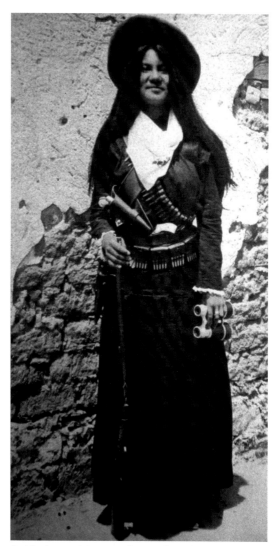

Soldadera, 1996. Acrylic on photo linen. 24" × 48". Wittliff Collections, Texas State University, San Marcos, Texas.

Sombrero Gate, 1992. Corrugated culverts, steel covered with wire mesh, foam rubber. 12' × 16' × 16'. Temporary installation, Snug Harbor Cultural Center, Staten Island, New York. Collection Goode Company restaurant, Houston, Texas.

known for having one of the finest collections of Mexican photography outside of Mexico, houses several of his images, including some from his Texas cowgirls series. Bill Wittliff, the founding donor for the collection and a kindred spirit, was a Kappa Sig brother with Bob in the early 1960s while they were both at University of Texas in Austin.

Tex-Mex influences come through in several of Bob's photo works. His 1996 photograph of a female soldier of the Mexican Revolution, *Soldadera*—a 48×24-inch image collected by the Wittliff—is transformed by enlarging and enhancing certain details, the binoculars and bandolier, with Technicolor and metal hues. With more intense and comedic effect, his photo works of revolutionaries—one with men seated with their rifles, and another standing—are revived with his use of color, including a pink bullet bag.

By echoing his own past work, Bob created a masterful photo work in *Pancho Villa and Friends*. Bob has gone digital by combining two of his photo works, *Pancho Villa* (1988) and *Señores y Señoritas* (1994). Wade (and his assistant) intermingled Pancho Villa and his group of revolutionary fighters with a group of smiling Mexican ladies. The five women blend seamlessly with the twelve revolutionaries, to the point that the photograph has even been mistaken as real. The resulting 20×60-inch panoramic digital print is an engaging image that appeals to all those who see it here at the Wittliff.

Throughout all of his works, Bob exhibits a sense of humor and irony rooted in his affinity for border culture and his Texas heritage.

"Sombrero Man" Rusty Rutherford, 1992.

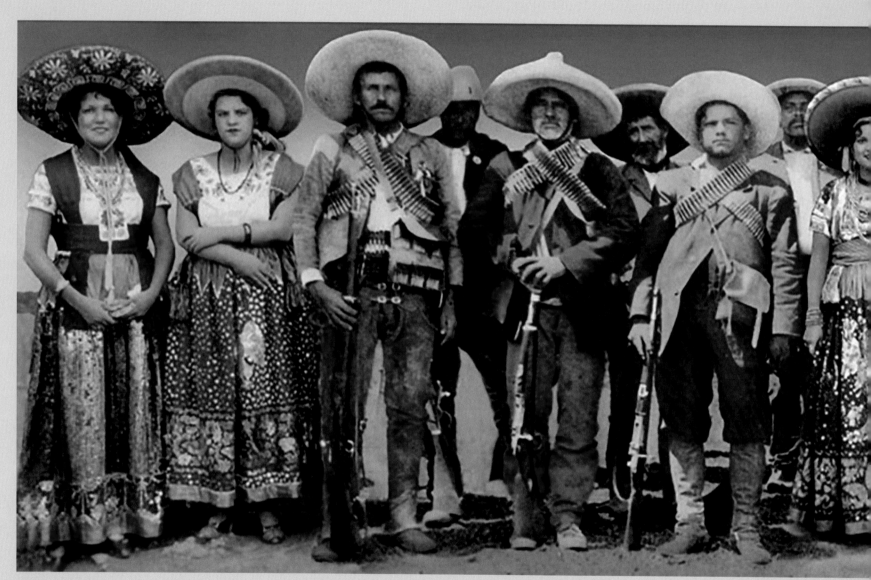

Pancho Villa and Friends, 2011. Inkjet print. 20' × 60'. Wittliff Collections, Texas State University, San Marcos, Texas.

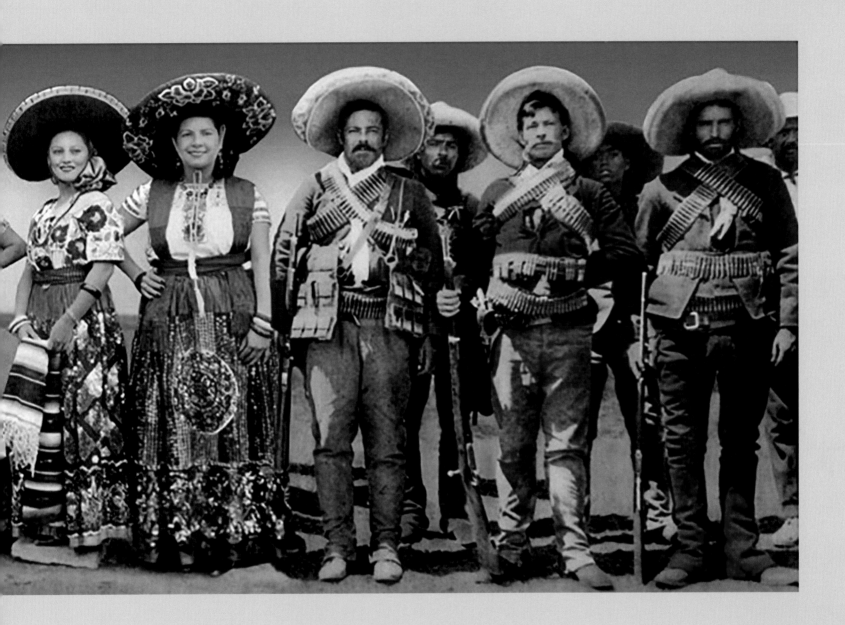

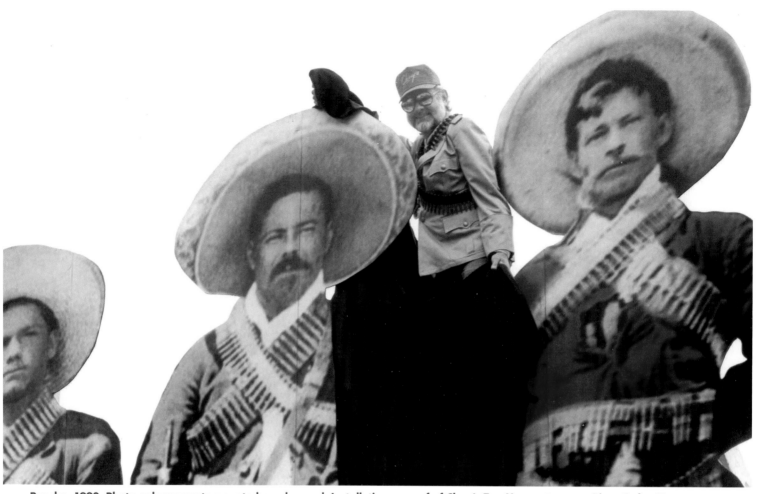

Pancho, 1992. Photo enlargements mounted on plywood. Installation on roof of Chuy's Tex-Mex restaurant, River Oaks, Houston, Texas. 8' × variable. Collection Chuy's company.

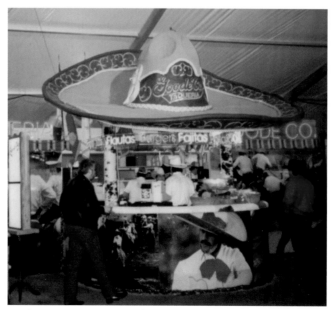

Sombrero Gate at its new home in Goode Company restaurant.

MALIBU MAN

Jesse Sublett

Posted there on his steel foot pedestal, like an anthropomorphic lighthouse overlooking the Pacific Coast Highway and the hills of Malibu, he could see it all through his football-sized eyes: NoBu, the hills of Topanga, Paramount Ranch, Beverly Hills, Encino, Griffith Park, Pacific Design Center, Tail o' the Pup, Randy's Donuts, Warner Bros., the Rose Bowl, Dodger Stadium, Boyle Heights, the streets of Compton, Sunset Boulevard . . .

Malibu Man had seen it all, heard it all. Over half a century—fifty-six years, to be more exact—Pacific Ocean at his back, sun beating down on his fiberglass skin, traffic winding down one of the most famous coastal highways in the world. Malibu Man was from that race of giants that once walked the earth. The Muffler Men ruled North America during its postwar peak, as rock 'n' roll guitars ruled the airways and Detroit-born V8 engines were the rumbling heartbeat of the land. Muffler Men were the great sentinels and beacons of commerce: hamburger stands, miniature golf courses, donut shops, muffler shops.

When you're twenty-five feet tall, humans can be uneasy in your presence. For many, suspicion turns to fondness; others become blinded to the sight. Little kids seemed to understand it best—at first afraid, then filled with wonder. Malibu Man remembered 1962, shortly after he was enthroned on this spot, next to the new Tastee Freez, when a little girl beamed up at him from the back window of the family station wagon. In those days, they had him dressed in white short sleeves and a paper hat, holding a giant hamburger. They called him Soda Jerk. But from the look in the little girl's eyes, you'd think she'd just figured out the great secret of the universe.

Later in the decade came the groupies and the free-lovers. One night in 1969, a VW bus puttered into the parking lot, Rolling Stones blasting from an eight-track. Long-legged hippie chicks climbed atop the van, grabbed his right leg, and blew kisses and flashed their boobs at him. One of them had a leather fringed vest and a bobbing blond ponytail. She was the one he remembered best.

A new guy bought the property in the eighties, a time when Muffler Men were dropping like flies. As suburbia peaked, the giants were left behind to preside over vast derelict asphalt graveyards. Herds of hooting drunken teenagers were lassoing and toppling the Muffler Men for thrills. Lumberjack Man, way up in British Columbia, had been dismembered and sold to a junker for $50. As if freezing his balls off all those years wasn't bad enough. In Arizona, two of the original men were still on the job, marked in tour guides as must-see attractions. Ironic, since the Bunyan/lumberjack models bore an eerie resemblance to axe murderers. Other survivors included Pennsylvania's Amish Man, a few remaining Phillips

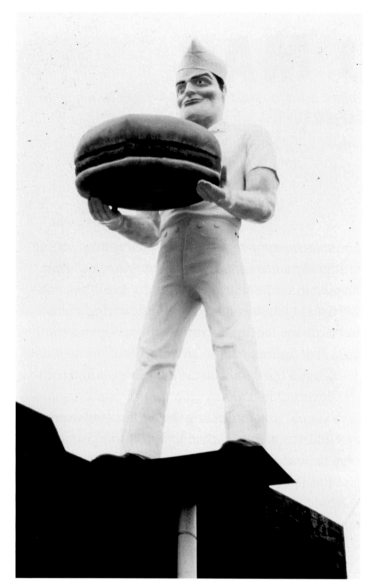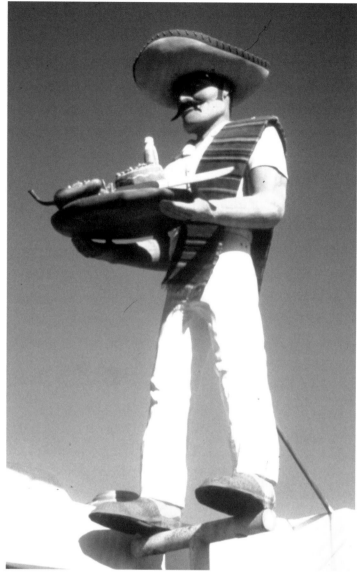

El Salsero/Malibu Man/La Salsa Man, 1987. 1960s fiberglass Muffler Man Soda Jerk transformed to El Salsero with high-density foam, serapes, tire treads, paint. Originally commissioned for La Salsa restaurant, Pacific Coast Highway, Malibu, California. 25' × variable sizes. Currently at same original address in Malibu, California.

66 Cowboys, and over on Figueroa Street, one of the saddest of his kind, Chicken Boy.

Though Southern California was renowned for its plastic surgeons, Malibu Man owed his soul to a Texan, Bob "Daddy-O" Wade, for his miraculous reincarnation in 1987. The new owner had built a Tex-Mex joint on the lot and asked Wade, a famous artist,

to perform a makeover that was more harmonious with the original soul food of the Southwest. Wade ingeniously recycled the top portion of the hamburger to create a sombrero for Malibu Man's sun-baked cranium, using the leftover split portions of his skull to create a taco. With a colorful serape and a few other alterations, the transformation was com-

plete. Malibu Man, who acquired new names such as El Salsero, was forever grateful to Wade for bringing out his inner Mexican. Even as so many of the old giants fell, Malibu Man felt complete.

Stories. Sights. Storms. Crime waves. Malibu Man saw it all, remembered everything . . . including the infamous Dennis Hopper Art Heist. One day in 2010, Daddy-O Wade was shocked to see a photo on TV of what appeared to be an exact clone of Malibu Man, slated to be exhibited at the Museum of Contemporary Art in Los Angeles. Instead of being credited for his work, the wall tag credited the famous actor, Dennis Hopper, immortalized by his roles in *Giant*, *Easy Rider*, *Blue Velvet*, and *Apocalypse Now*. Paired with the towering faux Señor Malibu Man clone was another figure, this one wearing Tony the Transmission Man's work uniform. Again, Hopper was identified as the artist.

Wade felt poleaxed. Had an epidemic of counterfeit cloning broken out?

Daddy-O made a call to Malibu. "What gives, Malibu Man? If Hopper kidnapped your offspring, why didn't you tell me you had kids? They'd have a trust fund by now."

Wade pulled strings, twisted arms, whispered in the ear of Julian Schnabel, sent texts: "Pls credit the original artist, i.e., Bob Daddy-O Wade!" Daddy-O didn't want to raise too much of a ruckus. However, Hopper was in a bad way, they said, and later that fall, he parked his Harley for the last time and sang "Happy Trails" to the wind.

Word on the street was this: Some time in 2000, Tony the Transmission Man was nabbed from his job site in downtown L.A. and taken for a ride. Hopper had hired some people to take Tony's measurements and create a mold for a new Salsa Man, apparently unaware that Daddy-O, an artist Hopper knew and admired, had done the redo, in recognition of Malibu Man's Latino heritage, stripping away the generic Soda Jerk disguise.

Señor Malibu knows more, but isn't talking. After all the things he's seen, why waste his breath on the small stuff? Exceptions have been rare. Only weeks ago, a humongous RV lumbered next to him. A lanky woman in Prada sunglasses and a white linen suit climbed the ladder on the back, reaching up to him. Her hair was tinged with gray, but he remembered the bouncy ponytail as if it had been only yesterday. She hugged his leg, blew a kiss, and flashed her push-up bra at him. "Malibu Man! Don't you remember me?" she said. "Give me a smile, you handsome devil!"

"Lady," he said, his voice thundering, his stoic gaze unwavering, "I'm trying to work here."

DADDY-O AND DAISY BELLE

Katie Robinson-Edwards

Texas Armadillo, 1971. Photo emulsion on unstretched canvas. 4' × 6'. Collection of the artist.

Daddy-O's oversize objects are legendary: a forty-foot long iguana that lived atop the Lone Star Café in New York for decades, Guinness World Record–setting forty-foot-high cowboy boots in San Antonio, and giant dancing frogs that graced Carl's Corner truck stop on I-35, to name just a few. One could describe the art as brash, kitsch, and discernibly "Texan." People often let out a shout of recognition because they know these roadside masterpieces, even if they don't know Daddy-O's name. It's the subject matter that grabs our attention. For example, it's easy to be wowed by the twelve-foot-long rainbow-banded Pride Armadillo at Facebook's headquarters in Austin, and not pause to consider the detailed craftsmanship.

And that paradox makes Daddy-O's work irresistibly appealing. The iconic subjects—a saxophone, a dinosaur, the shape of the state of Texas—speak for themselves. But look a little longer and notice the careful construction of each object. This artist is an

Altar to Dora, 1973. Hand-tinted photo emulsion on unstretched canvas, with glitter. Outlined with pretzels, upside-down stuffed armadillos on glitter star. 8' × 6' × 5'. Temporary installation at the North Texas State University (University of North Texas) Denton, Texas. Collection of the artist.

exquisite draftsman and maker, a skill he has honed for more than fifty years.

Although all his sculptures demonstrate a unique combination of virtuosity and absurdity, it all came together when Daddy-O made Daisy Belle, the mega-size bronze bucking armadillo straddled by a larger-than-life cowboy. In 1982, a new shopping mall was slated to go up in Pasadena, Texas. It was the only mall in the Houston area not located on a highway. Pasadena was home to Gilley's Club, immortalized two years earlier in the movie *Urban Cowboy*. The group building the mall was Federated Stores Realty, a subsidiary of the Rouse Company, dedicated to better living through shopping malls. Their founder believed that art improved the shopper's experience. When the company put out a call for artists to adorn Pasadena Town Square, Daddy-O won the commission based on his sketch: a straightforward line drawing of a cowboy riding a bucking giant armadillo. Then the Ohio company requested he send them a three-dimensional scale model. Hoping that verisimilitude would seal the deal, Daddy-O paid a visit to his taxidermy buddy in Waco. Together they positioned a gutted, refrigerated armadillo into a bucking pose and sprayed polyurethane foam right up its nether regions. (Evidently that's how one stuffs a dead 'dillo.) Daddy-O took it back to Dallas, mounted up a toy store cowboy, and spray-painted the whole shebang in a color called Statuary Bronze. Who knows if the Rouse Company ever knew the lifelike maquette in their office was a real 'dillo. They wrote a check and Daddy-O got to work.

Daddy-O makes his big ideas happen in part because of his rigorous training at UT Austin and Berkeley and the decade he spent teaching life draw-

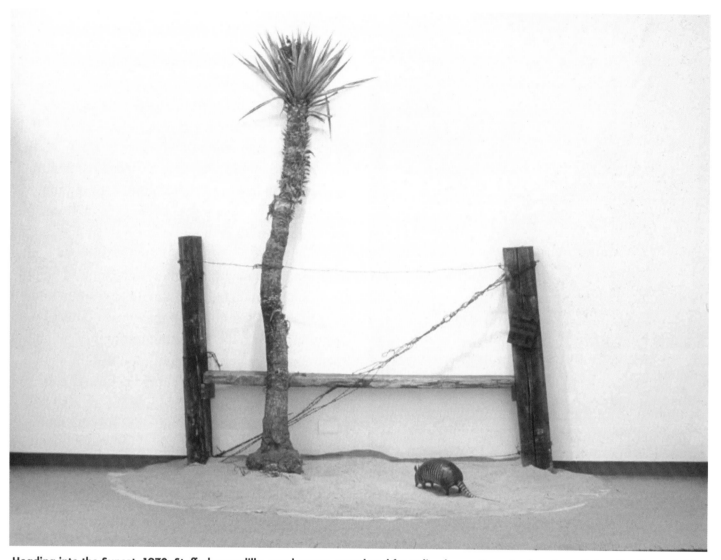

Heading into the Sunset, 1970. Stuffed armadillo, sand, yucca, wood and fence line brace. Sunset-colored spotlights. 8' tall × variable dimensions. Temporary installation at the Fort Worth Art Museum, Fort Worth, Texas.

ing as a college professor. He can render anything, and can always find the right people to help him fabricate it at a gigantic scale.

He built the 'dillo armature in his Dallas studio and drove it to Metz Castleberry's foundry in Weatherford, Texas, in the back of an El Camino. For weeks, he slept at his buddy's house in nearby Fort Worth and drove to Weatherford each morning to work on the preparatory clay 'dillo and cowboy. It was bad enough that it was the peak of summer. But on casting days, when the bronze needed to reach 2000 degrees, the heat was unbearable. The only thing that could make it tolerable was happy hour. The trouble was that Weatherford was in a dry county, meaning no saloons and no carryout. Pretty soon Daddy-O figured out that every morning when he drove in from Fort Worth, he could add a case of beer to his 7-Eleven breakfast sandwich. That made the

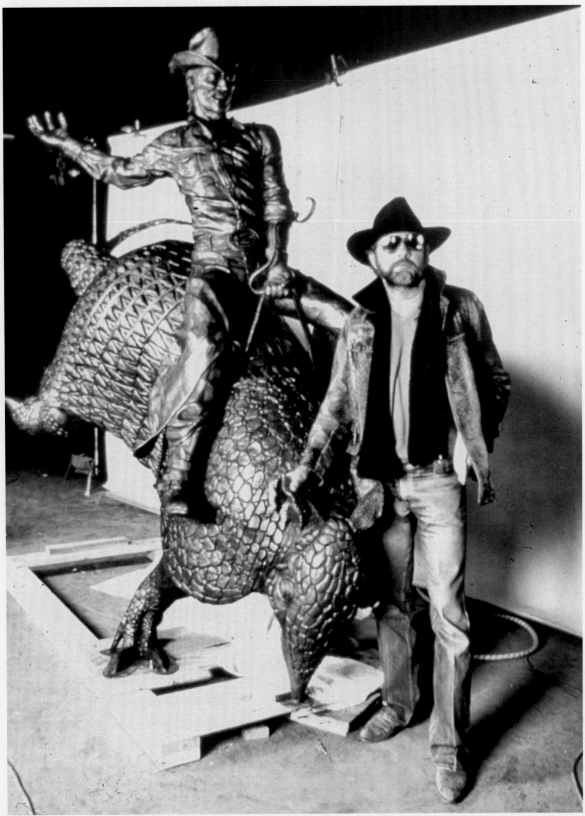

Daisy Belle, 1982. Bronze. 9' × 12' × 4'. Private collection Pasadena, Texas. Photo: Ron Phillips.

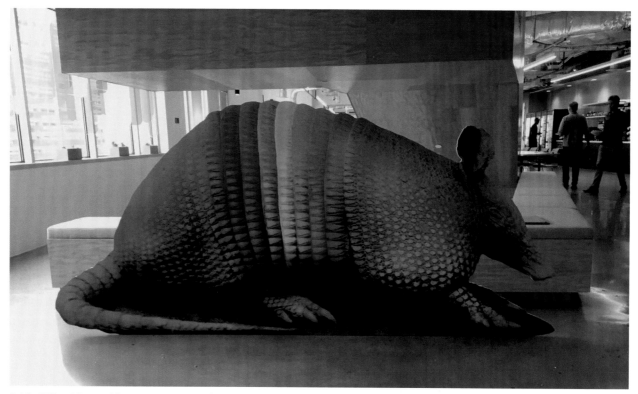

Pride Dillo, 2017. Inkjet on Sentra, steel. 53' × 10' × 3'. Commissioned by Facebook, Austin, Texas.

foundry guys happy, but the 7-Eleven cashier finally had to ask: "I hate to bother you, sir, but I noticed you buy a case of beer at eight o'clock every morning." Daddy-O had to 'fess up.

Weeks later, Daisy Belle (the armadillo's Latin name is *Dasypus novemcinctus*) was born in Weatherford, Texas, and trucked to Pasadena. The bronze cowboy riding a two-ton armadillo was placed near the Foley's wing, where it greeted shoppers for decades. The company even installed a plaque that explained "The Legend of Daisy Belle." She was the four-time winner of the Bucking Armadillo award in the 1920s, with such a reputation that she traveled the rodeo circuit from the Gulf of Mexico to Canada. But finally the National Rodeo Association voted to

discontinue giant armadillo riding because it was too dangerous, so Daisy Belle closed out her career at the Pasadena Rodeo and retired, fat and happy, in the 1930s. Indeed, she represented the "unique spirit of the state."

Many years later, Daddy-O learned Daisy Belle had been removed in the late 1990s because she no longer "fit the theme" of the mall. ("These things happen," as he says.) She was sent off to the Pasadena Convention Center, where she was rolled out for the Pasadena Rodeo, until she was finally sold at auction to a private collector, who poured her a new slab. Somewhere in Texas, Daisy Belle lives on. She is the emblem of Daddy's O's skill, academic training, hard work, hard living, and embrace of the absurd.

DADDY-O'S CRITTER FEST

Or, Stressing Togetherness

Dan Bullock

We know Bob loves his critters of all sorts. Bulls and broncs and frogs and armadillos and iguanas. And many others. You name 'em, Bob has sculpted and painted and photographed them, and you'll find them everywhere. Indoors, outdoors, high and low. In galleries, museums, bars, and bistros. Atop buildings, in fancy schmancy private patios. World class, worldwide.

Bob, a keen observer of man and animal, has noticed our human inability to get along. So he's concentrated on finding hope in critter behavior. Critter love, if you will. Noting the success of crossbreeding in the creation of the jackalope, Bob tried to encourage a new hybrid of armadillo and iguana, shown here in Bob's top-secret critter love shack. And featured in his 1978 solo show in Venice, California. The mating happened with enthusiasm; the naming proved more difficult. Armaguana, guanadillo, or iguadillo? What's your choice?

As the Daddy-O was spreading his message of critter love, he spotted this wonderful example of amorous exuberance when he found these two young bulls (yes, you read that right) enthralled in "brotherly love" for all to see. Well, at least those on the highway near Cedar Hill, Texas. Bob was thrilled to see another example of his beloved critters beloving each other, hopefully being role models for the rest of us. Stressing togetherness.

And speaking of this *Getting It Near Cedar Hill* image, Bob got a big kick out of opening the highly respected *Artforum* magazine in late 1971 to see this photo published as part of comments by noted art reviewer Robert Pincus-Witten, covering Bob's first solo show in New York City at the Kornblee Gallery. Pincus-Witten ended his remarks by stating that "a reproduction in a major art mag is worth two one-man shows."

So in a world of too many angry folks, we can thank the Daddy-O for shifting our focus to an appreciation of critter love—animal husbandry, if you will—through the magic of his imagination and creative renderings. "Stressing Togetherness" might be a great slogan for our national reclamation of our better selves. Thanks, Bob!

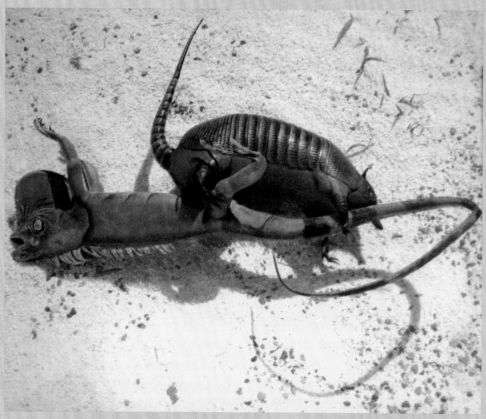

Making of Armaguna, 1978. Photo oil on photo linen. 40' × 48'. Collection Blanton Museum of Art, University of Texas, Austin, Texas.

Gettin' It Near Cedar Hill, 1971. Photo emulsion and unstretched canvas. 48' × 72'. Collection of the artist.

NECK & NECK

Marsha Milam

From six frogs to blown-up photos of Pancho Villa mounted on a Houston rooftop to a giant fiberglass fish installed in Lake Austin—I know Bob "Daddy-O" Wade. It all started when I was doing PR and marketing for a little Tex-Mex restaurant you might have heard of named Chuy's. With its eclectic look and anything-goes attitude, Chuy's was a perfect fit for Bob Wade.

In November of 2000 Bob invited me to a going-away party for one of his "children," as he calls all of his creations. In front of Ranch 616 in Austin, Texas, stood a life-size gold fiberglass two-headed, two-tailed longhorn.

Bob had earlier sent a stuffed two-headed calf to art exhibits in the United States and Paris, so when asked to create an "artcow" (the trend was sweeping the country), Bob came up with this incredible creation. He started with two fiberglass cows, clipped the head and tail off one, and rigged them together for the sculpture. Being an artist of integrity, Bob then had Fix A Wreck coat it with a fuzzy texture called "kitty hair." Fix A Wreck then painted it automotive bronze, Bob attached two rubber balls from the infamous Austin toy store called Toy Joy for the eyes, and the Two-headed Longhorn was born.

This also happened to be during the time when the 2000 presidential election was still undecided between George W. Bush and Al Gore, so Bob aptly named the creature Neck & Neck in honor of our national confusion.

Neck & Neck was headed to the Waco Art Center for a gala fundraiser named Wacows—A Mooving Experience (seriously), and Bob was afraid he would never see him again. Realizing I also worked closely with the County Line BBQ, Bob asked me if I thought they might have an interest in Neck & Neck and provide a good home for him. And of course they were. How could they could resist?

So on December 9, 2000, I put on my cowboy boots and fringed jacket and drove to Waco to attend Wacows—A Mooving Experience. Neck & Neck was to be auctioned off to the highest bidder and my job was to stay within budget *and* be the highest bidder. Having organized a number of rock 'n' roll auctions in my life, I knew a few tips on buying at auction. Here's one for ya: determine how much you want to pay for something and *start* there. Everyone will think you are crazy and won't want to bid against you. So I started where I needed to finish and with relief heard the auctioneer say, "Sold, to the little lady in the fringed jacket."

County Line renamed the longhorn The Legendary Neck & Neck, and it resided on their rooftop in San Antonio for a few years. Later, it was transferred to the County Line on the Lake in Austin, where it stands guard from its rooftop perch.

So Bob can visit his children (is it one steer with two heads or two steers with one body?) and enjoy barbecue at the same time.

Neck & Neck, 2000 Parts from two cast fiberglass bodies, fiber texture "kitty hair" compound, spray-painted. 5' × 8' × variable sizes. Created for Waco Art Center fundraiser. Collection County Line BBQ, Bee Cave, Austin, Texas.

A TRUCKLOAD OF STEERS AND OTHER CRITTERS

Jim Ferguson

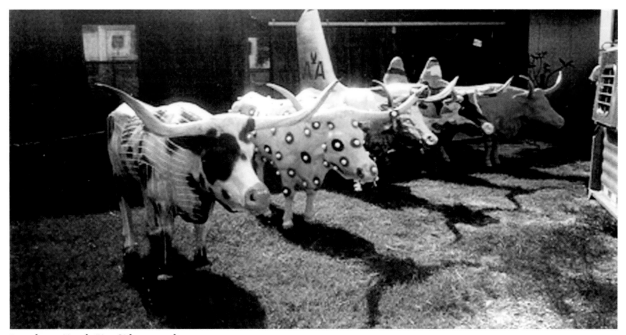

Longhorn Herd, 5' × 8' long each.

I've always believed that for an advertising agency to create award-winning work for its clients, it must have an environment that would inspire creativity.

So when I walked into the largest ad agency in Dallas to become the chairman and chief creative officer, I was stunned by its drabness. It looked like a mausoleum—marble floors and gray walls. And its creative product pretty much reflected the environment it was created in—lifeless. So immediately I had the office walls painted bright colors, bought artwork, and enlarged photos. The common spaces were equipped with Ping-Pong and pool tables.

But that wasn't enough. The interior offices were taking shape, but the massive atrium in the center of the building needed lots of help. Lots of help.

So I called Bob "Daddy-O" Wade. I knew if anyone could add some Texas-style pizzazz to the place, it would be the one and only Daddy-O.

A while later a truckload of "steers" showed up and were installed in the atrium. Only a cowboy on acid could have imagined a herd quite like this. There was Mad Cow, with chainsaws for horns and wearing a Freddy Krueger mask. The American

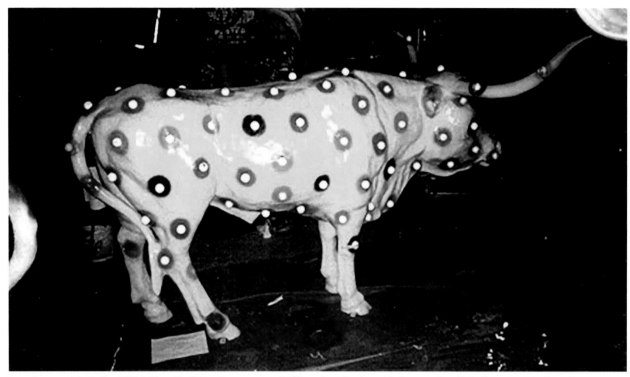

Longhorn with Balls, 2004 [detail of longhorn group]. Fiberglass body with inserted golf balls, spray painted. 5' × 8' × 3'. Commissioned by Temerlin-Mclain (TM Advertising), Irving, Texas. Private Collection, Texas.

Airlines Cow, which was painted silver with wings and an AA logo painted on the tail. A Subamoo Cow in honor of client Subaru, with wheels for legs and a steering wheel coming out its neck. In honor of a staff member serving in Iraq, the Camelflage Cow, a cross between a longhorn and a camel with humps painted in Desert Storm camo. Since Adams Golf was another client, there was a steer covered with embedded golf balls from horns to hoofs as if it been caught in the cross fire on a driving range. And finally, Climbing the Cowporate Ladder, a steer wearing pinstripes, a leather necktie, and spectacles, climbing a stepladder.

Mission accomplished.

Now when visitors, clients, or potential clients entered the lobby, they immediately knew this was a creative agency.

And did it do the job of creating a creative atmosphere? Let's just say that we became the most awarded agency in Dallas for our creative work . . . within the first year.

Side note: Years later, when a new management team took over the agency, I got a call. Either come get the steers outta here or they were "goin' in the Dumpster." I had them shipped to my ranch in Hico, Texas, where they now graze carefree, far from the stifling corporate ad world.

BUG LITE

Bill FitzGibbons

I met Bob "Daddy-O" Wade when I was the head of sculpture at the Visual Art Center in Anchorage, Alaska. I was planning the first annual sculpture exhibition for the Park Strip located in downtown Anchorage, and a friend of mine from Texas recommended Daddy-O. He said that being from Texas Bob knew how to make large-scale sculptures out of found objects.

When I contacted Bob, I asked him if he would like to come up to Alaska and make a large piece from stuff that we had at the art center for the exhibit. Long story short, he ended up making a twenty-five-foot fishing lure out of a pontoon from a floatplane and suspended it from a seventy-foot crane—looking like it was about to be cast out into Cook Inlet.

After leaving Alaska, we moved to San Antonio, where I became the director of the Blue Star Contemporary Art Center. While I was putting together a sculpture exhibition in 2002 for Blue Star, I asked Bob if he had something for the exhibition. He looked around and realized that he had a steer "body" left over from an exhibition that he had in Waco. This body had no head or tail. Always the consummate assembler, Mr. Wade used a beer keg for the head and a bug zapper for the south end of the northbound steer. This sculpture, appropriately named Bug Lite, also has a utilitarian purpose. The beer keg top comes off and becomes a beer cooler. *Voilà!*

Bob with Bug Lite, 2002. Fiberglass body, beer keg with horns, bug zapper, painted. 8' × variable sizes. Created for Blue Star Contemporary Arts Center, San Antonio, fundraiser. Private collection, Texas

This functional artwork allows you to be able to drink a cold one without the worries of flying mosquitoes.

LONGEST LONGHORNS

Chris O'Connell

For the first three years I worked at the *Alcalde* magazine, I never noticed the horns right in front of my eyes. Being tucked away on the third floor of the Etter-Harbin Alumni Center, across the street from Darrell K Royal–Texas Memorial Stadium on UT's campus, I barely noticed the twenty-five-foot gargantuan object hanging from the first-floor rotunda as I passed by it a couple of times each day on my way to the coffeemaker. Then I met Daddy-O.

Bob Wade's emails had been clogging my "etc." folder for a while. He had a way of popping back in every few months to let us know he had completed a new piece or that a documentary crew was follow-ing him around. Oblivious as I can be sometimes, I figured Bob was one of an unending multitude of Texas graduates who fancy themselves artists or writers and demand coverage in their alma mater's alumni magazine.

I don't remember when I figured differently, but it was probably halfway down I-35 on the way to visit Bob's enormous boots in San Antonio for a profile I was writing for the magazine in 2017. Listening to Bob regale me with stories of a lost Airstream outside Paris, anecdotes about his days as a junior yo-yo instructor for Duncan in the early fifties, and some unprintable tales of crossing the border into Mexico as an impressionable teenager, I realized that

guy was a genius . . . and possibly insane—the best combination. I also learned that one of his patented larger-than-life sculptures was located in none other than the building in which I spend forty hours a week. That big set of longhorns I passed by every day with nary an upward glance? Bob made those. And as is true of many of his other pieces, their final resting place is quite different from the one in which the artwork was made to originally reside.

In 1987, Richard Chase asked Bob to create a big boot and cowboy hat to stand outside and greet entrants to the brand-new Tommy's Heads Up Saloon, soon to open in Dallas's Deep Ellum neighborhood. Two weeks before Tommy's was to open to the public, Bob got a frantic call: the huge space above the stage looked naked without decoration. Whatever went up there would have to be big. Bob got right to work, creating a twenty-five-foot-long piece based on the souvenir longhorns he used to see as a kid in Juárez, when he'd cross the border from El Paso.

He and his St. Croix welder created a steel and wire structure that looked a bit like the Eiffel Tower on its side. A quick-dry expert plastered it all up, and Bob got to work spray-painting over that. An upholsterer finished it off with some Naugahyde—for that worn-in leather look—and rope. Voilà. By the time Tommy's opened its doors, the stage was adorned

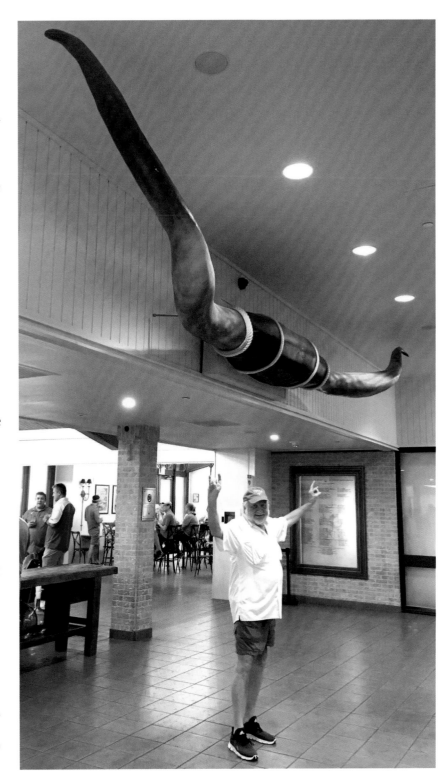

Bob with Longest Longhorns, 1987. Steel structure covered with wire mesh, plaster, Naugahyde upholstery, rope, spray-painted. 25' long × variable dimensions. Originally commissioned by Tommy's Heads Up Saloon, Dallas, Texas. Collection Etter-Harbin Alumni Center, University of Texas, Austin, Texas.

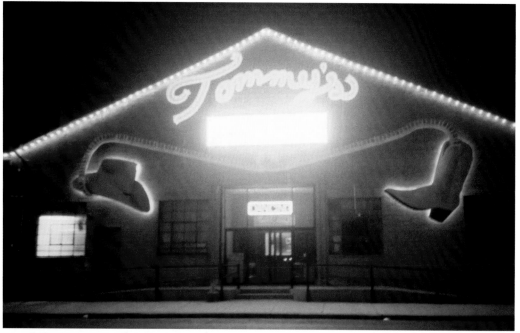

Facade for Tommy's Heads Up Saloon, 1987. Steel framework covered with steel mesh and stucco. Steel keyboard painted, neon. Hat and boot 10' × 10' × 18' each. Commissioned by Tommy's Heads Up Saloon, Dallas, Texas.

Giant Longhorns over the stage at the grand opening of Tommy's Heads Up Saloon, with Tanya Tucker Performing

with a set of longhorns that looked like they once belonged to some sort of giant mutant space steer. Of course Bob cut one of his usual deals—part cash, part bar tab. Hell, he reasoned, if a good chunk of that money was gonna go to cold beer anyway, he might as well cut out the middleman.

But Tommy's went belly-up after a year, and with a sizable bar tab left at the soon-to-be-defunct gin hall, he was given the option to take the horns back. Well, it was either that or make a beeline for the bar and try to make his way through the balance he was owed via frosty bottles of Shiner Bock. The alumni association (not to mention Bob's liver) is grateful he chose the former.

The piece was nomadic for a while, wandering around the Metroplex at various venues, including a Daddy-O solo show. The University of Texas was putting on a show celebrating the history of Texas sculpture, and the curator inquired about the horns. Bob got his hands on a trailer and hauled the piece down to Austin, where it was hung high in the lobby of the art building from which he had graduated way back in 1965.

After the show ended, Bob pulled off another trick. Instead of taking the horns home or storing them at one of his various stash spots around town, he called up a group of his Kappa Sigma buddies and conned . . . er . . . convinced them to help donate funds for the horns to hang in the newly renovated alumni center. Their names are immortalized on a bronze plaque on a brick column below. Bob and his wife, Lisa, point it out at home football games.

Like many a Daddy-O masterwork, and like the man himself, the horns have been places, heve been seen by all sorts of folks, and somehow, some way, through some combination of backroom deals and cosmic energy, circled back toward home.

I like to remember that in a previous life at Tommy's, the sculpture that hangs so proudly above throngs of straitlaced college kids and their parents before Longhorn football games once towered over nightclub patrons: drunk, smiling sweetly, fighting, hopelessly in love. It probably stunk of stale Pall Malls and likely acted as a landing spot for sweat, spit, and Lone Star. They'll never know. Maybe now they do.

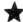

DADDY-O WADE
Exporter of Texas Culture
Temple Boon

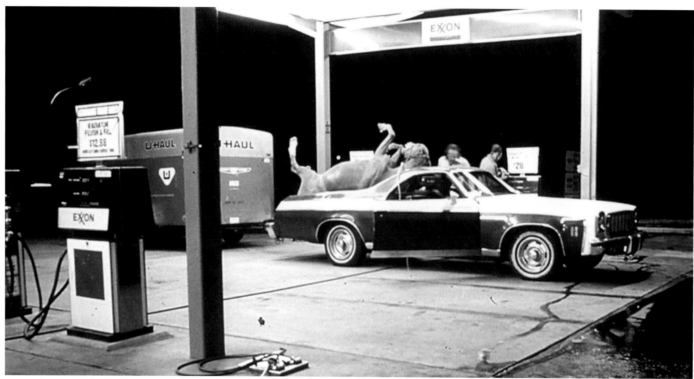

Funeral Wagon the Horse, 1976. Mounted bucking bronco in El Camino at Exxon station in Arizona en route to California for Texas group exhibition at California State University, Los Angeles, California.

Back in the 1960s, Daddy-O noticed his friend Stanley Marcus, of Neiman Marcus fame, was importing European culture to Texas by staging extravagant galas in his store. This observation triggered an epiphany in Bob's fervid brain. He would export Texas culture to the world.

One of the earliest efforts to accomplish this was an exhibit at Cal State University in Los Angeles.

Daddy-O and seven other Texas artists put up a show called Texas in Los Angeles, in January of 1976. The centerpiece of the show was a taxidermized horse. The full-size stallion was mounted in the bucking bronco position. Daddy-O named the critter Funeral Wagon.

The story of Daddy-O's road trip to L.A. with Funeral Wagon riding in the bed of a Chevrolet El

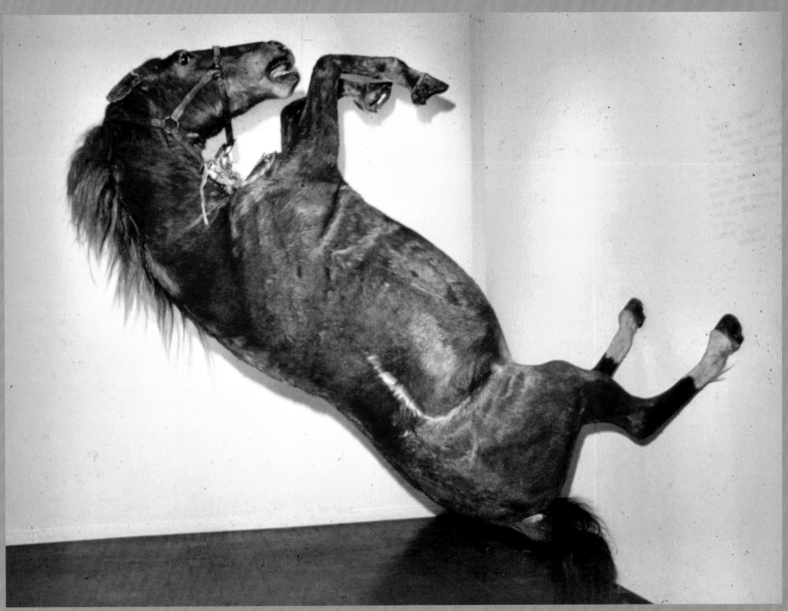

Funeral Wagon and Texas Sideshow, 1976. Mounted bucking bronco cantilevered with life story written on the wall, photo canvas, hay bales, salt lick, and various Texana. Various dimensions. Temporary installation at California State University, Los Angeles, California.

Camino ranks up there with some of Hunter Thompson's most crazed gonzo, drug-fueled odysseys.

Daddy-O set out from Fort Worth with two other Texas artists, John "Flex" Fleming and George Kline, in Kline's El Camino. Funeral Wagon was riding on his back, with all four hooves in the sky. He filled the entire bed of the truck. They pulled a small U-Haul trailer filled with paintings.

When the trio arrived in El Paso, they went over to Juárez and bought some black mollies and a bottle of mescal, which they consumed for nourishment. They then pulled out of El Paso in a driving rainstorm. Thirty miles down the road, all three artists simultaneously experienced an intense itching sensation all over their bodies. The content of the conversation during this itch-and-scratch fest is lost to the ages, but Daddy-O was convinced that they had solved most of the world's problems.

They stopped for gas in Arizona. Funeral Wagon was soaked through and looked a fright. A cowboy was filling up his pickup at the next pump. He was looking at the soggy horse in a woeful manner. Finally he said to Daddy-O, "Well, what happened to him?" Daddy-O went into a full P. T. Barnum/improv mode and spun his tale on the spot. "Well, we were following this stock trailer and this horse flies out and hits the road. Killed him dead. We stopped and loaded him in the El Camino. Now we're trying to catch up with the owner to tell him that his horse is dead." The cowboy said, "He looks bad." Daddy-O said, "He took the rigor mortis." The cowboy shook his head and rode off into the night.

When they arrived at the college, they began to put up the show. All three artists were still in a highly altered mental state. Daddy-O bolted Funeral Wagon to a white wall in an upside-down position. The affect was a Salvador Dalí–like surrealism that suspended disbelief. Daddy-O then penciled "The Legend of Funeral Wagon" on the white wall. The text told how the crazed beast had killed six Texas cowboys who had tried to ride him, thus explaining his name.

On the other side of the white wall, Daddy-O put a real stuffed two-headed calf and a hay bale. After surveying the finished installation, Daddy-O decided that it had an air of "Texas wacky" about it.

As Daddy-O was stumbling out the exhibit hall in a state of delirium, totally exhausted, having not bathed, slept, or eaten in three days, he glanced back at a group of students who were reading "The Legend of Funeral Wagon." They were slack-jawed and seemed mesmerized. Daddy-O smiled and muttered to himself, "My exportation of Texas culture is a success."

I KNOW WHAT SHINOLA TASTES LIKE

Iggy

Jack Massing

I grew up between Buffalo and Niagara Falls in Tonawanda, New York. After high school I attended Niagara County Community College. NCCC was a great school for visual art at that time, a rare confluence of interesting students and motivated professors. NCCC was also engaged with Artpark in nearby Lewiston.

Artpark began in 1974 with funding from the State of New York to showcase the process of making art. The artists working on projects in the park were encouraged to interact with visitors. Some of the most well-respected artists of the time created many amazing and important projects in the park. Artpark's employee workforce was drawn from students from NCCC and young artists from the region. Having visited the park often as a high school student, I was very interested.

I worked at the park for three summer seasons. Most everyone worked hard all day long and celebrated hard after dark. When a project needed more hands or muscle, we would all pitch in together to get things done. Everyone seemed to be having the time of their life. We likened the experience to an art camp on steroids sautéed in herbs and mushrooms.

In the summer of 1978 I met Bob "Daddy-O" Wade and his posse. At the time I was assisting an artist named Story Mann. Story was living in Austin when he was invited to participate at Artpark, and Daddy-O was up from Dallas. I sensed a little competition between them. Story tried to keep his project as secret as possible and Daddy-O tried to keep his project as public as possible. No one could see the progress of Story's artwork because it was on the very edge of the escarpment overlooking the lower Niagara gorge. When the piece was completed, visitors would have a considerable hike down into the gorge, back up the steep side to a rope ladder that led to a ditch one had to crawl through under barbed wire. The ditch led to a small opening under a cement dome through which you would shimmy and enter a hidden chamber. Story drank twenty Cokes a day, and we all had poison ivy and bad sunburn.

Bob Wade, on the other hand, had ample park-

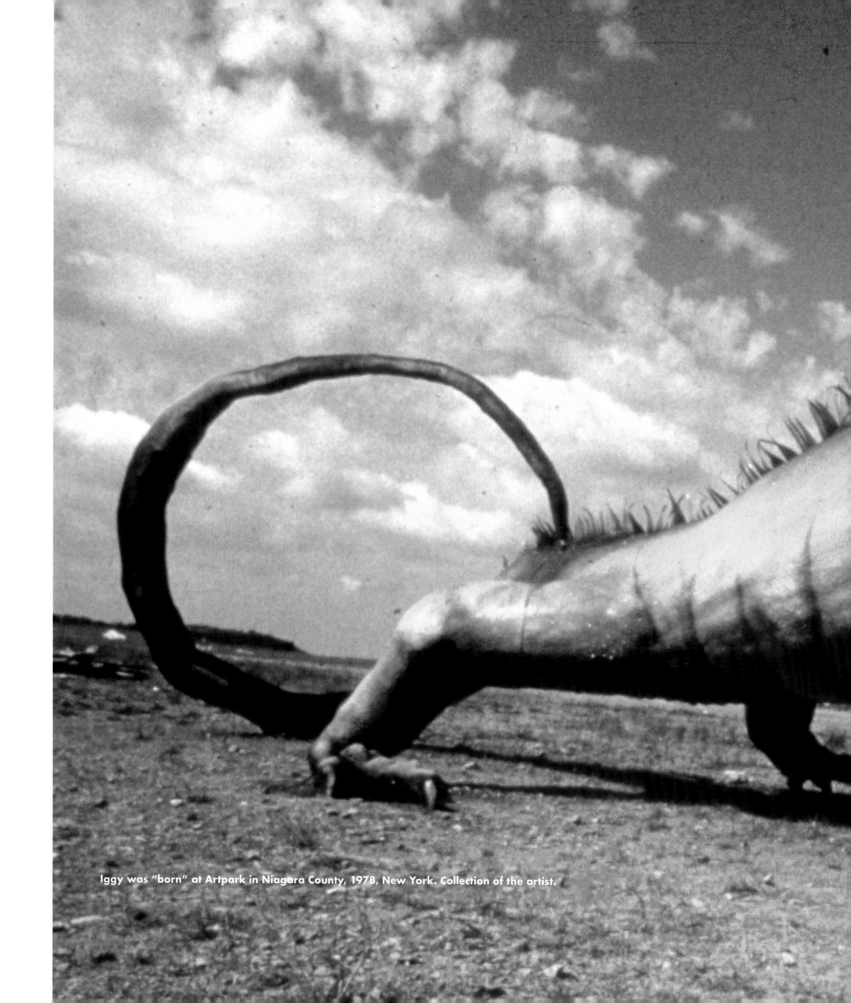

Iggy was "born" at Artpark in Niagara County, 1978, New York. Collection of the artist.

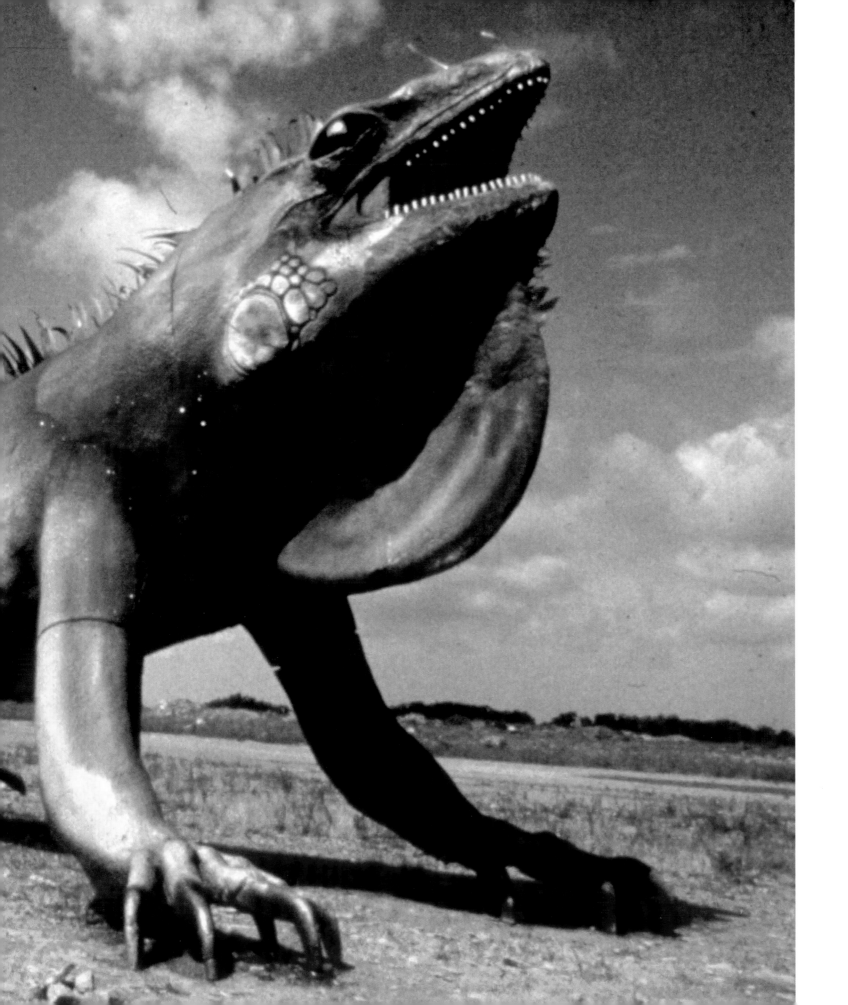

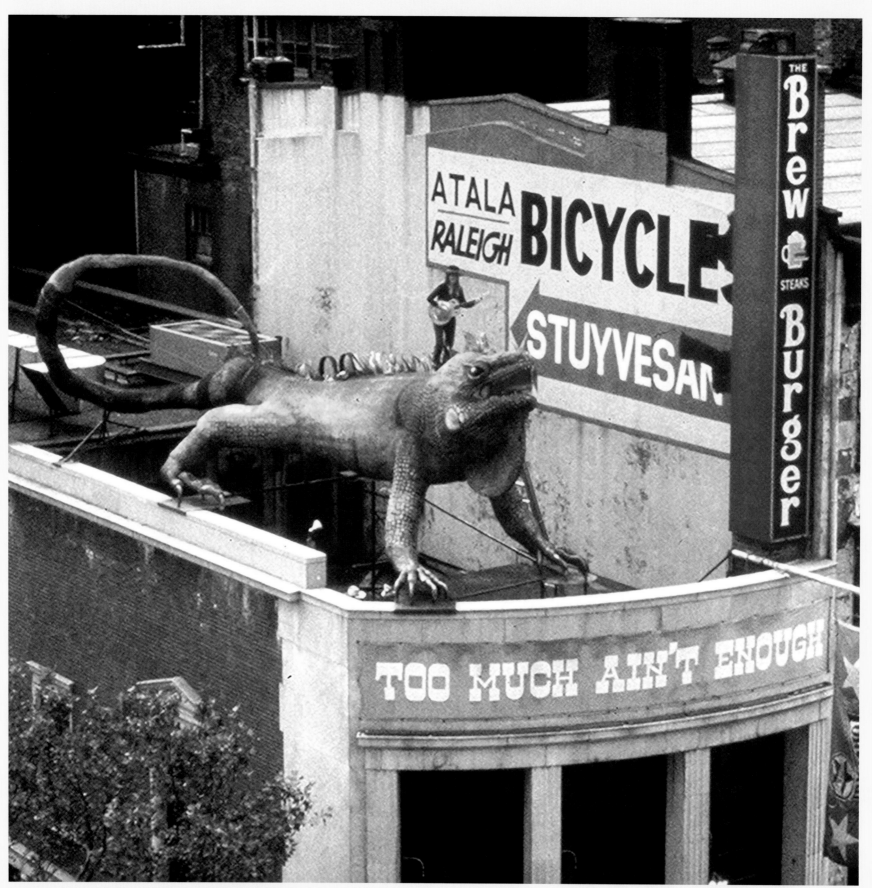

Iguana installed on the Lone Star Café, Fifth Avenue, New York.

ing spaces and a makeshift welcome center with a gallery, cold drinks, air conditioning, and friends with enough Texas hyperbole to fill Lake Ontario. His site was out on a high spot along the road between the entrance to the park and the heart of the facility, called the Art L. He was out there holding court and making a giant iguana that was modeled after the stuffed remains of an actual animal whose life was transformed into Mexican tourist kitsch. I did not know it at the time, but Daddy-O would become my introduction to Texas a couple of years later and a lifelong friend.

After that summer I went back to school and spent time in New York City to hang out with friends connected in various ways to Artpark. I heard that Daddy-O had installed Iggy, the forty-four-foot-long iguana, on the roof of a bar on Fifth Avenue in October of 1978. It was magnificent and surreal. Unfortunately, in April of 1980 I was asked to help move Iggy after complaints from the locals and battles over city ordinances. I was given an industrial metal cutting saw to separate the armature under its feet, which rested on the roof of the Lone Star Café. The idea was to remove the reptile to a more appropriate zoo, but Daddy-O figured he could perform a little surgery, then pick it up with a huge rented crane from the street, spin the lizard around, and set it down out of sight from the street. Well, that worked out, and Bob became an even bigger celebrity.

Over the years I visited Daddy-O in Dallas, Santa Fe, and Austin. I would see him in Houston, out in Marfa, and around the state. During my time with him, he revealed his true nature: a mentor, always fun, endless wacky ideas, and always cultivating good friends, then taking their pictures. He told me once that he knew the difference between shoe polish and cow dung. I am not so sure—he is so full of shit his eyes are brown.

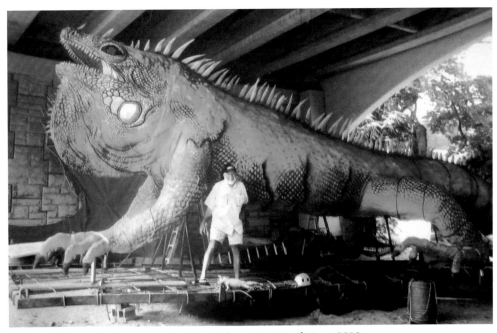

Bob working on the iguana under the bridge at Ft. Worth Zoo, 2010.

ATTACK OF THE FORTY-FOOT IGUANA!

Iggy

Michael Brick

The thing looks fearsome enough on the ground, forty feet from teeth to tail, spikes raised and claws extended, rearing its head as though to give some lacertilian battle call. New Yorkers of a certain age and a certain musical persuasion may remember it well. Blessed with eyes of devil red, a protruding dewlap, and a bared rack of incisors to complete the vision, this beast of bright green cut the sky over a major Texas city, suspended from the undercarriage of a helicopter, dipping toward board members of the Fort Worth Zoo.

And yet no cries of terror sounded; no patrons fled. Quite the contrary.

"I knew it was going to be one of the finest moments of my life, and it was," said Bob Wade, better known as Daddy-O, the artist who fashioned this outsize iguana sculpture, better known as Iggy, from polyurethane and steel thirty-two years ago in New York.

For Mr. Wade, a native of Texas, the installation was a homecoming. Though his works include out-size cowboy boots in San Antonio and an outsize football helmet in Austin, he has not contributed a significant public display to the North Texas Metro-plex since his outsize frogs were removed from the roof of a Dallas nightclub some years back, which is another story (though similar).

Iggy's story begins at a display space near Niagara Falls, but it really got going in 1978 at the Lone Star Café, the much venerated and much more maligned honky-tonk at Fifth Avenue and 13th Street in Manhattan. The café's proprietor bought the sculpture for $10,000, half in bar privileges, to decorate the roof.

"It had this confident, cocky, regal kind of look, derived from all that earlier stuff, dragons and dinosaurs," Mr. Wade said. "In a place like New York, it could hold its own."

By force of sheer monstrosity, Iggy soon became the mascot of the tequila-swillingest, cosmic country-blaringest, ten-gallon hat-wearingest joint in all of New York. Poised above the legend (borrowed

Sam Shepard has "the right stuff" to put his head in Iggy's mouth, 1991. Collection of the artist.

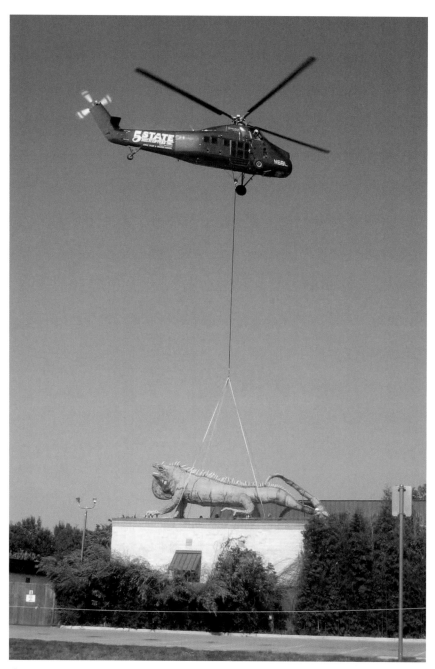

The Lone Star Iguana, 1978. Steel framework, steel mesh covered with window screen, sprayed with urethane foam, hand-blown glass eyes, sheet-metal fins, spray-painted 14' × 40' × 16'. Installed on the roof of the Fort Worth Zoo Hospital, Fort Worth, Texas.

from Billy Joe Shaver) "Too Much Ain't Enough," it gave silent witness to the sort of debauchery occasioned by performances from Willie Nelson, Kinky Friedman, and Albert King.

"The iguana looked like most of us felt," Mr. Friedman once said, meaning bug-eyed and out of sorts.

Through crime, weather and the Koch administration (Hizzoner was a fan), Iggy persevered. When neighbors complained, a court of law pronounced the sculpture a work of art, not a sign subject to regulation.

But after the bar closed in 1989, Iggy appeared in public only occasionally, including a year or so at Pier 25, before being acquired by the Fort Worth oilman Lee M. Bass. Even in Texas, appropriate venues for the display of a furious giant lizard have been hard to come by in recent years, so Iggy lingered in storage.

In 2007, the Fort Worth Zoo, of which Mr. Bass's wife is a co-chairwoman, broke ground on a new herpetarium.

While former patrons of the old Lone Star Café might at this point in the narrative suspect some impending connection to venereal disease, the facility actually houses reptiles and amphibians. In any event, talk soon turned to the notion of: Hey, what about that big ol' iguana sculpture?

Which is how, after a thorough refurbishment, Iggy came to land with a 2,600-pound thud on the roof of the zoo hospital building, where he is set to remain indefinitely.

"It may be a little early to call him a mascot," said

Alexis Wilson, a spokeswoman for the zoo. "He's sitting sentry."

Back at his home in Austin, where he answers the phone, "Daddy-O," Mr. Wade pronounced himself satisfied with the installation.

"It could be anywhere," he said. "New York would've been fine. That was the original plan. But I think things have changed in New York such that you might not be able to get away with it now."

Chronology of Iguana Sculpture—1978 to 2010

Spring 1978. Wade designs big Iguana sculpture, based on Monk White's stuffed Iguana from Puerto Vallarta (Night of the Iguana).

August 1978. Wade is invited to Artpark. Wade and Rick Hernandez drive thirty hours to Artpark near Niagara Falls, Buffalo, New York. Iguana is built in sections for future transport.

October 1978. Iguana is sold to Mort and Dick and moves to New York City to the rooftop of the Lone Star Café on Fifth Avenue.

April 1980. Iguana goes into hiding due to city code problems (still on the roof but not visible), even though a judge declared it a sculpture, not a sign, in November 1979.

October 1, 1985. Goes back up with unveiling by New York City mayor Ed Koch and Texas governor Mark White.

April 1989. Lone Star closes and Iguana is bought at auction and goes to Keswick, Virginia, to live on a horse farm.

April 1990. Iguana goes to Charlottesville, Virginia, for a new paint job. Actor Sam Shepard arrives to give it his blessing.

December 1990. Iguana goes back to the horse farm.

January 1997. Iguana gets sold again to Wade and Monk and goes to Richmond, Virginia, for a new paint job.

April 1997. Iguana goes to Tribeca in New York City to Pier 25 courtesy of Cassullo & Townley and is installed on the top of a shipping container.

October 1998. Iguana gets sold again to Fort Worth patrons and goes to a barn outside of Fort Worth (Mary's Creek). It gets damaged by a tornado and by cattle chewing on the parts.

2009. Iguana is moved secretly to the back of the Fort Worth Zoo for a complete makeover. It's stored under a bridge.

February 2010. Iguana gets a new paint job by Stylle Read and Wade.

June 1, 2010. Iguana makes a grand entrance via helicopter to its new home on the roof of the Fort Worth Zoo. The event is covered by over three hundred stations worldwide over two days.

Today seasonal hats are attached to the Iguana year-round.

Total Miles Traveled: 2,634

WHAT DO YOU SAY TO A GIANT DRAGONFLY?

Cleve Hattersley

Apparently, you say yes. In 1982, Mort Cooperman, founder, spiritual leader, and chief loon at the Lone Star Café in New York City, did just that, when Daddy-O asked if he had a need for a giant dragonfly at the Lone Star. With a listed capacity of two hundred and twelve and week-end crowds that often reached a thousand sweaty, dancing-in-their-seats (and almost always obnoxious) people, sure, the club had plenty of room for a twelve-by-sixteen-foot bug.

The critter, dubbed *Dragonfly Texanus Giganteus* and captured somewhere between Laredo and Bob

Dragonfly, 1979. Steel framework, foam, plastic beads, plexiglass, rubber, spray-painted. 3' × 12' × 16'.
Private collection, New York

Dragonfly "flew" above the dance floor at the Lone Star Café. Collection of the artist.

Wade's frontal lobe, was so large, the only place for it inside the club was directly over and high above the postage-stamp-sized stage. Mort's partner, Bill Dick, had the construction skills to hoist and position the 150-pound sculpture, but the often-heard rumors of Bill's mob connections in Queens gave rise to some fears of faulty construction. That's a New York thing. *Capisce?*

But one giant dragonfly could easily have taken out a full band, if held up by the wrong materials. Imagine if it had fallen on James Brown or Etta James. Dragonflies would never have lived it down. Wade would be living in a dirt floor shack somewhere in the third world. No, he'd likely have been-

crucified, which I believe is another of Bob's secret dreams (imagine the price of his work after a fucking crucifixion!). Fortunately, it did not come down until the gavel came down at auction, at the closing of the Lone Star Café a few years later.

And so the dragonfly flew off to parts unknown, perhaps never to be seen again. Rumor has it the Big Bug landed a gig at a small out-of-the-way tavern in Upstate New York, wherein the tavern owner has it rigged to drop down from above the bar at the push of a button. I'm thinking more than one drunk has shit his pants in a small out-of-the-way tavern in Upstate New York.

FROGS

Shannon Wynne

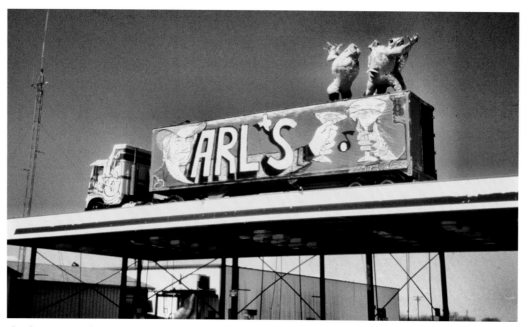

The frogs at Carl's Corner truck stop.

In 1976, I was a tall thirty-one-year old wannabe designer/filmmaker in Dallas, Texas. I wore yellow parachute pants while seriously trying to make my mark in the ultraconservative DFW Metroplex.

That summer I met Bob Wade through Monk White and the Fort Worth "Meeker" crowd, a group of artists and musicians who hung around with art patron and connector Jim Meeker. It was the bicentennial year, and I had developed a limited-edition bicentennial T-shirt that I figured would make me rich as all get out, and at the same time Daddy-O was putting together his football-field-sized map of the United States. He was older than me but still funny as shit, so I helped him recover the Bob's Big Boy statue that was stolen from the map. The next year I was an "adviser" on Bob's project that went to the Paris

Biennale—a 1947 Spartan trailer called the Texas Mobile Home Museum. In 1980 Bob displayed his sixteen-foot dragonfly for the soft opening of my new restaurant, 8.0 Bar. The event was great and I remember Daddy-O falling off his barstool in slow motion, taking two patrons with him (too much dragonfly juice).

In 1983, I was working on my new dance club, Tango, in Dallas and realized the former bank building needed something to make it stand out. Daddy-O came to mind, since he made a splash in New York with his *Iguana* on the roof of the Lone Star Café in 1978. So Daddy-O went to work on something for my roof.

Wade's studio, Daddy-O's Patio, was a barely standing funky place filled with stuff; stuffed igua-

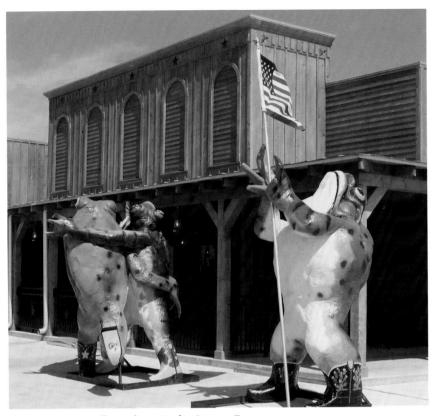

Three Frogs at Willie's Place, Carl's Corner, Texas.

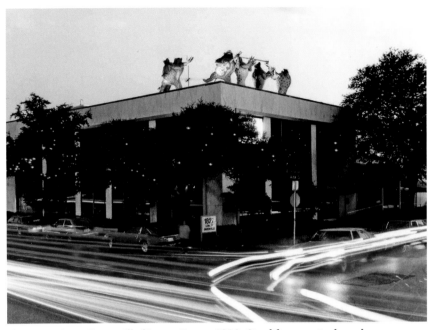

Six Frogs Over Greenville/Tango Frogs, 1983. Steel frame, steel mesh covered with window screen, sprayed with urethane foam, sheet metal, wood, spray-painted and motorized. 8' tall × variable sizes. Three Frogs, collection Chuy's Tex-Mex restaurant in Nashville, and Three Frogs, collection Taco Cabana Mexican restaurant in Dallas, Texas (same address as original Tango)

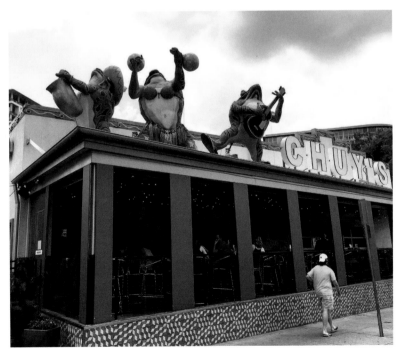

Three of the frogs still grace the top of Chuy's in Nashville.

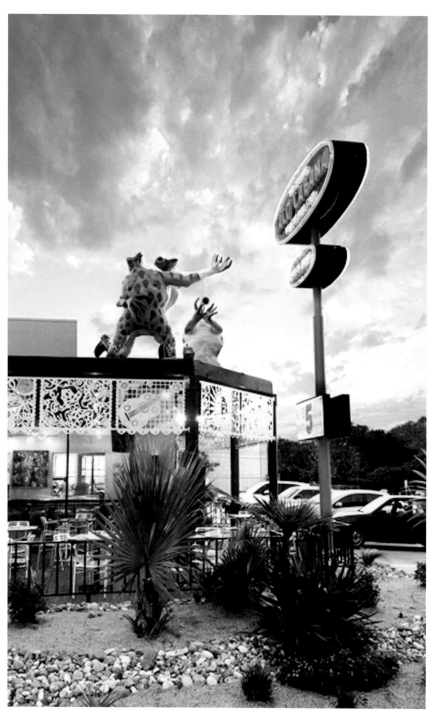

The frogs atop Taco Cabana, 2014. Collection of the artist.

nas, deer asses, and stuffed frogs (Mexican curios Monk White had bought in Puerto Vallarta). From the crazed milieu of props and beer came Mr. Bob's idea to make giant frogs for Tango, and since my dad built Six Flags Over Texas in 1961, why not Six Frogs Over Tango?

A friend had an empty warehouse near the Lower Greenville club, which became the Frog Factory, and Daddy-O assembled a crew of characters and started to crank. Literally crank. Two of the giant foam insulation frogs were dancing by way of barely engineered electric motors; the others played musical instruments. They were lit up and spinning for the grand opening as Count Basie and his Orchestra wowed the crowds.

The city sign department was not pleased, and drummed up a phony excuse to stop the loud music by accusing the frogs of being a "sign." A media frenzy ensued. *People* magazine wrote about it, *The New York Times* sent reporters, and a fiery hearing at City Hall with slews of art experts proving up Daddy-O was a bona fide *arteest*, all proved to be the best advertising a nightclub could have. We won and were now on the map.

The frogs eventually ended up at Carl's Corner truck stop near Hillsboro, Texas. Three of them went on a statewide "sculpture tour," and all six survived a devastating fire. Chuy's Mexican restaurants bought three and sent them to rooftops in Houston and then Nashville. The other three were bought by Taco Cabana in Dallas and sent to its new location in Lower Greenville. Yep—same corner, new building!

Ross Perot the elder asked at one point, with his elfin grin, "Where them frogs?" I proudly reported they were performing in Nashville, wearing yellow parachute pants.

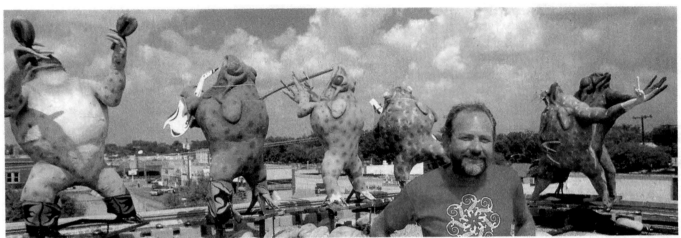

Ben Weaver—Camera 5

Daddy-O and his dancin' frogs: Yet another battle between the true Texas sensibility and the cult of good taste

Are They Signs or Art?

Bob (Daddy-O) Wade's in trouble again—and him an *artiste* of international repute, the transatlantic big time. Daddy-O, who thinks his sculptural "varmints and critters" reflect a "fairly typical Texas sensibility," was the toast of Paree with a smash-hit exhibition at the Beaubourg. His works have appeared at the Whitney Museum in New York, and Joan Mondale, wife of the former vice president, particularly admired his pair of cowboy boots 42 feet tall, now on display at a San Antonio shopping center. And Daddy-O's big iguana was upheld in court in New York City as a sure-fire example of Art, the judge tut-tutting those Manhattan Philistines who saw it as some kind of advertising gimmick. Forty feet long, that iguana was the biggest urethane reptile on lower Fifth Avenue.

Daddy-O's frogs are only 10 feet tall, but they're Art too. A curator of the Dallas Museum of Arts said so, and she should know. So what if four of them are playing musical instruments and two of them are dancing? So what if they're motorized, and the girl frogs have long eyelashes? So what if they're standing on the top of a nightclub, Tango, and they go through their jive only during business hours? Only in Dallas—the Town That Once Banned Pinko Artists Like Picasso—would any bunch of rubes in three-piece suits fail to see the frogs as Art. Daddy-O got more than $25,000 for his frogs, which *must* mean they're Art: would a *sign painter* get 25 G's?

Dance 'til You Croak: But Dallas is divided, pro-frog and anti-frog, between the true Texas sensibility and the cult of Good Taste. The city sign board is anti-frog, influenced by some fellow who predicted dire consequences if the frogs were allowed to stand—the threat of creeping animationism, a precedent for Gawd knows what, maybe a giant gorilla holding two heads of lettuce on the Safeway roof. The jitterbugs are all pro-frog, of course: some of them held a party called Dance 'til You Croak, and everybody under 90 was there. The dude who owns the nightclub, Shannon Wynne, is suing the city to uphold his right to have frogs on the roof, eyelashes or not; he wants to call Arthur Murray's wife to testify that the frogs aren't dancing the tango, as some allege.

Daddy-O himself is philosophical. "I expected a little trouble," he says. "But I hope Dallas isn't too small a pond for my frogs." Meanwhile, some fool is probably working on the giant gorilla with the two heads of lettuce for the Safeway roof.

THE LIFE OF DINO BOB

Lynn Barnett

September 1, 2000: Dino Bob arrived in Abilene as part of the Abilene Cultural Affairs Council's 20th Annual Outdoor Sculpture Exhibition and is perched atop the Grace Museum garage. Bob Wade based his creation on William Joyce's beloved book *Dinosaur Bob*. The sculpture exhibit opening was held in conjunction with the opening of the National Center for Children's Illustrated Literature's beautiful new building.

For six years he sat happily atop the garage, benignly smiling down on a new generation of children who grow up with their favorite green landmark.

In April 2007, the Cultural Affairs Council is notified that there has been a complaint and that he needs to be removed within 120 days. The source of the complaint is never identified.

April 2007: Word spreads quickly about Bob's possible removal, and the community becomes outraged. William Joyce registers his disbelief!

Bowie Elementary children write to the newspaper and launch a fundraiser at their school.

A local businessperson creates the Save Dinosaur Bob website to raise additional funds.

Another local businessperson creates a Facebook page for Bob, and within a week Bob has over 900 friends.

More than twenty businesses contribute to print "Save Dino Bob" T-shirts and stickers. Because we thought that we would need mostly children's T-shirts, 150 smaller T-shirts and 100 adult sizes were ordered. The adult sizes sold out within twenty-four hours. High school and college students arrived in droves to purchase the T-shirts.

May 2007: The Grace Museum, cited as the instigator for Bob's removal (though this was never confirmed), was targeted with a protest march that took place in front of the museum during the May 2007 ArtWalk. Favorite newspaper headline: "Protesters Seek to Make Jurassic Mark."

City emphasizes to the Cultural Affairs Council that there is no deadline for Bob's removal and that he is not a problem from the city's standpoint.

May 11, 2007: Dino Bob article by John Kelso appears in *Austin American-Statesman*.

May 2007: The National Center for Children's Illustrated Literature board unanimously votes to give Bob a new home.

Early 2008: Fundraising is completed to purchase Bob from artist Bob Wade. Renovation expenses are minimal, as Sterling Volkswagen generously provided the extensive rehab work on the VW and Larry Millar's art class donates all the labor to repair and repaint Bob. Dino Bob is removed from his perch and he is taken to the "dino spa" for rehab.

June 2008: Dino Bob is unveiled atop his new home in conjunction with the monthly ArtWalk. Thousands of Abilene residents came downtown to celebrate the return of our beloved dinosaur.

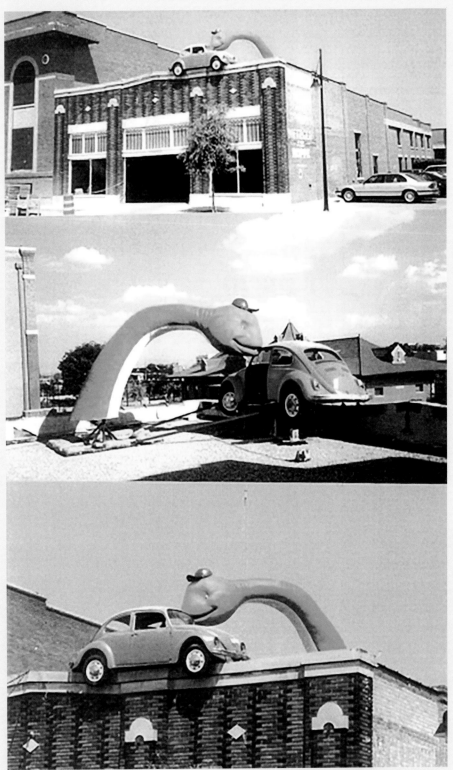

Dino Bob, 2000. High-density foam over steel frame, Volkswagen Bug, neon, paint.
8' × 25' × 14'. Temporarily installed on roof of the Grace Museum parking garage,
Abilene, Texas. Collection of National Center for Children's Illustrated Literature,
Abilene, Texas.

THE HOG AND THE ALTOID ALLIGATOR

Andi Scull

Austin, Texas, fall 2010

I walked up the stairs to the third story of the historic Castle on West 11th Street to meet with my new friend Vic Ayad ("Pee Wee" to his friends) so we could chat more about this outdoor mural gallery idea my friend Mariska Nicholson and I had talked about with his then-partner Dick Clark. It was hard to concentrate while sitting in the tower view office filled with ZZ Top paintings, James Brown memorabilia, and photos of Vic's close friends like Stevie Ray Vaughan, Kinky Friedman, and Ann Richards.

A couple of laughs and "we promise" moments later, Vic agreed to a temporary art project called the HOPE Outdoor Gallery (HOG) and was walking us back down the Castle stairs. Just before we left, he gave us his quick tour, which included the Altoid Alligator, a sculpture made of tins Vic had collected for years and eventually commissioned a badass Austin artist to use to create something original.

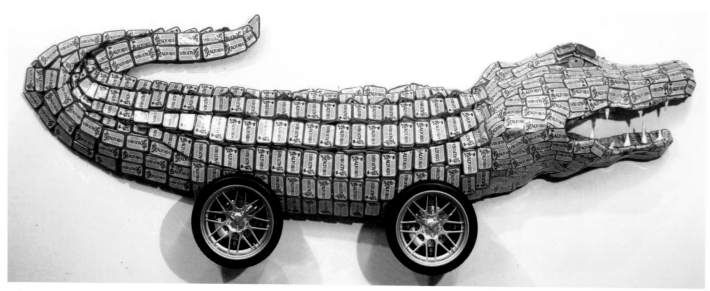

Altoid Alligator, 2006. Altoid tins attached to wire mesh over steel. Replica tire clocks. 3' × 8' × 12'. Commissioned by Victor Ayad, Austin, Texas. On loan to South Austin Museum of Popular Culture, Austin, Texas.

Thus the Daddy-O was introduced into my life.

It wasn't too long after that till Vic was inviting me to his colorful group gatherings, which included Bob "Daddy-O" Wade and Lisa Wade, who soon joined the advisory board for the HOPE Outdoor Gallery.

A few years later Vic gets this "Pee Wee" idea and asks the Daddy-O if he could make a hog out of hog parts for the HOG! Of course this was right up Bob's alley, and soon I was being sent text messages about this incredible sculptural endeavor.

Vic asked his buddies at Central Texas Harley-Davidson if Daddy-O could have all the used leftover parts. Three trips and multiple truckloads worth, to be exact.

Daddy-O started looking at photos of javelinas and razorbacks for sketches till he saw the perfect head from two gas tanks. He then used rearview mirrors as "cop glasses," and made ears out of fenders. With the help of Will Larson (an artist/art fabricator), he finished this new monumental piece in less than a week.

"You never know where these projects will go. They finally find a permanent home like a lost dog," the Daddy-O told me.

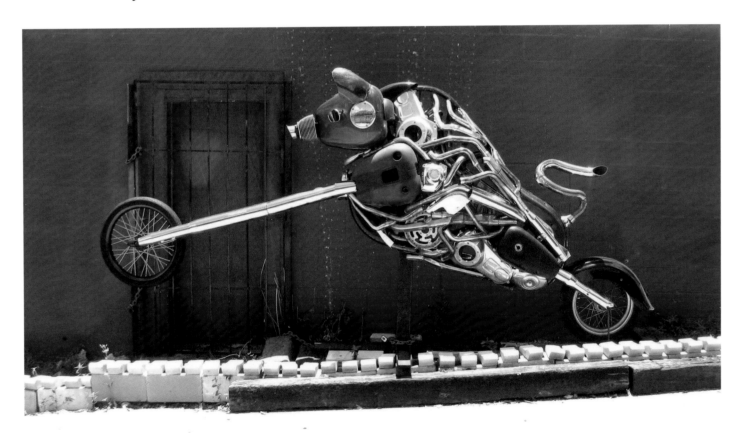

The Hog, 2016. Steel structure with welded Harley-Davidson motorcycle parts. 7' × 16' × 30'. Originally commissioned for the HOPE Outdoor Gallery, Austin, Texas. On loan to the South Austin Popular Culture Museum, Austin, Texas.

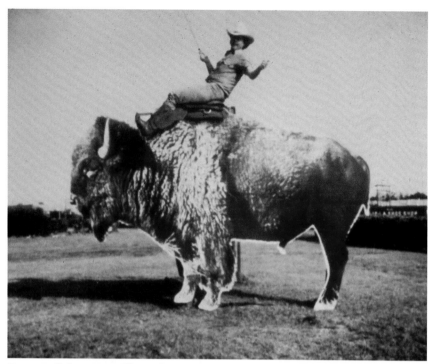

Texas Buffalo, 1982. Billboard screen print sections on plywood, saddle, wooden steps. 8' × 12'. Collection Abilene TX. Original photo: Laura Wilson

Critter Totem, 1985. Taxidermized animals. Variable dimensions. Collection of the artist.

Big Chameleon, 1991. Steel, painted foam, plastic fly, wood tree section. 6' × 30' × variable sizes. Temporary installation, the Maryland Institute College of Art, Baltimore, Maryland. Private collection.

THE SAGA OF THE BIGMOUTH BASS

Richard A. Holland

We all know Daddy-O's greatest hits: the cowboy boots in San Antonio, the Saints Helmet made from a VW on top of the Shoal Creek Saloon in Austin, Kinky's hat in Lockhart, and most of all, the famous iguana that graced the roof of the Lone Star Café in New York City in the seventies and eighties, and that now occupies a prominent spot at the Fort Worth Zoo. In Cowtown it is at least as big a draw as the gorilla and giraffe.

Less well known perhaps is the bigmouth bass floating in Lake Austin, just outside the Hula Hut. In 1992, Bob was a visiting artist at the Kansas City Art Institute, where he and his class built the structure for the big fish that would be a rooftop sculpture for the Big One, a new restaurant in Dallas that featured aquatic themes and a big mural by Armadillo World Headquarters muralist Jim Franklin. The restaurant was owned by Shannon Wynne, who had also commissioned Bob to create a group of frogs for his Tango Club in 1983.

In Kansas City, the structure was basically welded rods covered with diamond lath. A student named Jeff Rentschler offered to motorize the fish's

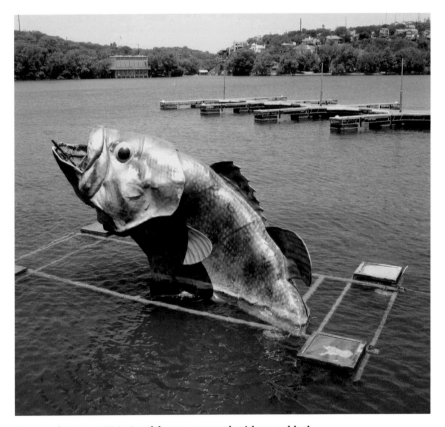

Bigmouth Bass, 1992. Steel frame covered with metal lath, sprayed with fiberglass. Motorized head, plastic eyeballs, spray-painted. 8' × 12' × variable dimensions. Commissioned by the Big One, Dallas, Texas. Collection of the Hula Hut restaurant, Austin, Texas.

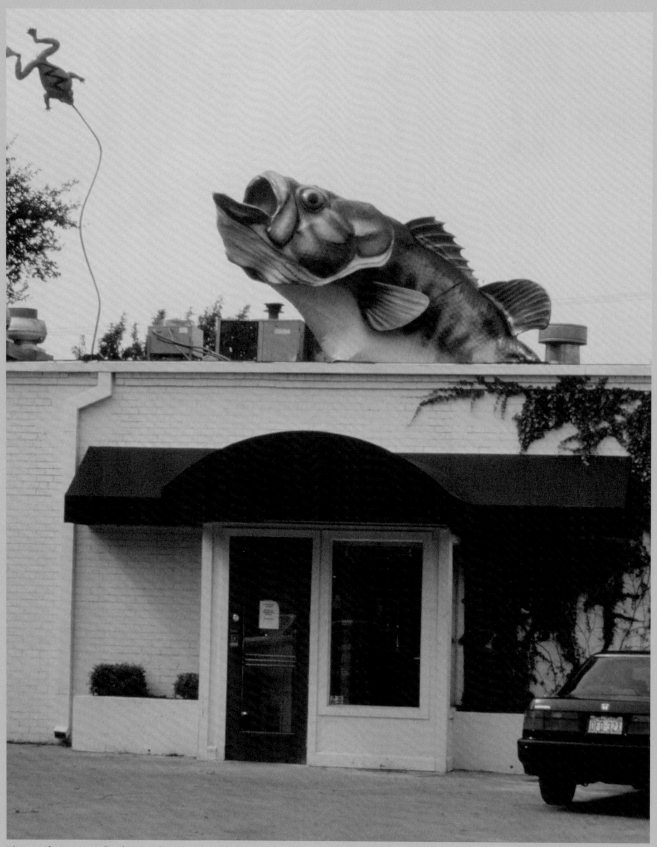

Bigmouth Bass on display at the Big One, Dallas.

head so that it could move back and forth, and Bob found a boat company to spray the mesh structure with fiberglass, not knowing water was in its future. The fish gets trucked to Dallas and receives a spray-paint finish "bigmouth style," as Daddy-O says. The fish then gets craned up to the roof of the Big One and plugged in, so the bass's mouth could move back and forth. The idea was that the fish would be eating the frogs. This was in 1995.

The Big One closes and Chuy's replaces it. Chuy's also acquires the sculpture for its restaurant called the Hula Hut on Lake Austin. (The Hula Hut has a Hawaiian theme and was immediately popular with the UT college crowd.) Mike Young of Chuy's and his crew rigged the sculpture onto floatation foam blocks and pipes. The bass made a flashy grand entrance with television coverage and an outrageous party.

High End Systems installed a smoke machine in the bass's mouth and strobe lights under the dock near the floating fish. Just imagine the night-time scene with drunk co-eds cheering the moving head, with smoke blowing and lights flashing on the Daddy-O's sculpture. Occasionally the smoke would get out of control and engulf the patrons (leading some to walk on their checks). For a while a naked female mannequin was rigged headfirst into the bass's mouth—Daddy-O says "as a snack"—and this stunt got quite a few laughs. After the mannequin was removed, there was "a drunk game," which was trying to throw empty beer bottles into the fish's moving mouth. All this fun for four quarters, with money going to charity. Daddy-O calls this the "fuck with the fish" era.

In addition, a huge "bobber" floated nearby, and various waterfowl climbed aboard the flotation cubes, sometimes doing their business. The fiberglass has withstood the elements over the years, with an occasional repair job on the underwater steel rods and periodic paint jobs. The college kids still drink beer around it, boaters tie up on the docks and drink beer near it, the birds contribute their deposits, and everybody has a great time. I think I'll stop by and throw a beer bottle into the bigmouth's mouth.

Bob & Rachel Wade at the installation celebration of Bigmouth Bass at Hula Hut, Austin, Texas.

BEECHCRAFT MARLIN

Will Harte

About ten years ago, Pam and I were riding bikes in North Austin and decided to drop in on the Wades to check out Bob's latest creations. Lisa, Turtle, the family dog, and Bob greeted us at the door, and moments later, beer in hand, we were ushered into the inner sanctum.

Wading, literally, through works in progress—a six-foot alligator made entirely of Altoid tins, a portrait of Roy Rogers (Bob's mother's cousin), wonderful colorized pictures of cowgirls showing lots of cleavage and thigh, all neatly strewn about the studio along with posters, photographs of celebrities awaiting the airbrush or photographs of friends and lesser celebrities that the subjects would gladly pay big money to have back . . . or be airbrushed out of.

Bob was working us pretty hard that day. However, the fact we were on bicycles limited our appetite for purchase, as it would mean a return trip to pick up said object, and the inevitable further purchases.

As we prepared to leave, Bob took us out the back door and on to the driveway. As I turned the corner, I noticed an unusual object blocking the drive: a 32-foot marlin. Bob explained that it was originally a Beechcraft Baron, which with a little of Bob's magic was now a marlin.

We had to have it.

A week later, with the help of Craig Jackson, who ferries Ferraris and the like to vacation spots for their owners, we loaded the marlin on a trailer for the trip to exotic Encinal, Texas. Craig said the marlin was well received by the viewing public en route.

With the driveway clear, Lisa could park her car in the garage for the first time in months. Meanwhile, back at the ranch, batteries were not included and some assembly was required—about three days of assembly, as it turned out. But it was worth it.

Bill Deupree, who was drilling the ranch, arranged for a rat hole driller to set a column next to the swimming pool and a crane to lift the marlin over the pool while welders affixed it to the column.

The first thing you saw as you entered the house was a huge marlin leaping over the pool. It was wonderful fun.

Bill eventually bought the ranch and Pam and I moved west, leaving the magnificent marlin behind.

I just looked at my watch, and it's way past time for a new Bob Wade creation . . . out west.

Plane Ole Swordfish, 2001. Cessna plane body, plastic, foam, corrugated metal, hubcaps, spray-painted. 6' × 30' × 5'. Private collection, Texas ranch.

SKY ART, ANCHORAGE, ALASKA
Summer 1989
Gary Webernick

Detail: Fishing Lure for The Allure of Alaska

Jumbo boots, gargantuan iguanas, mammoth musical frogs, motorcycles racing up vast telephone poles! Daddy-O—Bob Wade—in his Texas spirit makes objects that are LARGER than life and as BIG as Texas and Alaska!

I remember flying to Alaska from New Mexico for the Sky Art Festival in Anchorage in the summer of 1989. I heard stories for years about Bob and his art. Fortunately we had met the year before, after I had moved to Santa Fe, where Bob was headquartered. It would be good to see him and his wife, Lisa, in the land of the midnight sun!

Ah, the Allure of Alaska. So what would he be up to this time? What would he concoct for the Sky Art Festival? You never knew, but one thing you could count on—it would be HUGE and most likely humorous. Humor, whimsy, and monumental size are what Bob's sculptures are all about.

"So where's Bob?"

"Not sure. Someone said he had gone somewhere looking for some pontoons!"

"Hmmm, wonder what he's up to this time?"

The next day I am working away on my sculpture and see a truck pulling up that had a MASSIVE pontoon on it. Then some activity in the distance. Soon a substantial crane arrives—more activity.

Curious and intrigued, I stopped working on my piece to see what the next Bob sculpture would look like!

Ha! And there it was: the Allure of Alaska! Bob found a pontoon from an amphibious aircraft, colored it with fluorescent paint, adorned it with surveyor's tape, and rigged it to a steel treble hook. He then dangled the whole thing from a crane! Another GIGANTIC folksy sculpture up HIGH in the sky! An

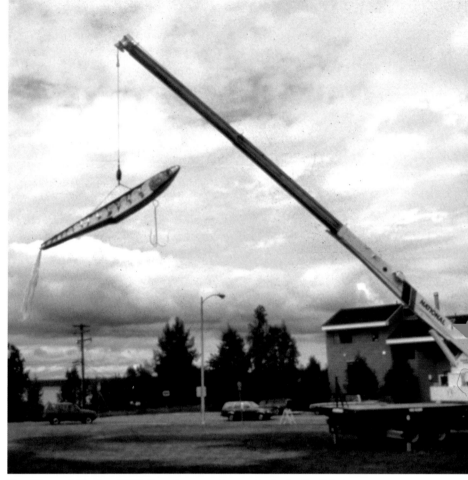

The Allure of Alaska, 1989. Seaplane pontoon, steel, plastic, fabric, crane, painted. Variable dimensions. Temporary installation at Delaney Park Strip, Anchorage, Alaska.

ENORMOUS fishing lure—that baby could catch a COLLOSSAL Alaskan fish if cast into Cook Inlet (the crane functioning as a fishing pole).

We watched as the lure moved slowly back and forth and the tail of tape blew gently in the inlet breeze. We laughed a bit and heard the story of how Bob got the pontoon, after which we laughed some more, then headed off for a celebratory beer or two to hear his next fish story.

TALE OF THE LONGHORN TAIL

Leea Mechling

Longhorn Tail is the very exciting sculpture piece that greets visitors to the South Austin Museum of Popular Culture (SouthPop) just outside the front door.

SouthPop made connection with Bob Wade through our founding president, Bill Narum, in about 2006. We really hit it off, and Mr. Wade

allowed us to hold a retrospective of his work in 2009: 40 Years of Blood, Sweat, and Beers—A Retrospectacle. The exhibit was met with rave reviews and SouthPop experienced record attendance. While Bob was at the museum hanging out with Henry Gonzalez (another of the founders of SouthPop) to plan the show, they both agreed it would be great

to have something 3-D on display just outside the front door. Bob started pondering about what he had on hand that he could use. Turns out he had the tail of an airplane in storage, along with a large fiberglass longhorn head that had been used in a project involving a truck, cactus, barbecuing, a functional water feature (hence the head—it had a pipe in its mouth that spewed water), and other craziness that had been driven around Austin and in Houston's art car parade. Bob and Henry got those two pieces out of storage and Bob crafted together the head to the tail of the plane. Instead of removing the metal pipe in the longhorn's mouth, Bob wrapped it in white tape and made it into a cigarette of sorts. The sculpture was tricky to hang, and it created a challenge for Henry, as he had to figure out how to rig it properly and safely. Finally they figured out a solution that involved leaning it and securing it with cables.

As Bob and Henry step back to view the genius installation, they realized it needed a title.

How 'bout Heads or Tails? Fasten Your Seat Belts? Puff the Magic Longhorn? Or just keep it simple: Longhorn Tail. Enjoy your trip.

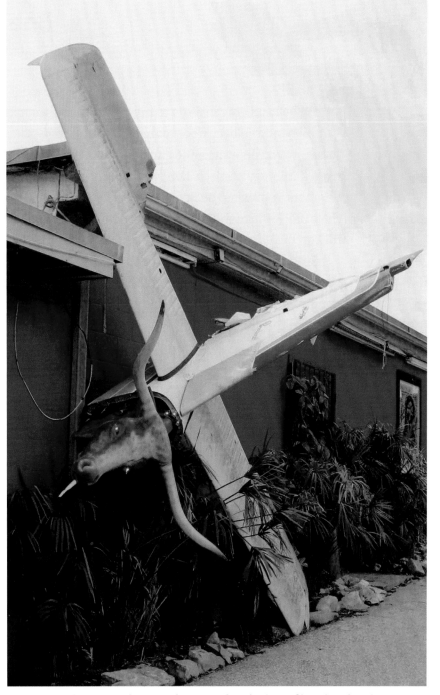

Longhorn Tail, 2009. Tail section from Beechcraft plane, fiberglass longhorn head with lighted eyes. 14' × 30' × 6'6". Collection South Austin Museum of Popular Culture. Austin, Texas.

THE NOSE CONE

Bob Wade

The last thing visitors to my studio get to see is out the back door to the end of my driveway. There sits a 1961 upside-down nose cone from a military plane. It's big, just like those strategic bombers known as the Boeing B-52 Stratofortress, aka the BUFF (official military acronym for "big ugly fat fucker").

Since the 1950s, the behemoth (157 feet long and 185 feet wide) has been in operation, and was circling Austin, Texas, when I was at the University of Texas in the sixties.

So how did this art piece/relic get to my driveway? Well, just like a lot of things in my life, it just showed up.

In 1992, Bill FitzGibbons was the director of an art school associated with the McNay Art Museum in San Antonio and asked me to come down from Santa Fe and do a "sculpture workshop." Typically I show the students my previous work with technical explanations, and then try to complete something before the end of the day.

I had rented a van and loaded my group of six inside for a whirlwind drive about in search of an object or two to work with. Stumbling onto a salvage yard of stuff, we spotted a weird round thing and pulled over.

After some wrangling, I worked a deal to have the "object" (a B-52 nose cone, they said) delivered to

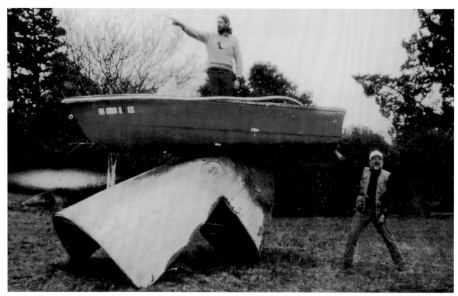

Don't Rocka Da Boat (Nose Cone), 1992–2002. Fiberglass boat mounted on B-52 nose cone. Altered in 2002 with addition of hand-painted "nose art" on both sides. Original installation at the McNay Art Museum grounds, San Antonio, Texas. Also Sunset Station, San Antonio, and Texas Lutheran University, Seguin, Texas. 6' × 13' × 8'. Collection of the artist.

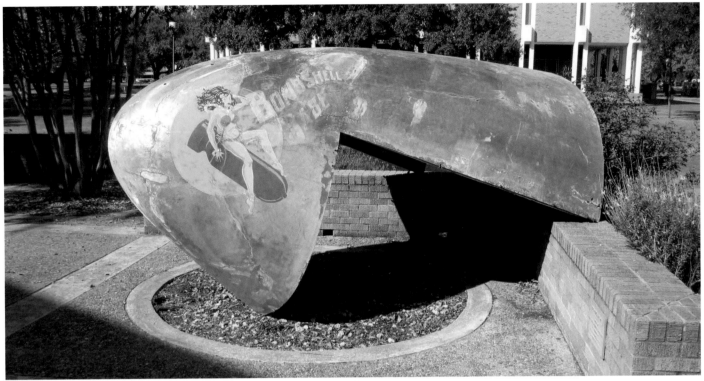

Texas Bombshell Nose Cone, 2011. Texas Lutheran University, Seguin, Texas.

the art school ASAP. We raced back excitedly to prep for some kind of transformation that would make it "art" but still needed something to go with it.

FitzGibbons announced that a has-been fiberglass boat was nearby, and we quickly grabbed it. After some brainstorming and engineering ideas, we decided that the boat would be bolted to the top of the upside-down nose cone. It worked as happy hour approached, and we located it on the ground of the formerly staid McNay. One student looked at the somewhat precarious concoction and said, "Let's name it Don't Rocka Da Boat."

Like many of my projects, Mr. Cone laid low in storage until FitzGibbons came calling again! This time he needed a sculpture for his 2014 Group Show at San Antonio's Sunset Station.

So out comes the cone, updated with some nose art on both sides.

Nose art typically occurred during World War II in the Air Force, where pinups were painted toward the front of the nose cone for good luck. So I had a sign painter do two of my designs for the sides of the object to make it art! A cowgirl riding a bomb and a hula girl riding a bomb.

And then in 2011 the art piece made a repeat appearance during my solo show at Texas Lutheran University, in Seguin, Texas, before settling into semi-retirement in the Wades' driveway.

Wouldn't it be great if this very nose cone flew over Austin during my college years?

A HEALTHY SHOT OF TEXIFICATION

Mike Shropshire

Biennale de Paris offers credentials that its arts festival at the Grand Palais should rank as the most influential presentation of its sort in the world. It's a celebration of innovation, and its exhib-itors have included some of the most distinguished and unpronounceable names in the arts kingdom. Any event of that international magnitude can always benefit from a healthy shot of Texification.

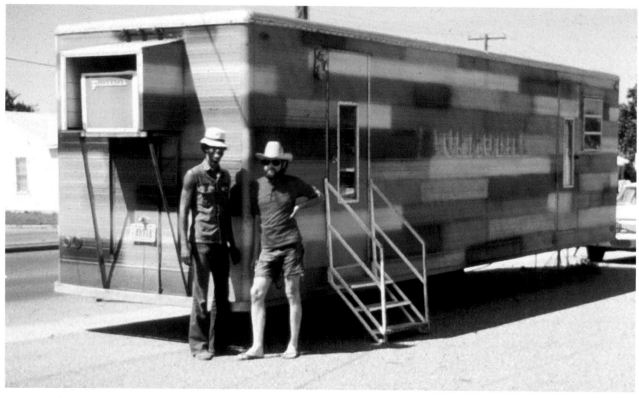

Waco Bookmobile, 1968. Spray-painted trailer, 9½' × 20' × 7½'. Commissioned by Waco Public Library, Waco, Texas.

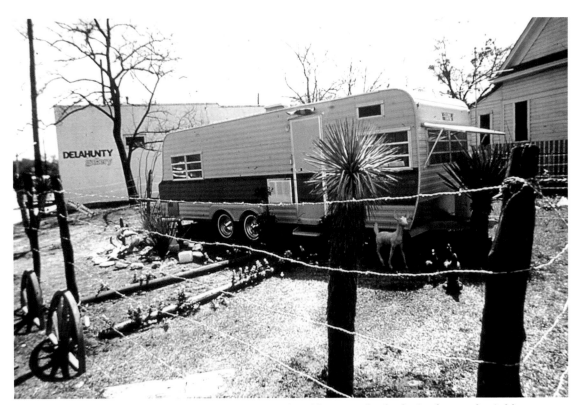

Home on the Range, 1975. Travel trailer "Homestead" with yuccas, barbed wire fence, plastic blue-bonnets, rocks, salt licks, skulls, concrete wagon wheels, and critters. Colored spotlights at night, with music. 9' × 45' × 75'. Temporary installation at the Delahunty Gallery, Dallas, Texas.

The Texas Mobile Home Museum was designed to offer just that: a postwar Spartan trailer coach containing selected artifacts such as twelve-foot longhorns, a stuffed two-headed calf, and other similar artifacts. The visual showpiece was an upside-down bucking bronco positioned in the forward portion of the display, an indication to the world that this thing was not from Vermont.

Audacious as it was, the master plan of the Texas Mobile Home Museum gained its most unique feature from a late and unplanned source. A man intent on starting a blue jeans company approached Bob

Wade and offered to provide a denim travel coat for the trailer/museum. Gratis. His ambition was to promo his product—custom-tailored jeans for wide-bodied Texans.

Fully clothed, the trailer was finally ready to embark on the most precarious aspect of the entire adventure. The Texas Mobile Home Museum somehow had to survive the journey from near North Dallas to the Houston shipyards. A heavy-duty three-quarter-ton GMC pickup was rented to haul the thing, and after at least two decades of sedentary lifestyle, the old Spartan possibly was not up for the trip.

Texas Mobile Home Museum, 1997. Customized 1947 Spartan trailer coach with saddle, steer horns, wood, rope, chrome barbed wire, hand-tooled leather belts, skulls, truck running lights. Interior simulated a Texas sideshow with stuffed bucking bronco upside down, stuffed armadillos and two-headed calf, 14-inch wooden longhorns painted to look real, bluebonnets, boots, stuffed snakes, tape deck playing outlaw tunes, white Naugahyde upholstery on walls and ceiling. Form-fitted denim cover with a long tail attached to the back. 8.5' × 8' × 25'. Lives in France.

Departure time was set for midnight. The cover of darkness was essential to this mission. Mechanical malfunction, driver error, or police intervention seemed likely. Once on I-45 and up to speed, the Spartan began to sway in the fashion of a drunk person attempting to stand in a canoe. It made plaintive moaning sounds that were later enhanced by a *whop-whop-whop*, signifying the travel coat was becoming dislodged.

The Texas Mobile Home Museum gritted its teeth, pressed on, and in the gathering predawn,

arrived at the dock a scant two hours prior to the freighter's departure. Once in Paris, the Mobile Home Museum was afforded a cheerful reception. The only question was whether those Parisians were applauding the art or the fashion statement.

After the trailer had arrived at La Havre and been transported to the display area in Paris, events occurred that Wade recalls were "more bizarre" than the contents of the trailer itself. Visitors to the trailer—beguiled by the massive longhorns that functioned as the most eye-catching hood orna-

ment in automotive history—timidly approached the trailer to inspect its contents. The largely Gallic art enthusiasts sensed a certain kinship with the presentation, owing to the fact that many exhibited equine facial characteristics that strongly resembled Trigger, the fabled mount of Wade's mother's cousin, Roy Rogers.

According to Dallas's Monk White, financier and gatekeeper of the operation, the French would gasp and grow pale at the visual confrontation with stuffed armadillos, steer skulls, and a dead horse, legs up, named Funeral Wagon. Yet being an assembly of aesthetes who dine on snails two meals a day, they quickly adapted. The Texas Mobile Home Museum was on its way to becoming the biggest American hit to arrive in Paris since Lucky Lindy.

And then, inevitably, the Biennale de Paris was over, and the immediate destination of the display was called into question. The curator of the event, whom White remembers as someone he thought was called "Budi" and who referred to the trailer as "the bus," assumed temporary custody of the display.

Its whereabouts then became a matter of international mystery and intrigue that rivaled the manhunt for Carlos the Jackal. Wade and Monk would fly over and scour the countryside, approaching strangers with color Xerox images of his missing artifact, only to be confronted with insincere shrugs and averted eye contact.

To the best knowledge Wade was later to obtain, the trailer had been sold, or more probably kidnapped by Gypsies, who sold it to a sucker.

Only upon his honeymoon with new bride, Lisa, in 1985 did Wade finally locate the trailer, abandoned and forsaken, in a Paris suburb. He jimmied his way inside and was able to rescue a couple of the remnants of the original display—a saddle and the mummified remains of Chief Quanah Parker. Negotiations for ownership of the museum involved a Frenchman's offering to sell Wade something that he already owned.

The voyage of the Texas Mobile Home Museum represented a sometimes turbulent trip. But it was a hell of a ride.

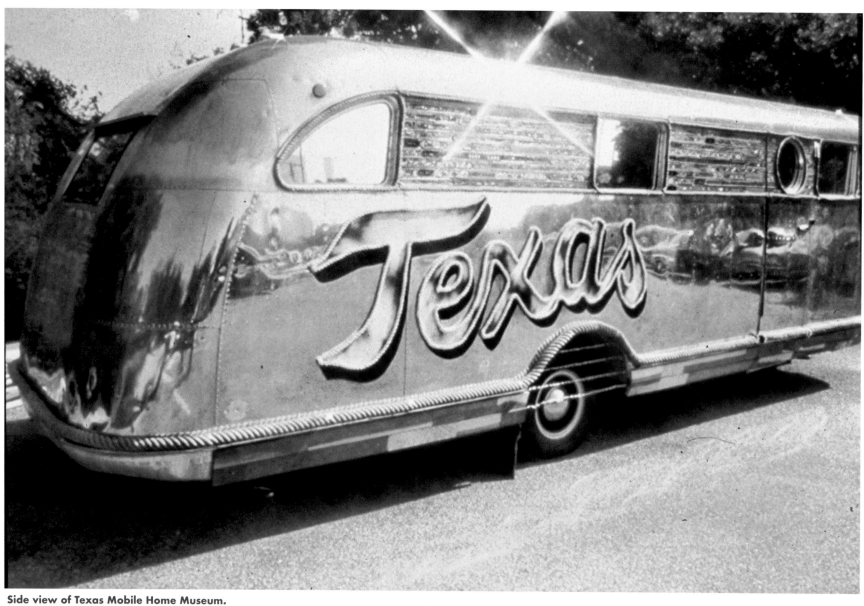

Side view of Texas Mobile Home Museum.

THE TEXAS MOBILE HOME MUSEUM

Bob Wade

Stanley Marcus brought "culture and the finer things" to rough ol' Texas via Neiman Marcus department stores. Much of it was French oriented. So now when a Texan "gets rich," all he wants is "Versailles." White-trash beehive hairstyles are "Marie Antoinette," and there are probably more phony "French mansard roofs" in Texas than real ones in Paris. Numerous Texans have devoted their lives to the importation of European culture. Meanwhile cowboy movies are made in Italy, and cowboy boots are marketed all over the continent. Some say I play around with "sacrosanct macho Texas imagery, heroic folklore, and various aspects of the complete urbanized yokel," but also that I probably am "genuinely fond of the cross-cultural domestic claptrap and mythic symbols that Texans salute in their bid for chauvinistic identity." My projects and installations have dealt with Texas manifestations and phenomena since 1973, including Map of Texas and Texas Star in Houston, Museum of Texas Stuff at 112 Greene in New York City, Texas Formal Garden and Cowtown in Fort Worth, Texas Artifacts in Los Angeles, Progressive Country-Western Art in San Francisco, and Home on the Range in Dallas. So I am

very pleased to export Texas culture to Europe and especially Paris, France, for the Biennale. Some of my cowboy culture is simultaneously showing at the American Cultural Center at rue du Dragon.

The Texas Mobile Home Museum was a project specifically designed to send a "little bit of Texas" to Paris. Prize cattle sales in Texas are now held in red-carpeted ballrooms in fancy hotels in order to "bring the animals to the people." Acknowledging the interest that Europeans have for Texas, cowboys, and so forth, a drawing emerged of a "custom, funky Texas trailer" (to be filled with stuff). A trailer search led us right to a 25-foot-long (approximately 7.6 meters) aluminum Spartan trailer coach, which once it was customized became the perfect mobile housing for the museum displays. It seemed appropriate that this "alternative museum" be incorporated as tax-exempt nonprofit and have an advisory board and a codirector, Clare Frost. Once again we set out for business sponsorship of a nonprofit public display.

We went in with the attitude of "if we can think of it, it can be done," and sure enough, donations of materials and services from local and national

companies enabled us to produce the project and arrange its delivery to Paris. Cultural manifestations in cowboy lifestyle and industrial developments after World War II made Texas cowboys ready to ride the wide open Texas spaces in all those big shiny new cars and trailers being mass produced. This trailer was made by an aircraft company, which was retooled to make Spartan travel trailers (the Cadillac of trailers). War had caused fast evolution in design and technology, and these trailers were influenced by military aircraft and new train and automotive streamlining. The trailer involved a combination of an airplane front and a bus/car rear end. It looks like something expensive.

The special alloy aircraft aluminum shines like chrome, and the assembly line put thousands of rivets everywhere. That's why the trailer looks so good after thirty years. It also has the Texan Cowboy Look, if you consider its resemblance to the Lone Ranger's speeding silver bullet and to six-shooters in general, with its rounded badass gun handle and the hundred leather belts fashioned as its gun belt. The shiny gleaming aluminum visually recalls the sheriffs' badges, belt buckles, silver dollars, Texas millionaires, and private ranch planes. Long like a ranch house and rounded in the front like a horse trailer, it's also curved in the back like a streamlined horse's ass. The face-like front presents giant "cow eye" display windows between steer horns on top and the air conditioner saddle cover as a nose. If it had big tail fins and a motor, it could be a "cowboy Cadillac," but it for sure has that big-spender Texas attitude about good quality and advanced technology. Skulls, rope, barbed wire, and horseshoes are obvious symbols, and join with the whole as an identifiable cul-

tural object, with universal characteristics related to the desire to be "a real cowboy." It is viable internationally.

The Mobile Home Museum is a great-looking object. It is ad hoc and joins numerous other native Southwestern activities such as car customizing and nomadic living in reworked trucks and vehicles by independent trail riders (half cowboy and half truck driver). Old buses, railroad cars, and mobile homes have been transformed into stationary restaurants and bars. In fact the customizing of these into "apartments on wheels" sometimes reaches such on art that the vehicles are never driven, but are instead seriously exhibited at car shows for prizes and trophies. Recent commercial architecture has taught us that a restaurant shaped like a covered wagon serves roast beef, and a new "old-looking barn" serves barbecue and steak. The exterior is thus a stereotyped extension and advertisement for the goods inside. The Texas Mobile Home Museum is some of all of this, but *museum* also means the displays inside, and the believe it-or-not nature of the objects derive directly from sideshows, roadside attractions, and roadside museums. So the mobile home museum is intended as a "show vehicle" and a small Texas museum. The fascinating and entertaining aspects are McLuhanesque for sure, as horses and highway vehicles are changing from transportation to entertainment, and cowboy car salesmen are giving you outrageous commercials on television.

Inside the museum, the walls and curved ceiling and back are upholstered in padded white Naugahyde. The floor is high-gloss knotty pine, the stereo sound system plays tapes by Willie Nelson, ZZ Top, LBJ, and others, and the ceiling is cut through

for a long narrow series of skylights. Rope trim is used throughout. Inside the entrance door up front, dramatic against the white, is Funeral Wagon, the infamous killer rodeo horse. Upside down on his back, this lifelike mount sets the mood for the trip through the museum. You see the world's longest pair of steer horns (twelve feet) and a record-length western diamondback rattlesnake (eight feet). You see a display case full of Texas tornado damage, and as you exit to the rear, you pass a Texas landscape vignette—stuffed armadillos, a calf with two heads, plastic bluebonnets, and cactus—all on the floor in a natural setting.

After you exit, you probably wouldn't even ponder on how this thing got here, but that process is unbelievable "Texas style" and will be documented in an upcoming Daddy-O Productions publication. Just remember that there are good guy cowboys and bad guy cowboys, and Western movies teach that sometimes gunslingers became sheriffs, therefore attaining good guy status. The cowboy movie star Roy Rogers is my second cousin on my mother's side. He recently opened the Roy Rogers Museum. Inside on display are his stuffed horse Trigger and his stuffed dog Bullet the Wonder Dog. He says he wants to be stuffed when he dies and mounted on the back of Trigger. A Texas millionaire was recently buried in her sports car instead of a casket. If all of this is myth perpetuation, I am happy to fight cultural homogenization by exporting Texas to Europe.

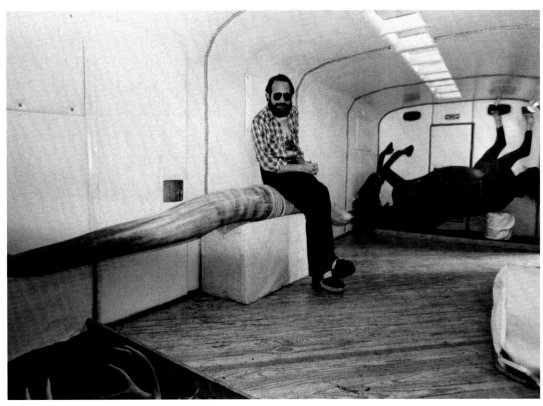

Bob inside the Texas Mobile Home Museum.

IGUANAMOBILE

Karen Dinitz

As a documentary filmmaker, you look for stories to tell. In the case of Bob Wade's idiosyncratic trailer and the road trip that followed, the story came via phone. A friend of mine, who was then a photographer for *The Dallas Morning News*, called me to tell me that she was at a fabrication shop standing in front of a '56 Airstream with an iguana head in front, an iguana tail in back, and a giant saddle straddling the domed top. And if that wasn't enough, the iguana was billowing smoke out of its mouth.

After a phone call with the man himself, I realized that not only was Bob "Daddy-O" Wade and his creation the Iguanamobile going on a Texas-size road trip to publicize his new book, *Daddy-O: Iguana Heads & Texas Tails*, but I was going with them. I could already hear the soundtrack.

We visited bookstores and schools, children's museums and art galleries. We drove in parades and down Main Streets. We parked in Borders parking lots and outside of bars—lots of bars. We pulled into Carl's Corner truck stop, just north of Waco, with Bob's frogs dancing on the roof over the gas and diesel pumps. We went to Houston, San Antonio, Fort

Signed poster for Budweiser Campaign, 1996. 14" × 36". Courtesy of Budweiser.

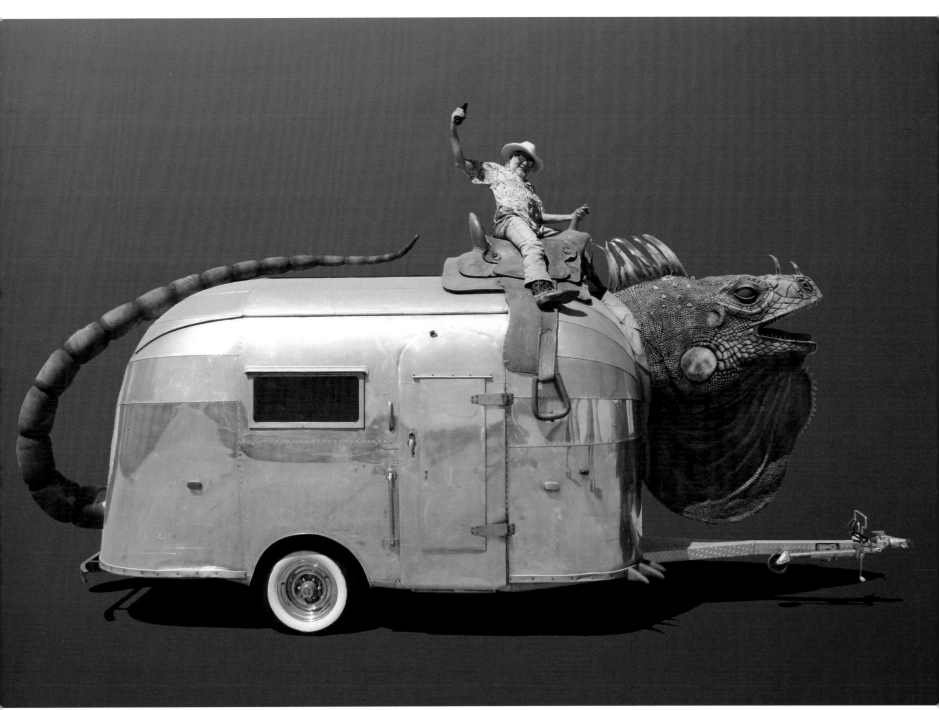

Iguanamobile, 1995. 1956 Bambi Airstream, fiberglass, steel, canvas, latex rubber, sheet metal fins, simulated saddle, lighted eyes, smoke machine in the head, diamond plate floor and banco seating inside. 9'6" × 25' × 7'3". Traveled Texas for Wade's book tour 1995; also for Budweiser commercials and tour. Collection Kevin Williamson, Austin, Texas.

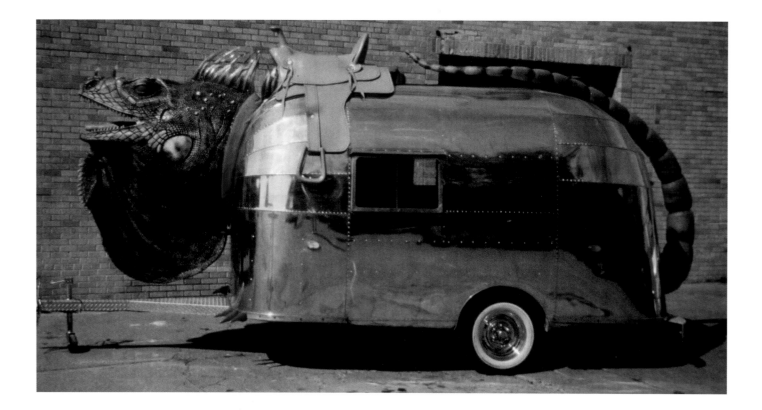

Worth, Austin, and places in between. We visited the forty-foot-high cowboy boots in San Antonio and the seventy-foot-high saxophone in Houston. A schoolteacher questioned the wisdom of showing a smoking iguana to a group of schoolchildren, and another woman thought the Iguanamobile was cool, but preferred Bob's "weenie" period. We had discussions in art galleries about the meaning of public art and the controversy Bob's work elicited on the question of art versus signs from some townships where his work appears on or in front of businesses. Everywhere we went the Iguanamobile sparked reactions. And I witnessed what I think is Bob's big talent: making art accessible to everyone by creating extraordinary things from everyday objects.

Bob is a collector of people and stories, and wherever you go you get a whole bunch of each.

By the end I had hundreds of new stories and a movie called *Too High, Too Wide, and Too Long*. The name was a tribute to another of Bob's outsize animal odysseys—this one, the story of how he delivered Iggy, the forty-foot polyurethane iguana, to the Lone Star Café near New York's Washington Square.

The joy of spending time with Bob and of watching the Iguanamobile driving down the highway was truly a fantastical, fun journey of art and road, taking us to the heart of Texas and a trip down Bob Daddy-O Wade's memory lane.

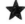

THE COSMIC TALE OF THE TRAVELS OF KINKY FRIEDMAN'S CAMPAIGN HAT

John Kelso

September 24, 2016

As they say, what goes around, comes around. And what made the loop this time around was Kinky Friedman's hat.

We're not talking about the cowboy hat the Texas humorist, writer, and musician wears on his head, but the huge Western hat artwork that decorated the front of a teardrop trailer Kinky's campaign staff drove all over Texas when he ran for governor in 2006.

How Kinky lost the election beats the heck out of me. He had a great campaign trailer, named the Gov Bug—although the name Hebrew Hummer also was discussed.

"That was a good one, but I think it hit the editing room floor," said Little Jewford, Kinky's right-hand man. Then there was that poignant campaign slogan, provided by Willie Nelson: "Criticize him all you want, just don't circumcise him anymore."

"Unfortunately, about all I remember is that and the Gov Bug and that it traveled all over Texas," Kinky said from Hawaii, where he's getting ready for a tour in Germany.

Our traveling hat story begins in 2005 with Cleve Hattersley of the Austin band Greezy Wheels. Cleve was working for Kinky's campaign and needed something colorful to promote the effort, something that could tour the state.

So he talked to Austin artist Bob "Daddy-O" Wade, who suggested a trailer. Cleve liked the idea. So Wade designed a small trailer decorated with a Kinkyesque mustache, a big cigar (Kinky's a cigar

Kinkymobile/"Guv Bug," 2006. High-density foam with coating and paint, teardrop trailer painted fuchsia with graphics and 3-D cigar. 6' × 8'. Commissioned by the Kinky for Governor campaign.

guy), and the oversize cowboy hat, which measures eight feet front to back.

After the campaign was over, the trailer was parked in back of Kinky's campaign headquarters on Ben White Boulevard. Then it disappeared, said Little Jewford, who suspects it was stolen. Allegedly it ended up in a storage unit somewhere in Austin. And when nobody had picked up the contents, they were auctioned off.

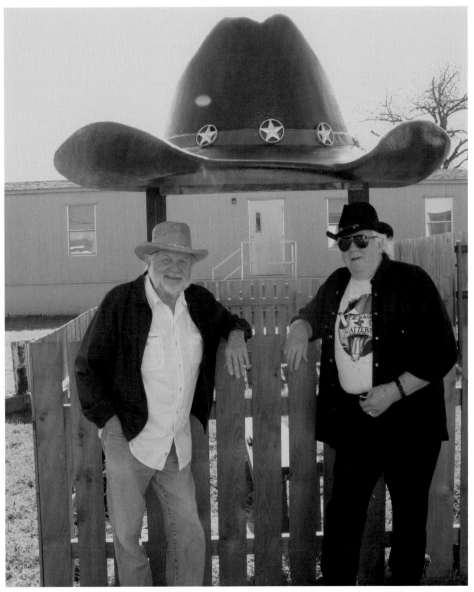

Kinky's Hat, 2006. Painted high-density foam and steel. 3'6" × 7' × 8'. Collection Texas Hatters, Lockhart, Texas.

NEW MEXICO COMBINATION PLATE

John Tinker

It is May 1987, and Bob Wade is scheduled to arrive midmorning at the loading dock of the Museum of Fine Arts in Santa Fe with the components for his installation New Mexico Combination Plate. This piece is to be included in the alcove shows, a series of rotating exhibits with spaces designated for each artist, within the first-floor galleries of the museum.

As I slowly open the loading dock's rolling overhead door, not knowing entirely what to expect, there sits a flatbed truck loaded with about a third of a late 1940s Chevy coupe car body, crumpled and slightly twisted as only the New Mexican landscape can manifest. Bob's nearby Chevy El Camino is loaded with a variety of materials ranging from sheets of corrugated metal, a bundle of latillas (long smooth and slender wooden poles used in traditional northern New Mexican ceiling construction), and additional boxes and buckets, contents unknown. This is the Bob Wade I know, and we are in for an enjoyable afternoon.

As we roll the components into the building, with nervous and slightly confused museum registrars looking on, we begin installing what is to become Bob's affectionate tribute to the culture and sensibilities of northern New Mexico. The Chevy is gently positioned front and center in a landscape of sand, stacks of adobe bricks, and various arroyo-inspired accoutrements. Mounted on the wall directly above is a large photographic image of a heavily tattooed woman, further glamorized by Bob's trademark airbrushed enhancement. She is flanked on either side by actual tortillas, color enhanced, symmetrically arranged and looking right at home on the museum's hallowed walls. The adjacent wall to the right is sheathed with corrugated metal, another ubiquitous construction staple, sporting a noble cutout of the Zia symbol, the state's logo. On the opposite wall the wooden latillas are installed horizontally to hold folded and arranged tourist rugs found in shops and trucks stops throughout the Southwest.

The New Mexico combination plate, an entrée commonly featured on many New Mexican restaurant menus, is reimagined as an homage to the region, one executed with an assembly of cultural "ingredients" familiar to the area. Exhibiting a sophisticated eye and a keen sense of context, Bob "Daddy-O" Wade has delivered once again. I look back on this irreverent and hilarious ride with my friend with great affection.

New Mexico Combination Plate, 1987. 1940s Fastback Chevy cut in half, corrugated metal, wood poles, sand, adobe bricks, woven blankets, clear-coated tortillas, photo emulsion canvas. 10' × 18' × 9'. Temporary installation at the Museum of Fine Arts, Santa Fe, New Mexico.

BOB WADE'S BONNIE AND CLYDE MOBILE, MARFA, TEXAS

Lonn Taylor

Several years ago, my wife and I were enjoying dinner at Marfa's Blue Javelina restaurant when a cacophony of sirens and gunshots erupted outside on U.S. Highway 90. A battered sedan came by at ninety miles an hour, followed by four Border Patrol vehicles and a sheriff's car with lawmen leaning out of the windows shooting at it. We were witnessing a narcotics chase, which ended on the east side of town when a bullet went through the sedan's rear window and the seventeen-year old *narcotraficante* decided to pull over and give up. His bullet-riddled sedan sat on the shoulder of the highway for several days before someone towed it away.

That is why I did not give a second thought to the old bullet-riddled yellow Chevrolet Step-Van that suddenly appeared in the parking lot of Marfa's Lost Horse Saloon. I assumed it was the relic of another narcotics chase and I soon ceased to notice it at all. So I was taken aback when my old friend Bob Wade called me and asked if I would write about his Bon-

nie and Clyde Mobile that was on loan to Ty Mitchell from John Langdon's collection. I went back to take another look at it, and sure enough, in red paint just under the windshield, are the words "Bonnie and Clyde Mobile © BobWade.com 1982." It needs a larger label.

Wade bought the vehicle in Dallas in 1982 to drive in a New Orleans Mardi Gras art car parade. It was painted dark gray and had been a laundry delivery truck. He had it painted school-bus yellow so that the bullet holes would show up. Then he took it to a shooting range in Garland and paid the owner $60—$10 in labor and $50 for ammunition—to pepper it with machine-gun fire. He was stopped several times by the police driving it from Dallas to New Orleans (it probably didn't help that he was in a convoy with the Texas Kid, two other art cars, and several cars filled with girlfriends, dogs, and hangers-on). He tossed plastic toy soldiers to the crowd during the parade and was soundly booed; the crowd

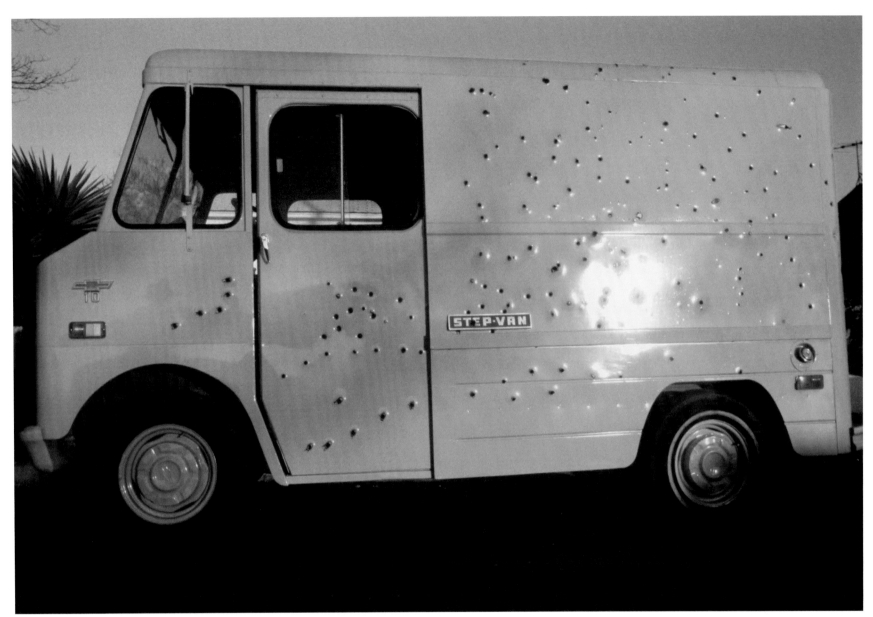

Bonnie and Clyde Mobile, 1982. 1972 Chevy step van, painted school-bus yellow. Machine-gunned at Plano, Texas, firing range. Financial assistance by New Orleans Contemporary Art Center for annual Krewe of Clones Art Car unit, Mardi Gras parade, 76' × 156' × 75'. On loan to the Lost Horse Saloon, Marfa, Texas. Collection of the John Langdon estate.

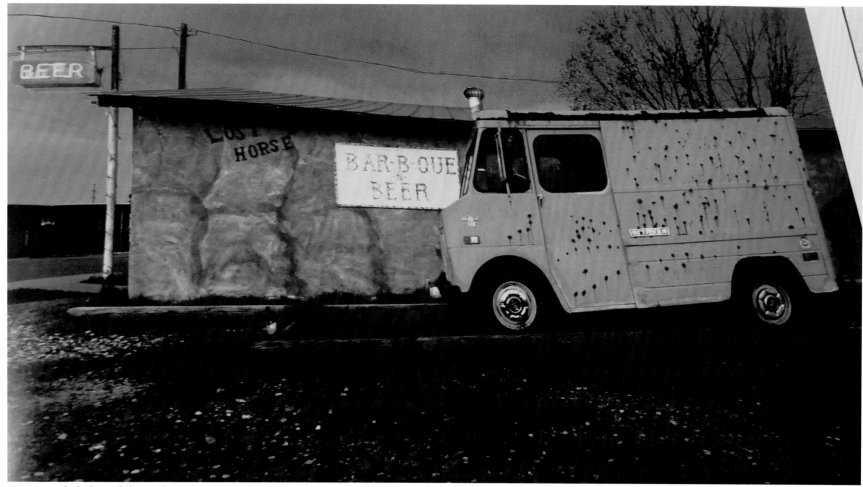

Bonnie and Clyde Mobile, parked outside the Lost Horse Saloon.

evidently felt that the van was not in the Mardi Gras spirit. Bob says that maybe naked girls on the roof wearing crisscross gun belts would have helped.

It is appropriate that the van has ended up in Marfa, since Bob lived there when he was in the fourth grade, long before Donald Judd thought of moving there. He says he is the first contemporary artist ever to live in Marfa.

I asked Bob how he was able to resist squeezing off a few rounds himself when he was having the car shot up. He lowered his voice on the phone and said, "You know, I'm a real Texas guy and all that, but I've never felt comfortable around guns." I've always known Daddy-O was a softy at heart.

Land Sea Air, 1977. Pencil on paper, 9¼" × 8½". Collection of the artist.

JUNKYARD DOG AND SKULL

Bob Wade

As any old hot rod/custom car guy knows, car stories can have interesting twists and turns, as does this one about the Skull and the Junkyard Dog.

Part of my payment for working on a project at the beginnings of Carl's Corner Truck Stop was a 1957 Chevy 210 four-door—six cylinder—light blue and white. Not top of the line, but pretty cool for an occasional cruise around Dallas.

It moved with me to Santa Fe, where during winter months it was outfitted with snow tires. It moved with me to Austin, where it was used less and less until Jeff Morehouse had an idea: take it to his auto junkyard in San Antonio and put a big motor and different transmission in it. It would then be "badass," a sleeper with clout.

Jeff was an attorney whose side passion was cars. Needing more space for his odd collection, he bought a salvage yard on the south side of San Antonio. I loved visiting Jeff's Alamo City Inc., as it reminded me of my car days in El Paso, when we rooted for spare parts in salvage yards there. I got to know the "maestro" mechanic who pulled parts and cut things apart. So I figured Jeff could transform Little Blue with ease.

As a thank-you, I offered to make Jeff a Junkyard Dog sculpture that would stand guard at the entrance to his fine establishment, but of course I would have to use car parts from his great selection of stuff, and needless to say, would require the expertise of the maestro welder/parts man.

So I drove down to the Alamo City with a loose idea, a VW hood, gloves, and work clothes, hoping to find an older car I could stand on end and transform into a dog.

And there it was: a 1966 Plymouth Fury, eighteen feet long and seven feet wide wide—old-school.

I showed my drawings to my new right-hand man, and with my El Paso/Juarez border Spanish directions, began to cut and assemble an outsider-artist-influenced steel and rubber assemblage: the VW hood nose, a 1990 Cadillac hood tongue, and a 1969 Impala ears and teeth.

Since all this was done on the ground and was a little theoretical, we couldn't wait to hoist it up and move it out front. Fortunately it worked, and Austin's Ranch 616 hosted a party with food and music and wonderful mixed crowd.

At about the same time, Ranch 616 needed some decor for their food booth at a Day of the Dead event

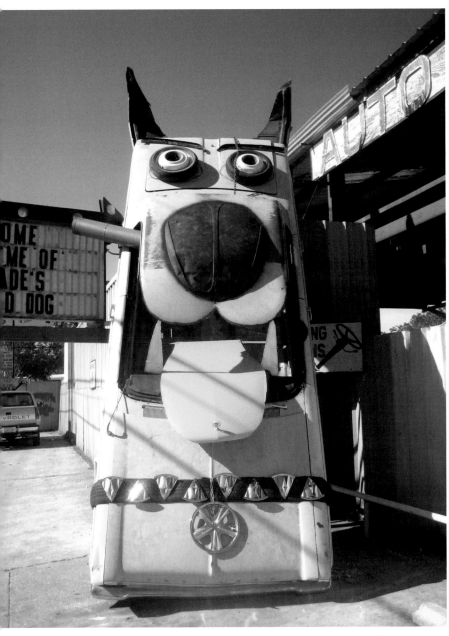

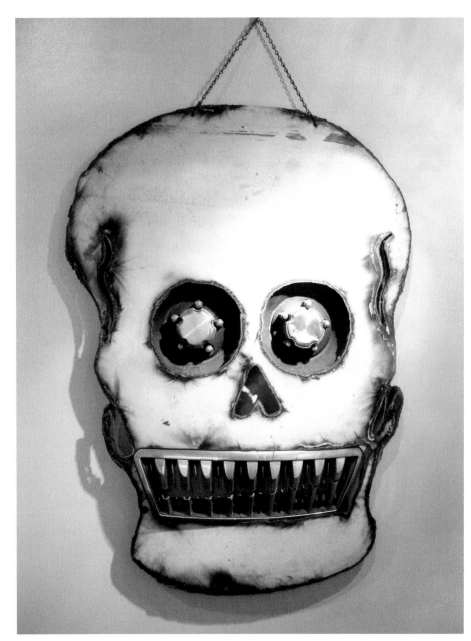

Junkyard Dog, 2006. 1996 Plymouth Fury, 1990 Cadillac hood tongue, 1969 Impala ars and teeth, 1972 Volkswagen hood nose, tire tread collar with chrome parts and ubcap. Compact car spare tires, aluminum cigar, 20 feet tall. Created for Alamo City uto Parts, San Antonio, Texas.

The Skull, 2007. Buick hood, Kia grill, truck hubcaps. 59' × 40' × 3'. Created at Alamo City Auto Parts, San Antonio, Texas, for Day of the Dead displays and exhibitions. Collection of the artist.

Christine Wade and Bob Wade with Little Blue, 1985 Santa Fe, New Mexico. Photo: Lisa Wade.

in San Antonio, and I offered to make a giant Día de los Muertos skull.

Jeff agreed to "lend" me the maestro and parts and I got out my gloves again.

This time it was a Buick hood with a Kia grill for teeth and truck hubcaps for eyes.

It worked again!

And Little Blue? Well, I took the upgraded '57 for a spin around the neighborhood by the salvage yard, and its ultra-loud dual exhaust plus its quirky new transmission kind of told me that I really didn't need a badass car. So Jeff sold it for me, and it now has a new career in old San Antone. Thanks, maestro and Jeff!

Daddy-O, Super Chicken, and Jeff Morehouse, with Junkyard Dog at Alamo City Salvage Yard, San Antonio, Texas, 2006.

GETTING ROPED

Dan O'Hara

A recent reflection on my twenty-year friendship with Bob Wade brought to mind an installation I did with him in San Antonio at Sunset Station. Driving the Ball Texas Style, as he would name it, would be one of his wackiest.

As he recruited me to assist him, I remember these words: "It will be easy, no big deal." Being a former US Marine, a Great Lakes sailor, and a general contractor, I said, "Bring it on!" And bring it on he did.

A huge pile of triangular-shaped fiberglass panels that when screwed together would become a giant twenty-foot faded yellow golf ball, an antique fire truck converted into a South Texas hunting vehicle, donated by Jeff Morehouse, and a large crane were all waiting for me at the site when I arrived.

Any request for written instructions would have been a waste of time, as Bob was already telling my crew how he thinks the ball is put together.

Fortunately, while Bob was occupied with curator Bill FitzGibbons and a growing vocal group of other artists (who could see their work dwarfed), my

Drivin' the Ball, Texas Style, 2004. Fiberglass mounted on hunting vehicle. 30' × 25' × 9'. Temporary installation, Sunset Station, San Antonio, Texas.

crew was able to reconstruct the rickety ball. Now with many straps and Daddy-O's guidance, the crane raised the giant swinging sphere and we guided it precariously onto the vehicle's two-story top. After strapping the old driving range signage object down tightly, Bob jokingly said, "Run!"

Months later, half of the ball was shown at San Antonio College. Then the components were hurriedly and unceremoniously disassembled and placed behind a warehouse, where a herd of steers showed their appreciation for Bob's art by walking on it and cow flapping the pile.

Another of Bob's balls may have met its demise, but as Monty Python once suggested, he may have another ball.

Ray Benson with Bob and the Gib-skin Guitar 2005.

DADDY-O'S TACO BUS

DJ Stout

For thirty years I have driven by El Arroyo on my way to work. Most mornings I instinctively turn to look at the Tex-Mex joint's front parking lot to check out their famous message board, an outdoor marquee sign with movable letters that features a daily offering of wit and wisdom—a kind of old-school version of today's memes.

One day I noticed a new addition to the parking lot. Behind the message board, tucked into the west side of the restaurant, which literally sits on top of an active arroyo (a Spanish term for a dry creek that fills only after it rains), there appeared a structure that at first glance resembled a broken-down school bus with its wheels missing. On further inspection, I noticed that there was something different about it—even charming.

The front of the old bus had been sliced off and lifted up to create a makeshift awning over a small rectangular window—about head-high—that looked like a place to order food. And that's exactly what it was. As it turns out, the bus had been transformed by my pal Bob "Daddy-O" Wade into a taco stand in 2012. I didn't know it at the time, but once the taco bus's creator had been revealed to me, it made perfect sense. Now the little blue taco bus has become an Austin icon and a daily destination, where morning commuters exiting MoPac, the city's over-

crowded thoroughfare, stop off to get their breakfast tacos before heading into downtown. In Austin the breakfast taco is a religious rite, and Daddy-O has created its humble temple.

I met Bob for lunch at El Arroyo to talk about his creation, officially titled El Nuevo Bus del Arroyo. We walked around the taco bus, recently updated with a bright blue and yellow paint scheme and the words tacos and ritas written out in neon across its crown, while the artist pointed out some of its features. The original bus had been used as a catering vehicle. It was light blue, faded and cracked from the sun, with *The Ditch*, El Arroyo's nickname, scrawled in yellow and burnt orange on its side. The bus sat next to the restaurant for years before El Arroyo's owner, Ellis Winstanley, asked Daddy-O to do something with it. Oh, and it had to be shortened by ten feet to fit the space.

Over enchiladas and margaritas, Bob, a great Texas storyteller, regaled me with a rambling, hilarious tale of how the taco bus came to be. Like all of the Daddy-O's creations, it involved a ramshackle cast of characters, including Gerald and Chris, whom the artist borrowed from Austin Metal and Iron; Tommy the welder; and two crane operators who happened to drive by while they were installing a commercial sign in the parking lot of a shopping center.

El Arroyo Taco Bus, before its transformation into art. Collection of the artist.

The story reminded Daddy-O fondly of his early hot-rod days in El Paso. He loves working with construction workers, grease monkeys, and sign guys—they are his people, and he loves the whole process of creating art. So much so that his enthusiasm and joy for his craft will make you a believer, too.

El Arroyo Taco Bus, 2012. Altered B-600 Ford school bus. Steel, wood, neon, truck horns. Interior serves as taco prep. 12' × 14' × 93'. Commissioned by El Arroyo Mexican restaurant, Austin, Texas.

DADDY-O WADE'S SAINTS HELMET

Jan Reid

The thing about the Saints Helmet is that you take it for granted, unless you're an arriviste caught in one of the traffic jams you all unloaded on Austin. It perches at an angle from a facade at 909 North Lamar. It looks like it could be giving you a courtly nod, or it might be about to bury you for a ten-yard loss. It's an adornment of the Shoal Creek Saloon, which has a patio out back where you can sit and enjoy beer and chat above the leisurely creek, unless there's a flash flood. The last time that happened, floating tables in its side room bobbed and swirled like leaves in a lily pond. But management and workers had the operation back open in five days. The joint has a pleasant air that is part throwback, part ornery survivor. The food's quite good, and not just the gumbo, crawfish, oysters, and hush puppies. When you come in the front door you're greeted by the sight of a classic shuffleboard you can play for free. The management is proud of having thirty-two TV screens scattered around the place, and staff will help you find the channel of just about anything you want, as long as it's a ball game or other sporting event. They shy away from politics and preaching. But why a football helmet? And why the Saints?

Keeping Austin weird is the easy answer.

Another, in my opinion, is that children have been born and grown up and graduated from college since the Dallas Cowboys even sniffed the aroma of a Super Bowl. Their fan base is jaded. The Texans haven't earned much of a fan base outside Houston. You wouldn't have encountered that helmet in Texas when Saints fans went to the games with grocery sacks on their heads and called their team the Aints. But those Saints are a fading memory. The Saints threw off history's shackles and beat Indianapolis 31–17 in the 2010 Super Bowl, the Saints' first. They got it done behind a shoo-in Hall of Fame quarterback, Drew Brees, who starred at Westlake High, in the hills just above Austin, but recruiters rated him unworthy of playing for the University of Texas. What's not to like about that turn of events? And to paraphrase the name of a baseball movie, if a rowdy gang crowds in a bar to watch all Saints games, the sculptor will come.

Daddy-O Wade is the Salvador Dalí of onetime El Paso hot rodders. He thinks big. A forty-foot-long iguana on the roof of the Lone Star Café in a posh but stuffy precinct of Manhattan. A troupe of singing bullfrogs that reminds you of the mariachis that descended on your table one mescal-soaked night in Ciudad Acuña. A two-headed longhorn. In this case

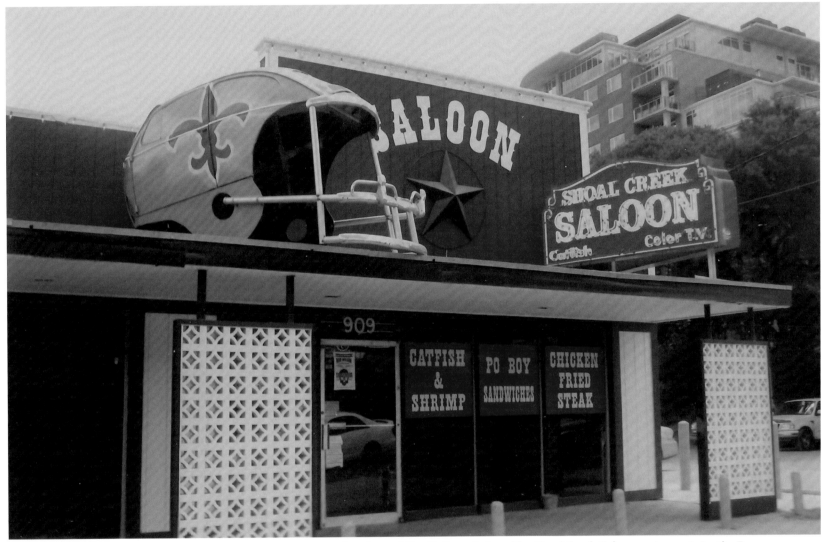

Saints Helmet, 2004. Volkswagen body and VW parts, spray-painted. 5' × 10' × 4'. Commissioned by Shoal Creek Saloon restaurant, Austin, Texas.

Daddy-O was first inspired by his daughter Rachel's toy saxophone. For a now-extinct Houston club called Billy Blues he was commissioned to sculpt a seventy-foot-tall sax. Daddy-O turned the toy over in his hands and saw that the bell or bottom curve of a sax looked like an old Volkswagen bug turned upside down. Daddy-O delivered Billy Blues's classy sax, and years later, Saints fever took over.

Ray Canfield, who grew up in Alvin, Texas, opened Shoal Creek Saloon on April Fool's Day twenty-five years ago with fare of just beer and wine and burgers. Across North Lamar for many years was a lot called Austin Sports Cars. Its owner was Bill Bittles, who liked Bob's idea of a sculpture that would rebrand the joint and attract new clientele. (A dominant theme back then was snow skiing, which

accounts for today's mixed message of skis sharing wall space with framed football jerseys. Fans of LSU football also have a game-watching club at Shoal Creek.) Daddy-O made a plastic model of a Beetle with a pane replacing the front storage compartment of the rear-engine car, and he and the sports car dealer sprung the idea of putting a VW turned Saints Helmet above the saloon's entryway. Daddy-O also arranged to have an old fraternity brother standing close by to exclaim what a great idea that was. Bill was the aesthetic advisor.

"When I realized they were serious," Daddy-O called on another Austin friend, who has a junkyard called VeeDub with all the deceased VWs you could want.

He didn't want the floorboard, seats, engine, wheels, or steering wheel—it takes four people to lift just the shell. He has an ace steelworker, Will Larson, who cut away the storage compartment and welded on a piece of metal with the appropriate curve. With the engine and windshield removed, the shell opened up so that the imagined football player was inside looking out. The side and rear windows were closed off with plates of sheet metal. Ace painter Don Twomey sprayed on the Saints' gold, and then Stylle Read painstakingly added the team's black fleur-de-lis logo on the side of the helmet. They fused two Volkswagen bumpers for the helmet's face mask. They transported the sculpture in early morning hours to avoid all but chance traffic. Another friend of Daddy-O supplied a truck with a small sturdy crane rooted to its bed and frame. The friend raised the helmet and swung it over for the crew to bolt it to the building's undergirding, and then they covered it with black sheeting and waited for daylight and the unveiling. A local TV crew showed up, and two attractive young sisters were hoisted for the photo op. Think of the hippies, families, children, and dogs that once rolled through town in that Volkswagen.

Austin's artistic salute to the Saints premiered in 2004, when the team finished just 8–8. But two seasons later, the front office of the Chargers, then in San Diego, decided Philip Rivers was their quarterback of the future, and Drew Brees, once more talking back to a vote of no confidence, signed with the Saints. (The Chargers haven't reached a Super Bowl since 1995.) Brees's No. 5 Saints jersey is on the wall above Shoal Creek's shuffleboard. The Saints organization is aware of the sculpture and the devotion of the team's Austin fans. One year they routed a preliminary part of the draft process through the saloon. It's fun to watch a game with the Shoal Creek gang, who call themselves Who Dats, adopting the New Orleans fans' rallying cry—"Who dat? Who gonna beat dem Saints?" They groan and blow whistles and on a central table assemble an offbeat mess of things meant to invoke gridiron voodoo. One leader, Lee Miles, is a self-described Austin slacker who grew up in Metairie, the city across Lake Pontchartrain from New Orleans. The others I met are Texans who have just decided the Saints are their team.

Drew Brees was thirty-nine at this writing, so the hometown hero is not going to make those touchdown throws much longer. But the friendly bar and Daddy-O's Saints Helmet sculpted from a Volkswagen shell are not going away. No developer of highrise condos will show up offering millions for that real estate. Sooner or later Shoal Creek will again flood.

SMOKESAX

Dick DeGuerin

"That ain't a sign; that's ort!"

Nineteen ninety-three was a busy year for me, what with the ATF/FBI fiasco in Waco and the political indictment of Senator Kay Bailey Hutchison, so when I got the call, my plate was pretty full. "The Daddy-O's tits-up in a ditch . . . again!"

How could I refuse? This looked like all-out war.

It seems that Daddy-O's latest public art project had fallen afoul of a bunch of bluenoses spearheaded by city councilwoman Eleanor Tinsley, whose single obsession was getting rid of all the ugly billboards in Houston. Along the way she'd created the sign committee, tasked with issuing permits, but mainly denying them, for "signs," loosely, and probably unconstitutionally, defined as just about anything remotely connected with a commercial venture, aesthetic value be damned.

You see, Daddy-O's old Kappa Sig buddy, "Chicken" Gallagher, was building a giant blues music and barbecue venue, to be named Billy Blues, on the burgeoning Richmond Avenue strip, and he naturally commissioned the Daddy-O to create a sculpture befitting the entrance, kinda like the statue of Sam Houston at the entrance to Hermann Park, or the giant iguana greeting folks to the Lone Star Café in Manhattan, or the World's Largest Cowboy Boots at San Antonio's North Star Mall, or, dare I say it, the Statue of Liberty in New York Harbor. Each

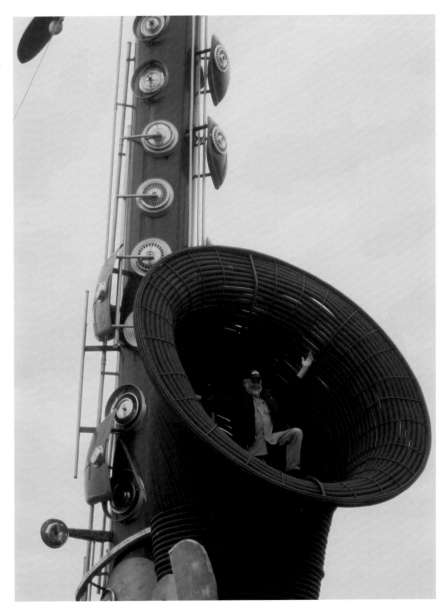

Bob inside his Smokesax, 2013. Billy Blues, Houston, Texas.

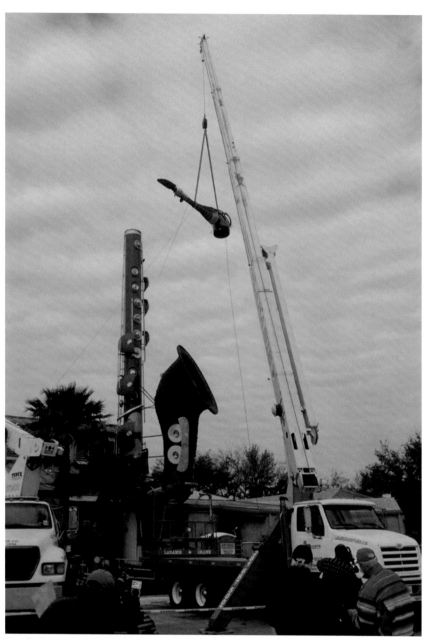

SmokeSax moving to the Orange Show Center for Visionary Art, 2013.

of these had withstood contemporary criticism in their day, even ol' Lady Liberty her own self.

So what brewed out of Daddy-O's fertile imagination but a giant blue saxophone, taller than Big Tex at Dallas's Fair Park, and infinitely more artistic than that silly but iconic cowboy . . . and a Houston thumb of the nose to stuffy Dallas. Yep, a giant saxophone, the bottom curve of which would be an upside-down VW with doors that would still open so the curious or musicians or the artistically inclined could explore the inside of a sax, have sex in the sax, or pose for pictures, yet another thing in common with Lady Liberty's tourists hanging out of her crown.

Daddy-O assembled a motley crew to help him—R. A. Hilder, Big Bill, Cock Dog, and Lick Lick—and work feverishly began. With his uncanny eye for seeing something else in ordinary objects, he would form the sax's bell from corrugated flex, the keys from hubcaps and room service plate covers, the reed from a surfboard, and the occasional beer keg, aluminum canoe, electrical conduit, and so on for good measure. "Chicken" Gallagher was getting nervous, watching the sausage being made, but was unwavering in his unlimited budget and support.

Meanwhile, the bluenoses had decided the nascent sax was a sign, and since they'd not issued a permit, it'd have to come down. Enter yours truly:

"Daddy-O, this is war! This is a goddamned First Amendment, free speech issue! Let's sue the bastards!" At this point "Chicken" Gallagher became concerned with adding legal fees to the already mounting construction costs, but what happened next was amazing. The vibrant contemporary art community came together in support of the Daddy-O, and the issue became political. The sign

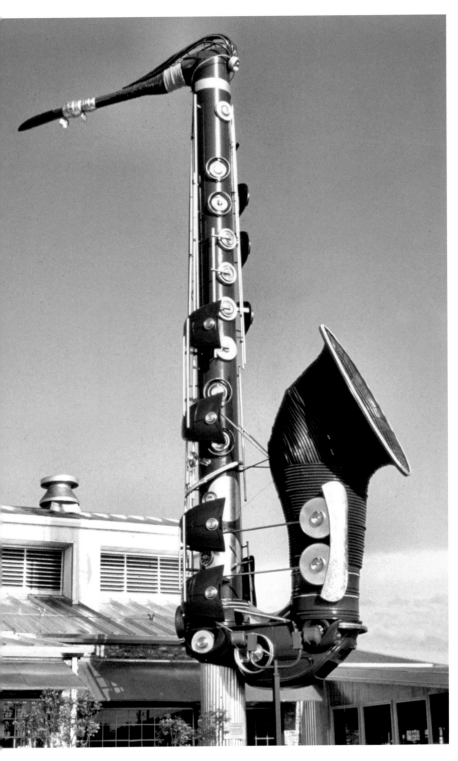

committee punted to the city council, and there reason (or the fact that powerful art patrons are often political donors as well) prevailed, and the Blue Saxophone was officially declared to be art, or in Molly Ivins's pronunciation, "Ort."

Several decades later, Billy Blues is gone, but the sax is still alive, although in hiding, waiting for a suitable new venue. Maybe prominently installed by the Gulf Freeway, where it'll be seen by jillions of commuters every day, raising their consciousness.

And that, boys and girls, is how Daddy-O continues to proclaim, "I don't make signs, I make art!"

Smokesax, 1993. Oil field pipe, upside-down Volkswagen Bug, beer kegs, surfboard, hubcaps, room-service food covers, plastic flex tube, lights, half canoe, half cattle feeders, steel, VW hoods, EMT pipes, spray-painted. 70' × variable dimensions. Commissioned by Billy Blues restaurant, Houston, Texas. Collection of The Orange Show, Houston, Texas.

RESPONSE TO WARHOL

Bob Wade

In 1999 I raced down to the Alamo Drafthouse Cinema in Austin to be the first in line to meet and get photos signed by two of the original Munchkins from *The Wizard of Oz*. It was Jerry Maren and Clarence Swensen, accompanied by their wives for a showing of a newly restored print of the unbelievable 1939 film.

I had been a fan of all things unusual, like midgets, sideshows, and oddities. I couldn't believe I got my photo taken with the foursome and they signed eight-by-tens, including one of the cast of *The Terror of Tiny Town*.

Clarence had several roles in the all-midget Western, and not only was he from Texas, but he lived in Austin as a retired University of Texas maintenance department employee. So when Eva Buttacavoli, then curator at the Austin Museum of Art, asked me to do a "Response to Warhol" talk during the Warhol show (2003), I immediately thought of Clarence, *The Terror of Tiny Town* (which I had on video), and all things "mini."

My friend Bill Bittles had a used sports car lot, and I remembered there was a British MINI Cooper

Andy Made Me Do It, 2003. Clarence and Myrna Swensen. Video, slide projectors, MINI Cooper car, appearance by Clarence and Myrna Swensen, coronita beer, mini hot dogs. Evening performance at the Austin Museum of Art. Austin, Texas.

there. Maybe it would fit through the museum's double doors and be the centerpiece for my presentation.

I somehow tracked Clarence down (he does appearances) and hired him and his wife, Myrna, to show up in Western attire and stand next to the MINI and the tiny town video on fast speed mode.

High up on one wall were side-by-side changing slide projections—one of Warhol's work and the other of my work. To polish it off, my friends at the Ranch 616 restaurant provided mini hot dogs and little beers called Coronitas.

I think Warhol would have liked it.

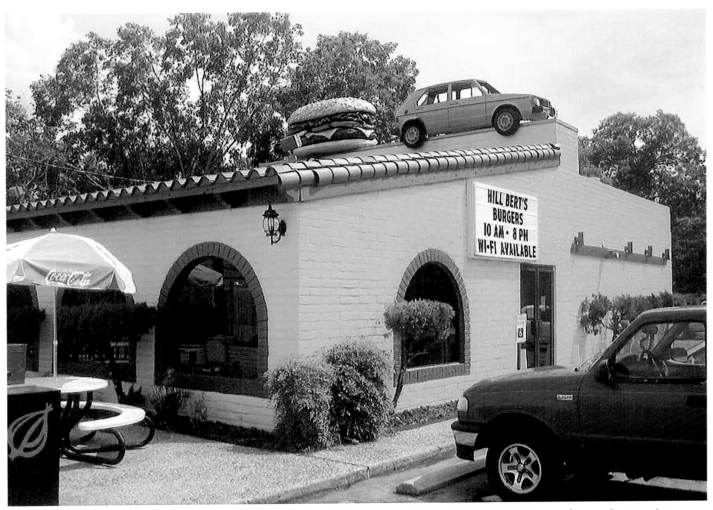

Hill-Berts, 2008. 1975 Volkswagen rabbit, cut in half, high-density foam, half hamburger by Faith Schexnayder, steel, spare tire, spray-painted. 55" × 12' × 30". Commissioned by Hill-Bert's Burgers, Austin, Texas.

Swingin' Chevy, 1988. Chevy Fastback cut in half, wood, car seat, chain. 15' × 15' × 3'. Temporary installation, Shidoni Foundry and Galleries, Tesuque, New Mexico.

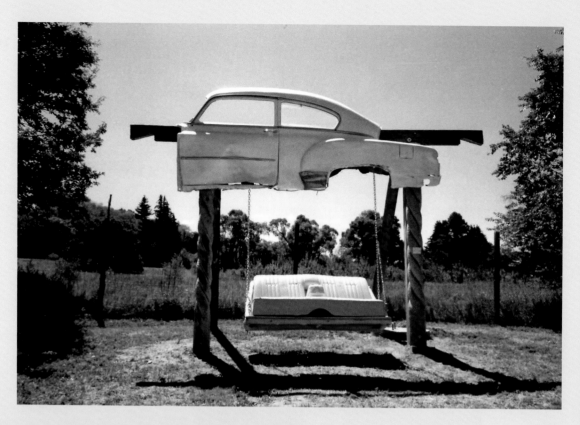

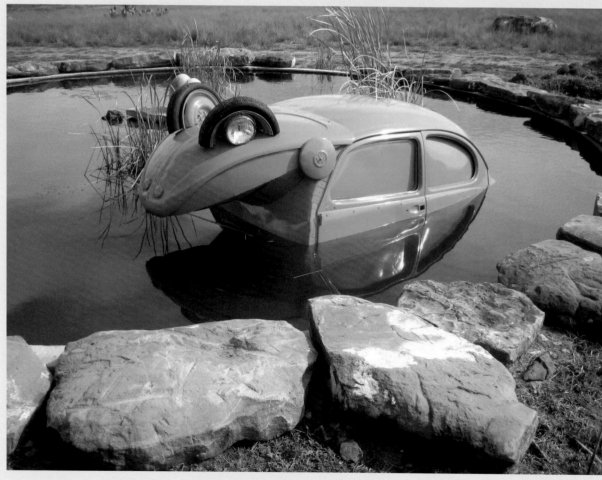

Volksfrog, 2010. Volkswagen body, hood, tires, hubcaps, auto paint. 4' × 160" × 60". Private collection, Texas ranch.

It was art, then it was junk, and now it's gone

By STEVE BENNETT
Staff reporter

All that's left is a leaky tire, a hose clamp, a rusted seat belt latch and a broken blue dipstick.

But artist Bob Wade chuckles and waxes philosophical over this pile of rubble. He thinks this is just another phase in the artistic life of his controversial sculpture "Another Use of Steel."

The piece — a bullet-riddled, rusty 1975 Ford Fairlane — was delivered to the front steps of the San Antonio Museum of Art for the Texas Sculpture Symposium in March 1987.

It was "created" by some "good ol' boys in Central Texas whose hobby it is to get old cars and shoot 'em up," says Wade, the well-known Austin native who created the giant cowboy boots at North Star Mall and the iguana atop the Lone Star Cafe in New York City.

Wade now splits his time between Santa Fe, N.M., and Dallas. The sculptor explores Southwestern myths in his work, and "Another Use of Steel" digs into the fascination with cars and guns.

"I'd worked with these guys (on photomural and video projects) in the past," the sculptor said. "I made most of the arrangements (for the Fairlane) by telephone from New Mexico.

"I hired a guy to haul it down there to the museum. I was told my piece was going in front of the museum. I got word — and I don't know if this is true, but it's a good story — I got word that the guy had the car on a trailer, drove up and somehow attached a chain to the car and to the building and then just drove out from under it. Kah-wop!"

The car was supposed to sit on a revolving base, but there was no

SAN ANTONIO LIGHT

"ANOTHER USE OF STEEL": The Ford Fairlane that started out as art did a short stint as a cube of junk, and now it's missing.

money for that, and museum officials, according to Wade, thought "a drunk with a machine gun had had a wreck out front of the building" when they saw the car.

The car was moved around to the back of the museum — out of sight, but not out of mind.

After the sculpture symposium ended, Wade asked Gene Elder at the Blue Star Arts Complex if he would take the car. Elder said sure, and the car was towed over, where it has had a fairly eventful life, including acting as a percussion instrument for the Austin alternative music group Miracle Room, who pounded and banged on the car while video camera captured the action.

Out in the elements in the Blue Star parking lot, the car began to deteriorate, losing parts and gaining rust. So, a couple of months ago, Elder, with Wade's blessing (and some of his money), had the car towed over to Ashley Salvage Co. and compressed into a hay-bale sized cube.

"I called up Bob and told him it had transcended being art and had turned into a junk car," Elder said. "I told him I wanted to compress it, and he thought that was a neat idea. He even sent $50 to help pay for the towing."

The cubed car was returned to the Blue Star, but about two weeks ago, the cube was stolen. The Wade sculpture was missed during a party on April 14 that artist Rolando Briseño was giving for the local unveiling of his 14-by-20-foot painting "The Big Table."

"I had been showing some people the Mexican exhibit in the Blue Star," said Heather Edwards, who gallery-sits at the Blue Star Art Space, "and we had been talking about the sculpture. When we walked out to look at it, that's when I first noticed it was gone."

A friend of Briseño later said he had seen two men in a red tow truck taking the crunched car away. He thought it was just junk dealers hauling off an eyesore, so he didn't make much of the incident.

"That's funny," Edwards said. "Because I was in the gallery one day about a week and a half before that, and two men in a green truck

were messing around out there. So I went out and politely asked what they were doing and they said, 'We're getting this thing off your hands, lady.' And I said, 'Oh, no, you can't do that. It's a piece of sculpture.' They looked at me like I was crazy, but they left."

It is not the first time a Wade sculpture has been vandalized or stolen.

"In 1977 for the Paris Bienalle I did the 'Texas Mobile Home Museum,' which was one of those big Airstream-looking silver mobile home things stuffed with Texana," Wade said. "I had a two-headed calf in there, some chrome-plated barbed wire, some longhorn horns, a stuffed armadillo — all kinds of stuff.

"It turned up missing — some European gypsies had taken it — and nobody knew where it was for about four or five years. Finally, some little ol' man ended up with it, but he couldn't get a clear title or something, so he tracked me down, and I bought it back. Everything was taken out, except for the armadillo. The thing's in storage right now outside Paris."

Would he buy the cubed '75 Fairlane back if it is ever found?

"Yeah, I would. Now I don't know how much I'd pay for it."

The day the sculpture was stolen from the Blue Star, Elder and Edwards called the police, who came out and investigated, but didn't offer much hope of getting the car back.

They also called Ashley Salvage and Newell Salvage that day. Both salvage companies said yes, two guys had come by with a compressed car trying to sell it, but they had a policy not to buy already-compressed cars.

As it stands now, the car is still an auto theft statistic.

Although he'd like the car returned — and would even pay to get it back — Wade isn't heartbroken or anything like that. He takes a 'Well, that's art' attitude toward his missing sculpture.

"They wanted found-object sculpture from me for that symposium, so I guess it's gone from found object to lost object or stolen object," Wade said.

"In a way, artistically, it's gone one step further. I guess it's in its next stage now. I'm just curious about where the thing is now, you know? And where is my two-headed calf?"

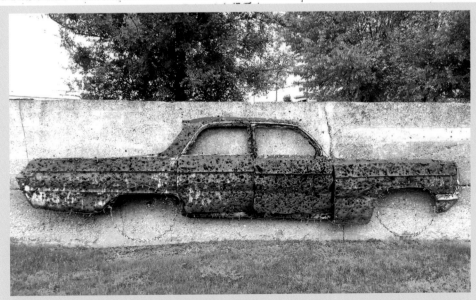

Another Use of Steel, 1987. Machine-gunned 1975 Ford Fairlane. Temporary installation— San Antonio Museum of Art, San Antonio, Texas. 16'6" × 6'2". Photograph by Will Larson.

LAGUNA PUTT-PUTT

Evan Voyles

My relationship with Bob Wade has roots in the past, going back to the seventies in New York and the eighties and early nineties in New Mexico, but we did not begin to conspire and collaborate until 1999, on the Ranch 616 project in Austin.

This is not that project, yet it has even deeper roots. Bob had a vision for a whimsical "chicken ranch"–themed miniature golf course art installation at the Laguna Gloria museum in Austin, where a good chunk of my youth was misspent. I do not mean to imply that I was smoking and drinking on the grounds; rather, I was taking art classes and attending exhibits and festivals.

This project was part of an outdoor group show in the 2000s, and the museum staff had solicited Bob's participation. And Bob, having misspent *his* youth in Waco and Austin, was aware of the giant neon chicken signs that advertised the Chicken Shack restaurants in those cities, from the 1940s on. And Bob was *further* aware that I owned one of these signs. Moreover, Bob was doubtlessly aware that many people would compare his chicken vision to the famous Chicken Ranch brothel (aka "The Best Little Whorehouse in Texas") in La Grange, another Central Texas town. I cannot confirm whether Bob ever misspent his youth or earnings *there*, but the possibility is compelling!

I also cannot confirm that Bob was not involved in smoking and drinking on the grounds of any of these illustrious venues.

Bob showed me his sketches for the project, including the live-chickens-in-a-chicken-wire-coop handicap, and showed me where he wanted me to stick my chicken. Of course I immediately agreed to help, and so in short order I loaded the giant steel chicken into my old pickup, delivered it to the art museum, and the rest, as they say, is history.

Bob and I share a belief that the large three-dimensional sculptural aspects of American signage of the early to mid twentieth century—especially when brightly painted with enamel and vividly lit with neon—push said signage beyond the precipice of advertising and into the wild frontier of fantastical art. Or at least folk art. The goal of such pieces is not just to persuade the viewer to make a purchase; the goal is to amaze, delight, and challenge the mind . . . as well as the soul. Such a belief was radical in the 1970s, when I was comparing Las Vegas pylon signs to the Parthenon in art history classes in New Haven while Bob was just down the road in New York City putting a forty-foot-long polyurethane and steel "stuffed" iguana on the roof of a new nightclub called the Lone Star Café. Is it a sign? Is it art? Does it matter, if you like it?!!! Homesick for Texas and humor, I spent a few nights (and a few beers) star-

Bob Wade with Chicken Ranch, 2012. Mini golf course hole, bricks, artificial turf, carved foam rooster, retro metal rooster sign, plastic pipe, portable chicken coop, wood, live chickens. 33' × 64' × 67'. Temporary installation at Austin Museum of Art, Laguna Gloria, Austin, Texas.

Texas Formal Garden, 1975. Mansard roof gazebo with skulls, concrete swordfish spouting water, crushed gravel, chicken feeders, live chickens, cactus, metal strips, chicken wire, nighttime spotlights. 8' × 60'. Temporary installation at Laguna Gloria (The Contemporary Austin), Austin, Texas.

ing up at that iguana and asking those questions. And subsequently, as an artist, a collector of vintage signs, and finally as a sign maker myself these past three decades, I have tried to continue to both pose and answer those very questions.

And Bob is both high priest and court jester of this belief system!

Bob has always embraced the larger-than-life

wacky colorful daring of the Texas psyche, and I have long thought that we should build a forty-foot-tall urethane and steel "stuffed" likeness of Bob, to mount on a roof somewhere in Texas. If we did, I can guarantee that Bob will jump on Large Stuffed Bob's back and ride him like a buckaroo.

One could argue that Bob has been riding a larger-than-life version of himself since the seventies!

<div style="text-align:right">Kathie Richardson</div>

Texas High-Rent White Trash Art

by Carlene Brady

Robert Wade was trying real hard to put his Texas Formal Garden together before the opening night deadline out at Laguna Gloria Art Museum. It was hot; an ice chest full of beer sweated in the back of his station wagon and two large dogs rambled and snorted around the bags of gravel, bleached-out longhorn skulls and other assorted tools of Robert Wade's unusual trade.

Next to the shrubbery, a radio blasted an accompaniment of rock and roll, its cord snaking back to the main building. As I was talking to Wade about his artistic concepts for the area, a news bulletin announced that a "demented Dutchman" had just put 13 slashes into Rembrandt's famous Nightwatch painting in an Amsterdam museum.

"This is really going to be a high-rent piece," Wade laughed. "Attention to detail, stuff like that. This piece also has Mexican, white trash and whatever else mentality you wanna call it. Just nail it together and don't worry about it. When ya fuck up, just cover it with something."

Wade was standing on a wobbly ladder, nailing shingles onto a central structure, which was not looking particularly well-structured at that point.

"A guy came earlier and said, 'How come you guys slanted it to the left?'" he mused. "Well, I said, we just kind of eyeballed it but really, we're reflecting contemporary building techniques." (Laughter.)

"I've always had this real funny thing about the Mansard roof," Wade went on. "This is architecturally called a 'Mansard' roof," he said, pointing to the structure, "which is a good example of an importation of European culture—which Texans have as one of their problems. A French roof—all 7-11's, Pizza Huts, apartment buildings, and almost all those kinds of places, all have this steep French roof...with these funny shingles. That in itself is like a false culture kitsch thing, like this fish (a large tacky ceramic fish, destined to be the spotlit focus of attention), or those little Venus de Milos shootin' water, all of that stuff.

"I talk about these things a lot," Wade said, "and this is the first chance I've had to do something with a Mansard roof. This is the real thing, y'know. A lot of people won't think this is art. They'll probably think the museum hired a couple of hippies to come out here and beef up this old garden."

Robert Wade, I guess you could say, is Texas' most famous contemporary artist. He's anyway the most visible: his work is in all the major shows in Texas, and he's recently returned from New York, where his new exhibit there of Texas-Believe-It-Or-Not-style wonders (two-headed calf, cattle prods, etc.) is currently tickling the fancies of a hard-core art scene inured to either conceptualist video pedanticism or the usual New York-style Real Painting.

Wade isn't a sculptor or painter as such. He's a grown man who is having fun making things; more to the point, playing around—with sacrosanct macho Texas imagery, heroic folklore and various aspects of the Compleat Urbanized Yokel. His work upsets a lot of people who don't see it as Art; his attitude of mild anarchy is refreshingly devoid of philosophical profundity.

I suspect Wade is secretly sentimental about the images he evokes; he seems genuinely fond of the cross-cultural domestic claptrap and mythic symbols that Texans

> "A lot of people won't think this is art," said Robert Wade. "They'll probably think the museum hired a couple of hippies to come out here and beef up this old garden."

he went on, "make up a story about the fish, kind of like a shrine. This is also like the way the Mexicans do their thing; they put Jesus and Mary in those little shrines.

"I'll have a speaker inside there," he elaborated, pointing to the Mansard structure, "which will be jacked into a radio, pumpin' out a little Ray Price or somethin' (this never materialized), then we got white gravel—just pour out a star. It's gonna be a night piece, heavy-duty night, spotlights on the fish, then on each corner of the star. I was gonna do black light, if I could get it."

(One of Robert Wade's fortes is a knack for scavenging all sorts of strange materials and objects needed to sustain and complete his ideas. A lot of his more ambitious work takes a good deal of on-the-spot labor, and he wanted me to make sure and give credit to Gene Binder, assistant curator at Laguna, for all his help in the construction of the Garden piece.)

"I bought the skulls and the fish earlier, but everything else we got around here," he said. "I like going to a place and finding just everything if I can get it."

He wanted to populate the garden with animals of some sort.

"I spoke to the feed store. Ducks are about the only things...pea hens, they'll go over the fence. Chickens maybe, if you clip their wings. Rabbits would stay, but they're so...I really like the idea of turkeys. There're some beautiful guineas down on Lamar—black, with little white spots. But they'll fly over."

Wade settled for chickens, and on the opening night there were indeed four little feed trays at the base of the centerpiece—but where were the unwitting participants in culture? Nastily enough, some unspeakable

Robert Wade about to connect with a chalupa—the Artist as Cultural Catalyst

<div style="text-align:right">J.R. Compton</div>

salute as their bid for chauvinistic identity.

He had a lot of ideas for his *Garden* piece: "I figure it like this: the whole thing about Indian painting, sand painting—it's like a garden theory. Texas people especially have these cactus gardens going on, right? So this is kind of an outgrowth of that.

"We're gonna put a sign out here,"

creature from the lake had forced the demise of all but one (which had apparently escaped to safer nesting grounds), and nothing was left but a few feathers.

* * * * *

The first Robert Wade piece I ever saw was a photograph of an installa- *cont. on page 15*

Wade
cont. from page 13

tion in a Houston gallery of his *Map of Texas*—a real map on the floor, made out of real dirt, which took up the whole space. It had the obligatory geographical ups and downs, and included little representations of local flora and fauna: a longhorn skull here, a clump of bluebonnets there.

"Hmph," I thought, being relatively uninitiated into the glories of being in the second largest state in the nation.

Wade's name kept popping up in articles and conversations, so I figured this guy must have something going for him. I finally came face-to-face with a genuine Wade at the Fort Worth Art Museum in July.

"*Cow Town*" was the title of a large environment which consisted, among other things, of a stuffed horse, a stuffed cow (the real thing, actual sizes), a fenced-in corral of sorts containing salt blocks, coils of barbed wire, boxes of brand-new cowboy boots and hats, and rope; all carefully arranged on a sawdust- and hay-covered floor discreetly sprinkled with glitter—overlooked by a 24-foot-long tinted photograph of a cattle round-up. All this was droningly punctuated by a taped Moosak of bovine musings.

"My goodness," I thought, craning my nose (in dread) for the expected associated aroma, which fortunately had been excluded from this show-stopping set-piece.

It took me awhile to perceive the the words "Cow Town" were in fact spelled out with the various objects—a certain alignment of barbed wire coils, a delineation of boot boxes—which you could more clearly detect from a specially built observation ramp.

"How clever!" I then decided. The historic connection of the work (a comment on the host city) evaded me at the time.

Robert Wade lives in Denton, where he teaches at North Texas State when he is not pursuing his various projects elsewhere. He lives in an ordinary, comfortably furnished (except for two formidably-associative dentist's chairs in the living room) small-town bungalow in a quiet part of town with his wife Susie, who *cont. on page 23*

cont. from page 14

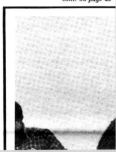

to the memory of that unparalled patron of the arts, Miss Ima Hogg. Miss Ima knew and encouraged James Dick, and attended many of his performances. Once, in an informal concert, he played a Bach Prelude without its accompanying Fugue. As he raised his hands to continue with a different piece, Miss Ima shouted from the front row, "Where's the Fugue, Jimmy; where's the Fugue?" Her spirit having been invoked Friday night, I'm surprised we didn't hear a voice at the close of the program hollering "Where's the Concerto?"

Robert Wade
cont. from page 15

is very nice and serves lots of cherry Kool-Aid to their guests.

The back study is full of assorted books, pictures, postcards and paint-sets—all serving as referential fodder for Wade's not so off-the-wall ideas for art and Kitsch-en sink conundrums.

An amiable and funny man, Wade is quick to show-and-tell about his favorite crazy postcard depicting the Hawaiian Showgirls from some Texas resort hotel, or to inform one about a great little set of colors especially designed for tinting photographs. He does a lot of photographic work, along with or separate from the "environmental" constructions he is particularly known for, either using blown-up images from his collection or pictures he takes himself.

Located several miles from Denton in a strange, sort of spookily empty part of the countryside, Robert Wade's studio is something else. There is nothing to be seen for miles

In his giant underground darkroom, Wade adjusts his custom-made enlarger.

<div style="text-align:right">J.R. Compton</div>

> Wade has developed a fantasy situation whereby he can enlarge his photographs up to 24 feet long.

except a few spindly structures and some black plastic flapping in the breeze. A door in a block of concrete pavement opens upward to reveal a long flight of steps downward into what used to be an underground missile silo. Wade works here, in an enormous space kept fresh by a huge

clunky air conditioner fan.

A long narrow metal section in the center, which used to be the platform on which the missiles stood waiting to be slowly uplifted to the surface and

then rocketed to kingdom come, now serves as a rather tricky sort of freight elevator.

It is here that Wade has developed a fantasy situation whereby he can enlarge his photographs up to 24 feet long. A special enlarger he had made for him stands a good 60 feet from the

emulsified canvas he developed to enable the production of one-shot photographic images. It's like being in a giant darkroom. "Only in Texas," I think to myself.

Of course, the developing trays have to be 24 feet long also, and Wade is trying to devise a system of getting the chemicals sloshing around all at once without having to enlist half a dozen students to heave-ho, lifting first one side of the enormous trays at once, and then the other.

* * * * *

What is Robert Wade's next project going to be?

"Well," he said, furrowing his brow a bit, "what I really want to do this winter is to get my U.S. map thing under way. I've got to get permission to use the land, but I think it'll work out okay."

It turns out that what Wade has in mind is to construct a map of the whole United States (much like his *Map of Texas*, only bigger and better) somewhere along the Ft. Worth-Dallas Expressway, beneath the flight path between those cities.

"What with Six Flags, the House of Wax and all those other tourist attractions I don't see why my map couldn't be a real family tourist attraction," Wade said, grinning. "Just think, some kid could go onto a lookout and say, 'Hey, Ma, I can see California!'"

Caught up in the whole idea, I enthused: "Why not try and re-create a whole *life-size* replica of the United States?"

He thought that one over a second, and then laughed.

TEXAS STAR

Peter Gershon

It's 1974. A spike in oil prices results in a national energy crisis that proves to be a boon for Houston as petrodollars flow into the city, and Houston is poised to overtake Detroit as the country's fifth most populous metropolitan area. Maverick museum director James Harithas has been lured away from the Everson in Syracuse to lead the Contemporary Arts Museum Houston, floundering less than two years after the construction of an ultramodern steel-skinned parallelogram-shaped building containing over 8,000 feet of uninterrupted exhibition space. Bored with the New York art scene, Harithas goes full Texan and puts thousands of miles on his truck's odometer as he seeks the best artwork the Lone Star State has to offer. In El Paso, he finds Bob Wade, who after completing an installation piece at the university there joins Harithas and his intrepid curator Mark Lombardi for a night of hard drinking in Juárez, to discuss Wade's inclusion in a big group show.

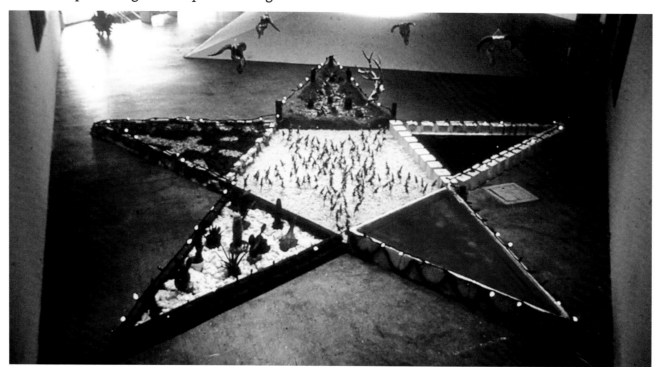

Texas Star, 1974. Cactus, cotton, water, goldfish, chili peppers, Fritos, plastic bluebonnets, crushed pillow foam, salt licks, wood, hay bales, stuffed critters. Outlined in lights with hanging skulls above. 16' custom viewing platform. 40' × 40' × 18'. Temporary installation at the Contemporary Arts Museum, Houston, Texas.

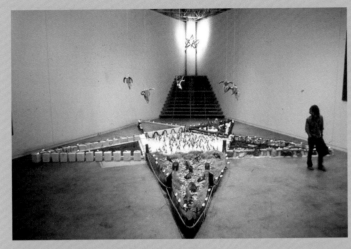

Texas Star in Oklahoma, 1974. Hats, rope, plastic blue-bonnets, skulls, dirt, crushed pillow foam, lights. 14' × 25'. Temporary installation, Contemporary Arts Foundation, Oklahoma City, Oklahoma.

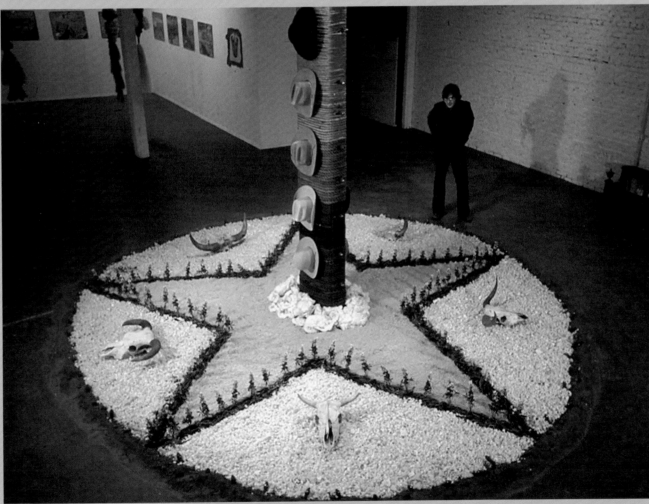

Detail of Texas Star, 1974.

Come fall, Wade is designing an installation for Harithas's first show at the CAM, 12/Texas, a survey of contemporary works that challenge presumptions of provincialism. He's in good company alongside art by James Surls, Michael Tracy, Dorothy Hood, and Luis Jiménez. Daddy-O's contribution is an enormous Lone Star decorated with materials that represented the state's variegated terrain: salt licks surrounding a pool of oil for the Gulf Coast; cotton and cacti for the Valley; stuffed armadillos and reptiles from Wade's favorite taxidermy shop for the Panhandle; plastic bluebonnets for the highway corridors; and a pachuco cross made from Fritos and chili peppers for the West Texas border. Wade suspends cow skulls over each of the five points and surrounds the whole thing with a border of blinking blue Christmas lights to magnify the effect. Harithas adds a stepped plat-form in the corner of the room so the diorama can be viewed optimally from above. At over thirty-five feet in diameter, it practically defines the show's visual identity.

The writer of a review in the Rice student newspaper observes that guests "wandered amazed and uncertain" among the works, but that "ultimately, interest and enthusiasm for contemporary developments in Texas art overrode the initial bewilderment." Speaking to writer Charlotte Moser shortly after the opening, Harithas characterizes the CAM as "the poorest and most ambitious museum in the state," then shows his bravado by declaring, "I'm not competing with what's happening throughout the country. The rest of the country is competing with me."

PROGRESSIVE CW ART

Jason Mellard

The year 1973 witnessed an aural explosion out of Texas, albums dropping like manna from honky-tonk heaven: Asleep at the Wheel's *Comin' Right at Ya*, Kinky Friedman's *Sold American*, Waylon Jennings's *Honky Tonk Heroes*, Michael Murphey's *Cosmic Cowboy Souvenir*, Willie Nelson's *Shotgun Willie*, Doug Sahm's *Doug Sahm and Band*, Billy Joe Shaver's *Old Five and Dimers Like Me*, B. W. Stevenson's *My Maria*, and Jerry Jeff Walker's *¡Viva Terlingua!*, for starters. The musicians didn't label what they were up to, but others did. In a classic *Texas Monthly* article that year, Jan Reid offered *redneck hip*, rendered *redneck rock* in his 1974 book. Michael Murphey didn't take kindly to the term, but neither did he cotton to efforts to have his "cosmic cowboy" moniker define the new style. Meanwhile, at Austin's KOKE-FM, a group of deejays, programmers, and scene leaders forged a new radio format that conveyed the music's roots in regional tradition as well as its countercultural openness to what the future might bring. They called it "progressive country."

With the music ringing in his ears, Daddy-O took those words as the title for his contribution to Exchange: SFO/DFW at the San Francisco Museum of Modern Art in 1976. Apparently, it was one of those many moments in our history when it had become imperative for Texans to explain themselves to the outside world, as this San Francisco–DFW cultural exchange launched the same year as Wade's entry in the TEX/LAX exhibition down the road at California State University–Los Angeles. If Daddy-O's crowning achievement in TEX/LAX was cantilevering a taxidermized bronco christened Funeral Wagon to the wall of the Union Square gallery in San Francisco, Daddy-O showed even more ambition by re-creating a Texas honky-tonk in the middle of a modern art museum. Wade claimed a room with tall, austere white walls, dropped the ceiling, and sprinkled it with glitter to give a sense of claustrophobic DIY construction. To darken the room, he paneled the walls with weathered, wormholed wood on loan from ceramicist Peter Voulkos. Then, to get just the right uncanny ambiance, he installed tubes of fluorescent light behind boards running the length of the room and lined the lighting fixtures with rows of plastic bluebonnets. For the altar in this honky-tonk church, Wade placed a classic Seeburg jukebox against one wall, a sonic portal to Texas stocked with 130 of the biggest country-western hits of the day. Wade thus transformed the rarefied airs of the museum into a den of rough and rowdy sociality, high culture's bête noire.

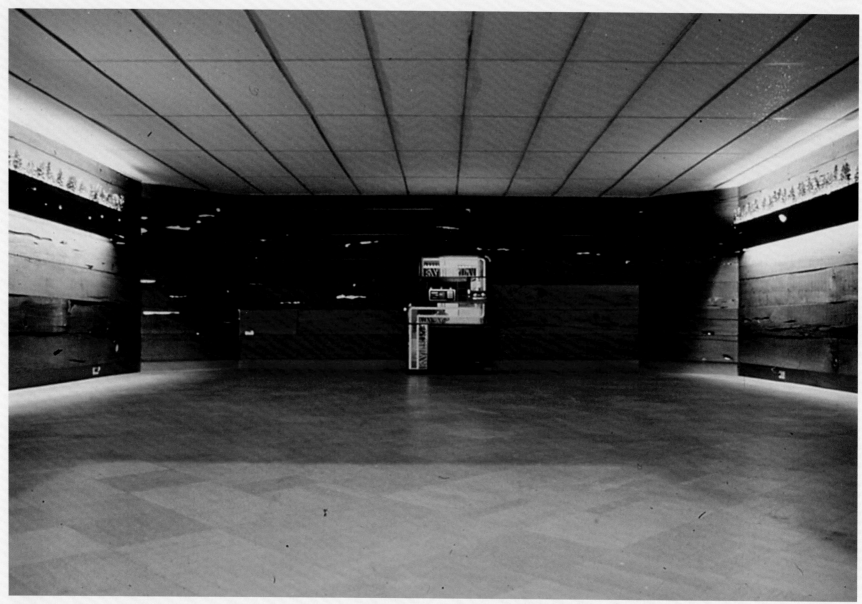

Progressive Country-Western Art, 1976. Simulated Texas beer joint with free jukebox playing 160 top country songs. Lowered ceiling with glitter, rough wood paneling, indirect lighting with plastic bluebonnets. 7' × 28' × 23'. Temporary installation at the San Francisco Museum of Modern Art, San Francisco, California.

CELEBRATING THE TEXAS BEER JOINT

Roy Bragg

J.Frank Dobie told the story of Texas via his writing. Cave-dwelling Indian tribes told the story of Texas via crude paintings.

Bob "Daddy-O" Wade tells the story of Texas through bigger and weirder than life art: the gigantic cowboy boots at North Star Mall; dancing frogs at Carl's Corner, near Waco; car doors pockmarked by buckshot; enormous iguanas; and in his newest work, aluminum foil, chicken wire, and a Wurlitzer jukebox.

Wired for Sound, an homage to the classic Texas beer joint, opened in the Annetta Kraushaar Gallery at Texas Lutheran University in Seguin.

The room's decor mimics that of Lilly's Bar in nearby Lockhart: Christmas lights crisscrossing from the ceilings; a mismatched table and chairs in a nook; and a back wall wrapped in aluminum foil.

"I asked Lilly why she did that," Wade said before the opening. "She said [her bar] had a rusty-looking back wall, so it was the logical thing to do."

Framed pieces surround the table and chairs, including a candid shot of Hank Williams Sr. and his wife Billie Jean taken in a Waco nightclub, and Our Lady of Guadalupe.

The centerpiece is the jukebox, culled from the esoteric junk collection of late Jeffrey Morehouse, a San Antonio attorney and art patron. It's on a stage, surrounded by chicken wire.

The exhibit's premise is simple—students walking through the gallery to class will be immersed in the ambiance of a vintage honky-tonk.

"They interact with the space," he said, "and they become part of the piece."

Some of Wade's other works are displayed in an adjacent gallery, including *Critter Wall,* a photo of a baby pig standing on top of a skunk, which is on top of an armadillo, which is on top of a coyote. All were stuffed.

The jukebox works, but the eight-hour musical loop is digital, fed through the overhead sound system from an iPod.

Wired for Sound is a continuation of his 1976 Progressive Country-Western Art exhibit at the San Francisco Museum of Modern Art, in which he put in a new floor and new walls and created an *Urban Cowboy* era dance hall.

"All of this is a reflection of Texas culture," says Wade, and, he adds, a chance to preserve it.

Texas is an urban state, and rural quirks are disappearing.

"The world is changing," he says. "It's going in another direction. You can argue about it, or you can do what I'm doing," he said, motioning around the room. "Which is stuff like this."

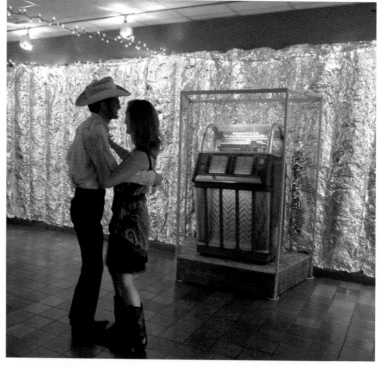

Wired for Sound, 2011. 1950s Wurlitzer jukebox, wood, chicken wire, tinfoil, Christmas lights, colored spotlights, four hours of Western and conjunto music sent through gallery speakers. 7' × 30'. Temporary installation in the Annetta Kraushaar Gallery, Schuech Fine Arts Center, Texas Lutheran University, Seguin, Texas. Photo: Kyle Olsen.

COWBOY BAND

Eric O'Keefe

The Daddy-O and I have a give-and-take arrangement. More often than not, Bob is in charge of the giving, and I work the take angle. Like the time Bob introduced me to America's greatest stockbroker, Monk White. Next thing you know yours truly is sipping a cold one in a chauffeur-driven Hummer limousine barreling down I-35 to Carl's Corner to go hang out with Carl and his pal Willie Nelson in between sets.

I had no problem with this arrangement—and neither did Bob. That's because the Daddy-O has always been big on karma. He's a Zen master who truly believes that good things happen to good people, and that's exactly what took place when I introduced him to Kevin Williamson.

Bob and Kevin hit it off like Butch and Sundance. To this day, I still cannot fathom why these two larger-than-life Austin natives had never met, be it

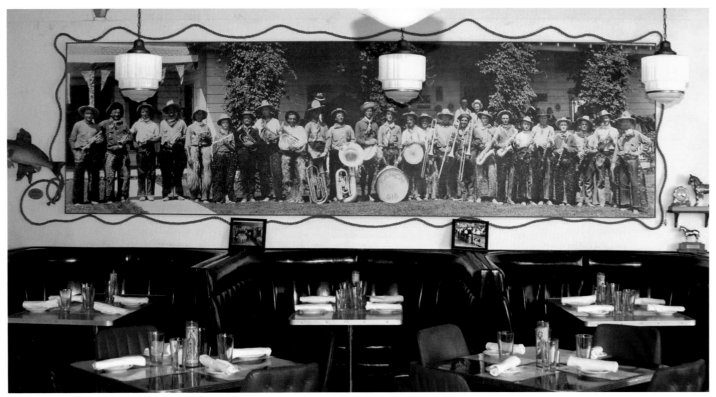

Cowboy Band, 1999. Digital enlargement from original hand-colored photo canvas. Commissioned by Ranch 616 restaurant. Austin, Texas. 4' × 16'. Photo: Preston Nagel.

on the patio at Guero's or backstage at Austin City Limits or down at Shoal Creek Saloon. Clearly, their introduction was my calling.

It was early 1998, and Kevin was in the throes of creating his South Texas icehouse, Ranch 616. The guy had a trigger finger. The briefest mention would provoke elaborate descriptions of his latest quest on South Congress as he sought out vintage vinyl and jackalope scat. Get this: Bob suffers from precisely the same malady. A rendezvous at Ranch was immediately arranged.

To label the empty shell at the corner of West 7th and Nueces humble would be kind. The most recent tenant had been the last stand of BB's Tacos. Prior to that it had been a strip joint. Kevin quickly cut to the chase. "The first thing you'll see when you walk in the front door is a cold box full of iced beer," he told us.

"Say no more," Bob proclaimed.

"Then you'll head way straight to the poured concrete bar," Kevin said.

"Where I'll be sitting," Bob interjected.

There would be ample room for Kevin's bowling trophies, a perch for his striking rattlesnake, a profusion of border tchotchkes, and a place of honor for the portrait of Jackie Williamson, Kevin's mother.

Then Kevin pointed to a cold barren stretch of cinder blocks. "And against that wall will be a long row of Naugahyde booths."

The Daddy-O began to tremble.

"And it will require a big-ass piece of art."

Tears of joy glistened in Dad's eyes.

"Bob, you got any bright ideas?"

Turns out Bob had just one idea: *Cowboy Band*, a sixteen-foot-long hand-tinted marvel that features a couple dozen ranch hands gussied up in their woollies and armed with an intimidating array of musical instruments. By the time Bob was finished with those hombres, they were runway models, accessorized in shades of ocher and aubergine and magenta.

Kevin's South Texas icehouse has since become an Austin landmark, and *Cowboy Band* the first of several commissions the Daddy-O completed for our good friend. Whenever I stop by Ranch 616, be it with or without those two boys, I can hear them roaring with laughter as the Daddy-O regales the faithful with reminiscences about the Kinkster, the Whitney, or that time at the Pink Adobe.

RANCH 616

Kevin Williamson

It seemed just like yesterday that I was standing with Bob in the middle of a gutted Mexican breakfast joint that I had just leased. It was empty except for a boom box blaring in the corner, a rented margarita machine and cups atop plywood on sawhorses, a couple of chairs, and the neon serving bowls "tail" section that Evan Voyles had just finished for the hundred-foot-long snake Daddy-O had designed for outside.

Arty people were pouring into an after-party I was throwing for Bob's gallery show, earlier in the evening, and it was surreal.

I had known about Daddy-O around 1980 while I attended SMU in Dallas, where everyone was oil and real estate rich and Bob had returned from New York's Lone Star Café after his giant iguana success. I also knew about Shannon Wynne and his restaurant/bars, and I felt a kinship with the whole enterprise; Shannon's cool concepts and Daddy-O's art magic, with clever playfulness that literally made establishments famous.

I have had a career in real estate, have been a gallery owner, and have done securities trading, working in towns like La Jolla, California, New York City, and Aspen, Colorado.

After some exceptional experiences in the restaurant business from opening Ajax Tavern in Aspen, Colorado, to being on the creative team that opened several Central Market grocery stores across Texas, I secured my own real estate in Austin in 1989 to open my dream restaurant and bar called Ranch 616.

The concept was a South Texas icehouse with visuals of hunting and fishing and focusing on the border towns of Texas and Mexico. Damn, I was excited!

I knew one thing for certain, I couldn't do this without the magic of Bob "Daddy-O" Wade.

Only one major problem! I didn't know him. He had moved to Austin from Santa Fe, and I wasn't opposed to stalking him for my opportunity. It was that important for me to pitch my concept and my restaurant to Daddy-O, and I had confidence I'd figure it out.

I had secured a funky location in downtown Austin on the corner of West 7th and Nueces. It was the former BB's Tacos. BB had a reputation for being tough and vocal. He even had several drag queens that were waitresses at this Austin original. BB's was a favorite of Governor Ann Richards, and the restaurant was close to the capitol, the governor's mansion, and our courthouse, so it attracted lawyers and lobbyists alike.

My goal with the South Texas icehouse was to celebrate Texas beef, Texas quail, venison, cold beer, and margaritas, so if Daddy-O would put his stamp

Ranch 616, 2015. Coated metal, motorcycle tank, stainless steel mixing bowls, lighted eyes, neon. 100' × variable dimension. Ranch 616 Restaurant, Austin, Texas. Fabricated by Evan Voyles.

on the business, it would cement my dreams of success!

I had met Bob briefly with Eric O'Keefe, but my real opportunity to meet the Daddy-O came at an opening night fundraiser for the Austin Museum of Art being held at the Covert Buick car dealership on West 5th and Nueces, just two blocks from the proposed Ranch 616.

There was still daylight when I arrived at 6:30 p.m. I saw Bob from across the room, and I strolled over and asked if he would please talk to me for a minute so I could pitch a dream to him.

Bob not only listened to me but paid me amazing respect and listened to my pitch. We followed up the next day with a meeting on site, and the rest is my story of success, friendship, and fun.

Designer Leslie Fossler and I went through Bob's stuff at his studio. He pulled out a long panoramic old photo that was in perfect scale, which became the amazing sixteen-foot hand-tinted photo canvas of a 1920s Montana cowboy band. It commands the entire dining room of Ranch 616.

Then came an exceptional hundred-foot rattlesnake, which spells *Ranch 616*, featuring the head of a rattlesnake with a neon tongue that moves and strikes, along with a ten-foot rattler's tail made of mixing bowls from the kitchen. This neon rattler also moves like a realistic rattler tail shakes before the snake strikes. Bob designed the snake and Evan Voyles fabricated it. Recently the snake has been outlined in neon and the patio became the Pistol Patio, which captivates guests' imaginations and blows their minds as they enjoy this truly Texas iconic restaurant. It seems just like yesterday that my dream came true. Thanks, Bob, for a great twenty-year ride!

By the way, they never came to pick up the rented margarita machine. We still use it at the main bar!

COWTOWN

Marc English

Wade's art works harder than a rented mule. His 1975 Cowtown piece exhibits what at first glance seems obvious, but a second look shows the man is deeper than a shallow pond. If words give shape to ideas, then letter forms give shape to words, and behind each of these letter forms, Wade covers Fort Worth historically, geographically, and economically. Consider the list of components for each letter: salt licks surrounding a stuffed calf ready for roping, cotton outlined with bluebonnets, stock

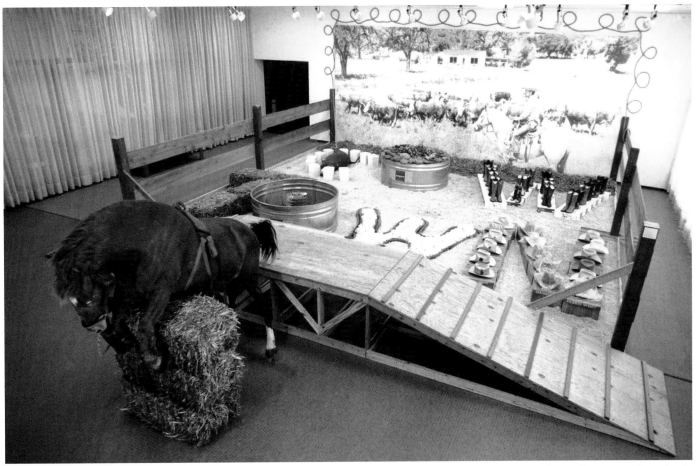

Cowtown, 1975. Stuffed horse, hay bales, viewing ramp, hand-colored mural, wood fence, salt licks, stuffed calf, cow patties, plastic bluebonnets, galvanized feeders, barbed wire, breeder cubes, sawdust with glitter, rope, cotton, boots, hats, steer sounds on audio loop. 11' × 30' × 45'. Temporary installation at the Fort Worth Museum of Art, Fort Worth, Texas.

Detail from Cowtown. Collection of the artist.

tanks with either barbed wire or cow pies topped with bluebonnets, hay bales, cowboy hats and boots. Wade evokes man, myth, critter, and landscape. Yet the letter forms are only the crux of the piece.

Approach Cowtown to the sound of stockyard cattle lowing, walk up the ramp to observe what's in the pen, and find that no detail has been missed: sawdust fills the gaps between letters. And not just any sawdust, but shavings from Fort Worth's legendary Angelo's BBQ (since 1958!—though today sawdust in the joint violates restaurant health codes). And not just sawdust, but sawdust littered with glitter, the better to add a sublime detail that, in that "white space" between letter forms, the real heart of

Fort Worth reveals itself in hardworking wood stuff and ephemeral glitter.

This is to say nothing (or at least this sentence) about the stuffed bronco, the wild mustang that so defined Texas, that found its way from the next-door Fort Worth Museum of Science and History to be part of this piece, then discovered itself on the road to the Paris Biennale two years later as part of Wade's Texas Mobile Home Museum, stuffed upside down into a vintage silver Spartan trailer coach, only then to be snatched away with its trailer home, the Fort Worth, Texas mesteño finding new life, spirited away by the Roma of France. But that story is for another day.

DEEP IN THE ART

Robert Faires

Picture yourself in the cab of a pickup, windows rolled down on account of the air conditioner being stone broke; glove box overflowing with maps, receipts, and eight-track tapes of Buck Owens and Lefty Frizzell; floor littered with Whataburger bags, empty packs of Camels, and crumpled cans of Pearl; a gun rack for a headrest; and a bluetick coonhound warmin' the seat between you and the driver, who's full of enough stories to last your whole trip from Beaumont to El Paso, even if that ride is a free-wheeling ramble as far north as Dalhart and as far south as McAllen, with stops at every honky-tonk and roadside curiosity along the way.

That's the feeling you get moseying through

Texas Sideshow, 1975. Boots, hats, photos, stuffed two-headed calf, horns, salt licks, pelts, bull dick cane, beer sign, deer hoof lamp, and various Texana. Displayed behind black plastic curtain. 16' × 24' × 12'. Temporary installation at 112 Greene Street, New York City.

Bob Wade's self-described "retrospectacle" at the South Austin Museum of Popular Culture. The work of the artist dubbed "Daddy-O" is so steeped in Texas culture and iconography—the old and the new, rural and urban, classy and cheesy—that 40 Years of Blood, Sweat, and Beers seems to encompass everything in the whole damn state. It isn't that the exhibit is so vast; Dallas has walk-in closets bigger than the entire exhibition space in this old South Lamar storefront, and even with most walls crammed floor to ceiling with material, the show is a pretty quick walk-through.

No, it's that everything included here just exudes Texas-osity, the way one oozes beery sweat after a three-night bender in Terlingua. The tinted antique photo of fresh-faced cowgirls waving their Stetsons

from a row of Harleys, the little taxidermized jackrabbit head with antelope horns coming out of his skull, the full-size fiberglass steer with a keg in place of his head and a bug zapper coming out of his ass, the Airstream trailer with the giant iguana head and a saddle on top, the eight-foot foam tornado festooned with trash, even the alligator made entirely of Altoids tins—all of it seems birthed from Texas dirt, pulled right out of the soil between the Red River and the Rio Grande. Bob Wade gets what the Lone Star State is all about—on a cellular level, it would appear—and has spent four decades not just making work about it but imbuing that work with a palpable sense of Texas's expansive, expressive, excessive, eccentric, irreverent, and rambunctious ways.

To judge from the year-by-year portrait of the

South Pop Retrospectacle, 2009. Objects and photo documentation of Wade's forty-year career. Temporary installation at the South Austin Museum of Popular Culture, Austin, Texas.

More from the South Pop Retrospectacle.

artist as a young man running along the upper wall of one room, Wade's absorption of Lone Star culture began at an early age. In the images of him from what look to be his fifth or sixth year, he appears in four different cowboy outfits, studiously decked out in little hats, bandannas, holsters, and toy guns. Though he sheds the Western wear as he progresses toward adolescence (the portraits extend to age thirty), his inner buckaroo must have continued riding the range of his native state, for once he returns from a brief self-imposed exile in California (something in him needed a master's in painting from Berkeley), Texas starts showing up in Wade's art in a big way. Literally. In the mid-seventies, he creates a series of large installations that bring together such archetypal objets d'Tejana as Stetsons, bluebonnets, barbed wire, oil derricks, cattle skulls, and cacti in sometimes mythic, sometimes satiric arrangements, typically around a large manifestation of that five-pointed Lone Star. These sculptural works are downright encyclopedic in their representation of things Texan, and it's a bit frustrating that here we're given only a few small photographs by which to admire them. They're so expansive, and they describe something so expansive, that you want to see them full-blown in three dimensions and walk through them.

But big as they were (most often 40 by 40 feet), these installations couldn't contain all of Texas as

Another view of the South Pop Retrospectacle.

"Daddy-O" understood it. So he sought out new forms with which to Texpress himself: the hand-tinted photographs, with subjects ranging from good ol' white boy hunters in gimme caps to Mexican revolutionaries in sombreros to those iconic cowgirls; the taxidermized animals, reimagined in fanciful ways (the aforementioned jackalope and Bug Lite) or compromising positions (an armadillo and an iguana making, as it were, the beast with two backs); the vehicles, from an anthropomorphized trailer with Kinky Friedman's signature Stetson, 'stache, and cigar to the bullet-riddled van dubbed the Bonnie and Clyde Mobile; and most attention-getting of all, the monumental sculptures—the twelve-foot-tall iguana that for years stood guard over the Lone Star Café in New York City, the eight-foot-tall frogs that sparked an art controversy in Dallas, the twenty-foot-tall cartoon dog made out of a 1966 Plymouth and other assorted car parts, forty-foot-tall cowboy boots, a seventy-foot saxophone. The various kinds of work allowed Wade a way to more fully tease out his notions about the state's history and myths; its geography and customs; its tastes in fashion, food, and music; and its attitudes toward that Holy Trinity of Guns, Cars, and Beer.

The biggest works are among his best-known, and considered in the context of all his work, it's easy to see why: They capture the spirit of Texas's sense of scale, that "everything's bigger in Texas" mantra typically uttered in these parts with a shit-eating grin. We love the bigness of the place itself, and we love the idea of people accomplishing big things in it. Like Pecos Bill, riding a twister and lassoing the Rio Grande to water his ranch and shooting all the stars from the sky except one, Bob "Daddy-O" Wade has been giving us those kinds of grand, mythic feats for forty years, one long, crazy Texas tall tale in fiberglass and steel, served up with a wink and a hearty "yee-haw."

DEEP-ROOTED CONNECTION

Edmond Ortiz

Artist Bob Wade is perhaps best known for the forty-foot-tall cowboy boots that welcome visitors to North Star Mall.

But the San Antonians who pose in front of the boots each December when they're lit up with white stars for the holidays may not know that Wade's cowboy roots run much deeper than his iconic statue. He's the second cousin of Roy Rogers.

The connection is one the owners of Down on Grayson had yet to discover when they called Wade in 2016 to help track down the perfect Western-themed image for their Pearl-area restaurant. Wade agreed to look but also suggested they do some searching on their own at UTSA's Institute of Texan Cultures.

Katie Courtney, who helped with the restaurant's design and is owner Pat Molak's daughter, did just that and found what she'd envisioned in an archive collection. It was a 1943 photo of Roy Rogers sitting atop his famed horse Trigger while surrounded by a crowd in front of the Empire Theatre. He was in town promoting his film *Idaho*.

Molak and Courtney called Wade to tell him what they'd found and asked him to enhance it for display at the restaurant. It took just one look at the image for Wade to realize when it was taken. Two days after that photo downtown, Rogers had traveled to Austin to meet his first cousin's son, Bob Wade, then an infant. "These guys had no idea about any of this," Wade says, with a laugh, adding that he happily agreed to work on the photo.

A longtime artist and art professor, Wade enlarged the historic print onto a digitized canvas where, once stretched to its current size of 67 by 84 inches, he was able to use airbrushing techniques to add transparent layers of acrylic color over its surface. The additions of muted tones (similar to those used in pre-Technicolor movies) add just enough detail to give the original picture new life without changing it. "I come from more of a painter's viewpoint," Wade explains.

Titled *Roy & Trigger—San Antone—'43*, the piece isn't the first work Wade created for use in the hospitality industry. He became interested in visual arts while his father was managing hotels across Texas, including in San Antonio. The entrance to the manager's suites weren't always welcoming, so Wade would help his dad add elaborate decorations. "I

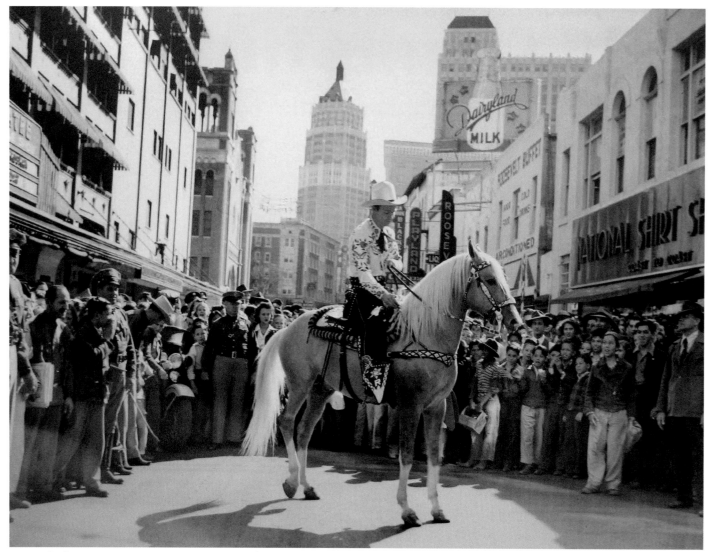

Roy and Trigger—San Antone—1943, 2016. Acrylic on digital canvas. 64" × 84". Commissioned by Down on Grayson restaurant, San Antonio, Texas.

drew and built things," he says. "I was always the kid who could draw better than anyone else in class."

His father's career meant he grew up all over the Lone Star State, which Wade says influenced his career and likely, his larger-than-life attitude toward projects. "They say everything is bigger in Texas,"

says Wade. "You're surrounded by that concept here."

His work for Down on Grayson is the embodiment of that tone. But it's also personal. "I was bringing something back to life," he says.

DADDY-O'S DOUBLE HITCH TO ROY ROGERS

Michael Barnes

In 2016, artist and showman Bob "Daddy-O" Wade unveiled a Roy Rogers piece made for Down on Grayson, an eatery in San Antonio. Wade used a still of Rogers on his palomino, Trigger, taken during a 1943 movie premiere in that city.

Lo and behold! Here's an itty-bitty Bob Wade posing with the celebrity.

While on the subject, he sent us some startling photos of his mother and aunt with the TV and movie cowboy. These images were taken in Austin two days after the premiere in San Antonio. "The house is on Bowman, across from the Tarrytown post office," Wade says. "The folks at Down on Grayson chose the photo for the commission piece, not knowing my relationship to Roy. My mother was his first cousin; their mothers were sisters. What a strange coincidence."

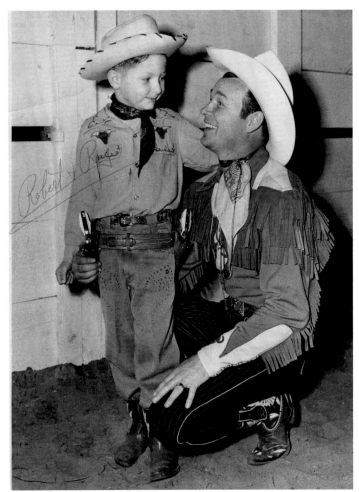

Little Bob with his cowboy hero cousin, Roy Rogers. Collection of the artist.

Roy Rogers with Bob's mother and aunt, who were Rogers's first cousins, Austin, 1943. Collection of the artist.

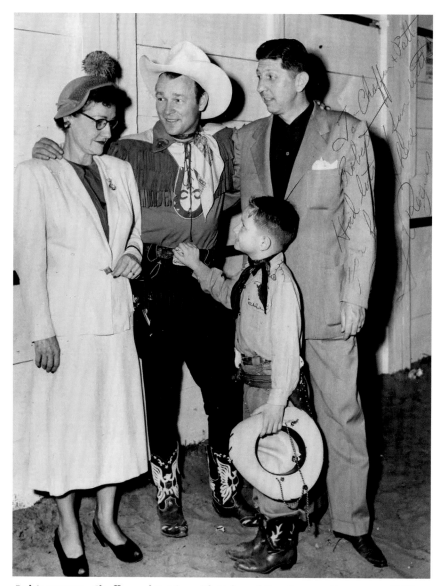

Bob's parents, Chaffin and Pattie, with Bob and Roy Rogers, Beaumont, 1950. Collection of the artist, as printed in *Daddy-O: Iguana Heads & Texas Tales*.

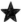

THE THIRTEEN COWGIRLS

Anne Rapp

I have lived with Daddy-O's *Thirteen Cowgirls* for over thirty years. My ex-husband bought them for me in the early eighties at a gallery in Santa Fe when we were working on a movie there. We were living in Los Angeles at the time, and the image hung on our wall until we split up. Since then the cowgirls have hung on probably thirty different walls. I've been a traveler and a nomad most of my life, just like the girls in the photo, and wherever I go, they go with me. I still find myself staring at them, trying to figure out their personalities—which ones I would've been friends with, which ones have the

Woody Harrelson goes one-on-one with Wesley Snipes in the 1992 movie *White Men Can't Jump*. His T-shirt features *Thirteen Cowgirls*.

Cynthia Nixon sporting a T-shirt with *Thirteen Cowgirls* on the front of it, during filming of the popular TV series *Sex in the City*.

best hair and boots, and which ones I wouldn't want to meet in an alley.

I think Bob helped a few of them out. He definitely made them intriguing enough to be carted around for thirty years. I have a friend named Steve whose granddaddy was a big rodeo cowboy in the 1920s, and he traveled all over the country bronc riding and roping. He won a lot of rodeos from Cheyenne, Wyoming, to Madison Square Garden. Steve once showed the old man this image, and he lit up and said he knew a bunch of these ladies. He called them by name. I wish I had been there. I could've confirmed which ones I wouldn't want to meet in an alley. I can imagine they were all pretty tough given their trade, regardless of whether they were steer ropers or more delicate trick riders.

Myself, I'm not worth a flip on a horse. But my granddaddy and my daddy raised cows all their lives, and my family still has a few here and there, so I guess I, too, in good faith can call myself a cowgirl.

Thirteen Cowgirls, 1979. Photo oil on photo linen. 20" × 49". Collection of Monk and Pam White, Dallas, Texas.

FREEDOM IN BEING WITH A LIKE-MINDED GROUP OF WOMEN

Diana Vela

As the only institution in the nation that specifically honors women of the American West, a significant proportion of the National Cowgirl Museum and Hall of Fame's holdings are on rodeo cowgirls. While we also highlight women in other related fields—ranchers, stewards, artists—it is the rodeo cowgirl who is most often associated with us. There is no better representation of those early rodeo women than Bob Wade's *Thirteen Cowgirls*. This piece is now ubiquitous; you know you have seen it . . . *but where?*

As someone who works in this field every day, I have come to believe that Wade's *Thirteen Cowgirls* resonates with people for a variety of reasons. Besides the fact that it is colorful, there is more to the appeal than simply that. We also see women in camaraderie, women who have perhaps just finished competing or maybe are about to perform in varying horsemanship activities.

There is a freedom in being with a like-minded group of women and peers; it is every woman. Every woman at some point in her life wants to be one of those women in that lineup, even if just for an hour. To be with this group, competing, performing, clearly doing something outside the traditional norm for

Bob poses with Governor Richards. She is turned to show a detail from Bob's *Thirteen Cowgirls*, silk-screened onto the back of her denim jacket. Collection of the artist.

the 1920s—something exhilarating—what a fantasy! And what an escape!

And what makes this particular piece even better is that this gathering was no fantasy; it actually happened, and often, in many places. Wade brings to life these remarkable women who often get overlooked, or worse, erased from history; *Thirteen Cowgirls* makes our job a little easier.

COWGIRLS AND HARLEYS

Julie Sasse

In 1982, Dallas artist Bob Wade swaggered into the famous and rollicking Elaine Horwitch Galleries in Santa Fe, New Mexico. He was carrying his hand-tinted vintage postcard photo enlargement of *Thirteen Cowgirls* he had just finished, up the street on the porch of girlfriend Lisa Sherman.

He approached his new friend Elaine and said, "Take a look at this!" Elaine shrieked with glee, took it over to a client, and sold it on the spot! The *Thirteen Cowgirls* images had been a hit at a charity auction in Dallas, and were featured in books and movies and on T-shirts, postcards, and television.

French Cowgirl, 1977. Mannequin, boots, Western clothing. Life-size. Detail of temporary window display, American Cultural Center, Paris, France.

Cowgirls and Harleys, 2016. Acrylic on digital canvas. 20" × 48". Collection of the Tucson Museum of Art.

A few years later, Elaine (a motorcycle enthusiast) was organizing a motorcycle-theme show and asked Bob if he had anything to include. Bob, who had displayed a series of old bike photos at the Phoenix Art Museum's 1973 First Exhibition of Motorcycle Art, said he would look through his postcards.

As luck would have it, the perfect card appeared: a 1936 Texas Centennial promotional photo featuring twelve Dallas police Harleys and four models in cowgirl outfits—hats in the air. The well-posed setup was in front of a Harley dealership with several police looking on. The building in the background had a massive Dr Pepper mural, and several great cars were also in the scene. Elaine loved it and included the new piece in her 1989 show, Harleys and Indians, in Palm Springs. This image also made it into books and onto T-shirts. A ten-foot version is displayed in the JPMorgan Chase bank in Dallas.

In 2016, the Tucson Museum of Art, where I am chief curator, organized an exhibition called The New Westward: Trains, Planes, and Automobiles That Move the Modern West. Bob's *Cowgirls and Harleys* came to mind, and he agreed to make a new one for the show. The feedback from visitors was extremely positive, and the museum wanted to give "the girls" a permanent home. So with the help of a generous donor, *Cowgirls and Harleys*, which I had known for decades, since I first worked for the Elaine Horwitch Galleries in the 1980s, is nearby again. And the porch where it all began? Bob and Lisa have been married for more than thirty years!

Ghost Riders, 1980. Telephone pole, motorcycles, steel, paint. 40' × 8' × 3'. Temporary installation, Florida School of the Arts, Palatka, Florida.

Bob with Ghost Riders in the Sky, 2009. Kemp Center for the Arts, Wichita Falls, Texas.

4 MINUS 2 EQUALS DADDY-O

Kent Zimmerman

The guys, the guns, and the car before it was blown up with nitroglycerin. Collection of the artist.

My Daddy-O days started in a gallery in Santa Fe. I'd heard of this guy, an art desperado if you will, like a lot of people, through the iguana on top of the Lone Star Café in lower Manhattan. At the time, (late eighties?) I was in the music biz, running and writing a trade magazine, where we spent a lot of time with Texas musicians, listening to their music, hanging out—Joe Ely, Butch Hancock and Jimmie Dale Gilmore—and that's when Daddy-O suddenly slipped into our orbit. "Our," meaning me and my twin brother writing partner, Keith. In addition to being music guys, we were book dudes. Our first was the autobio of Johnny Rotten, which put us on the "outlaw" trail. But before that, it was music like Waylon's *Honky Tonk Heroes*, the *Sgt. Pepper's* of country albums, that hipped me to true Texas country culture. Whether it was music or art or films, I've always admired game changers, and Daddy-O is certainly a game changer, the kind of guy who would make art out of Lee Harvey Oswald's screen door. (Ask him about that one.)

Anyway, back to *4 Minus 2 = Waco*.

Ninety-eight percent of folks in Santa Fe at any given time are tourists. I was no exception when I walked into a gallery filled with Daddy-O's photographic reproductions of his paintings, signed and numbered. It was an easy sell—two pieces, Pancho Villa and another, a panoramic shot of female rodeo trick riders standing on moving horses. By the time the pieces made it to my home in Northern California —Oakland, to be precise—I was on the hunt to meet the real "Daddy-O Dude," as we eventually called him. I rightly can't remember how we connected, probably through the gallery, but once push came to shove, we ended up writing a book together, published by St. Martin's Press, edited by the same guy who edited our Rotten book, Jim Fitzgerald, another mad passionate fan and patron of Texas culture.

4 Minus 2 = Waco (diptych), 1986. Acrylic and oil on photo linen. 3'5" × 9'10". Collection of Kent Zimmerman.

Which meant getting our NorCal asses down to a small, quaint, funky, ritzy village in the mountains outside of Santa Fe, where the Daddy-O Dude worked out of an enormous studio connected to his (and his lovely wife Lisa's) home. Writing Daddy-O's book meant rolling tape, transcribing stories, and assembling them into a three-act tome. As I recall, we stayed on deadline. Daddy-O was durable. The first night we got there, he got rip-roarin' pasted at Rosalea Murphy's Pink Adobe restaurant. On the way back to Daddy-O's, my brother and I were concerned about whether he would make the long haul through a book project. Turns out he did. He was up and at 'em early the next morning, buttering toast, dubbing my brother, Keith, and me "the Toast Kings." Our fears were immediately put to rest.

During the entire process of writing, I slept in Daddy-O's enormous studio on the floor, a beer cooler acting as my headboard. We'd roll cassettes all day, rummage through his collection of paintings and vintage stuff, and I'd watch Daddy-O paint with an airbrush. Every night I was surrounded by the ghosts of several paintings, my favorite being *4 Minus 2 = Waco*, which had just been shipped home from the Texas governor Ann Richards's office in Austin. Nearby hung a 1973 black-and-white loose canvas photo enlargement of Waco dudes and their girlfriends holding guns and a huge snake. Three of the guys are in both canvases.

Eventually we recorded a treasure trove of tapes containing a million stories, *Iguana Heads & Texas Tales*, all to be transcribed and turned into the book. Back in California, what I missed most was Daddy-O's toast and that notorious painting that lived in Governor Richards's office. It was a huge two-panel canvas of a shot-up car before and after being blown up and a lineup of Waco U.S. marshals and Daddy-O cradling shotguns and wielding nitroglycerin. The photos were taken during the filming of Ken Harrison's 1976 documentary *Jackelope*.

Eventually we had to make a deal. After a little horse-trading, I sent Daddy-O back his Pancho Villa print, kept the female trick riders, threw in some cash, a couple of draft picks, and sure enough, *4 Minus 2 = Waco* arrived in Oakland in a crate befitting a coffin, where it has remained on my wall ever since, over the fireplace, keeping watch over my life. *4M2EW* has witnessed several instances of my East Bay life. I was even shot, two bullets in, two exit wounds out, standing not far from it. There *4M2EW* remains, over the fireplace, not only because we love it, but also because it's too fucking huge to navigate downstairs.

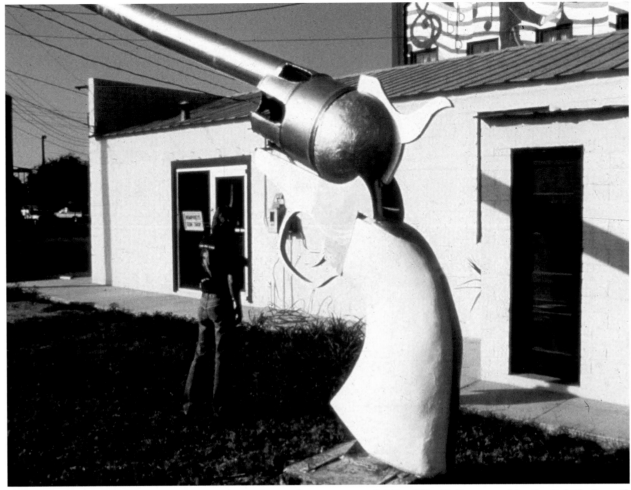

Texas Six-Shooter, 1981. Oil barrel, stovepipe, wire mesh, stucco, wood. 10' × 20' × 2'. Sponsored by the Del Rio Council for the Arts. Installed at Humphreys Gun Shop, Del Rio, Texas. Collection of Bob Wade/Humphreys. Photo: Boyd Elder.

Bob and Governor Ann Richards in front of *4 Minus 2 = Waco*. Collection of the artist.

Color-Blind in Waco, 1996. Acrylic on photo linen. 48" × 72". Collection of Wittliff Collections, Texas State University, San Marcos, Texas.

Waco Boys, 1971. Image on photo-emulsion unstretched canvas. 8' × 10'. Collection of the artist.

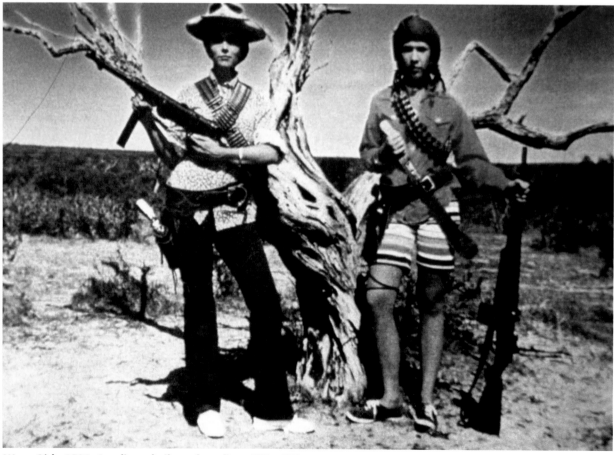

Waco Girls, 1986. Acrylic and oil on photo linen 48" x 33".

WORLD'S BIGGEST BOOTS

Michael Hoinski

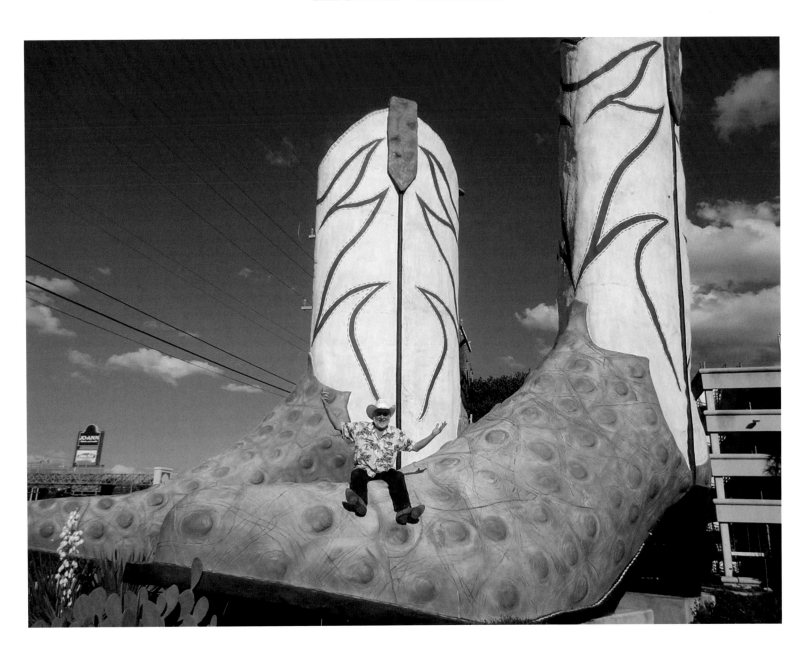

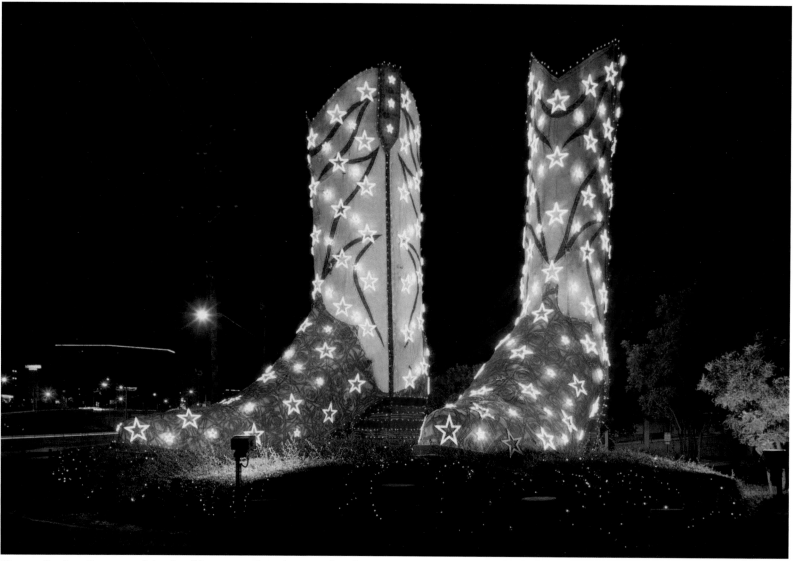

Biggest Cowboy Boots, at night. Steel frame, steel mesh covered with window screen, sprayed with urethane foam, painted wood and fiber-crete. 40' × 30' × 10'. Collection of the North Star Mall, San Antonio, Texas.

Before they stood in front of Saks Fifth Avenue at North Star Mall in San Antonio, where the people inside the quarter-million cars passing by them each day on Loop 410 can gawk at their Guinness World Record size, Daddy-O's forty-foot-tall, thirty-foot-long ostrich cowboy boots resided on an empty lot located a mere three blocks from President Jimmy Carter's home away from home: the White House.

In 1979, the Washington Project for the Arts, a DC-based nonprofit funded by the National Endowment for the Arts, had contacted Daddy-O about the commission on the prime piece of blank canvas at the corner of 12th Street NW and G Street NW. Texas Chic was en vogue on the East Coast at the time. Fashionable Western wear was dovetailing with appearances by the likes of journalist Dan Rather and future governor Ann Richards at concerts by the likes of George Strait and Willie Nelson at the Lone Star Café, in New York, atop of which was perched

another of Daddy-O's sculptures, a mammoth iguana named Iggy.

Daddy-O decided on a big-ass pair of cowboy boots because he wanted to leave a hell of a footprint on the nation's capital. It took more than two months for him to build the boots. They were fabricated out of steel salvaged in part from razed buildings in the area. Their frames were enveloped in wire mesh and sprayed with urethane foam, large dollops of which were squirted where the dimples were meant to replicate the high-end look of full-quill ostrich.

The boots remained on display for three months, with their unofficial tour guide a street performer dressed in an Uncle Sam costume. At the end of their run in DC, the Rouse Company, a shopping mall developer, purchased the boots for the grounds of its mall in San Antonio as part of a revitalization effort. In January 1980, three flatbed eighteen-wheelers transported the modular boots on 1,600 miles of back roads to their new home, where for a brief period in the early years a homeless man set up camp in the base of one of the boots.

Over the past four decades, the boots have achieved status as a national monument of Texas on par with Big Tex at the State Fair of Texas. They have appeared in numerous print advertisements, in television commercials, and on the reality dating show The Bachelorette. They were also featured in the San Antonio version of the snow globes that Saks Fifth Avenue makes for each of the cities in which the department store chain operates. An especially good time to visit the boots is during the Christmas season, when they are decorated with eight thousand red and white LED lights formed into stars, reinforcing Texas's boast that the stars at night are indeed big and bright.

Bob on roof across the street from The Boots, 1979. Washington, DC.

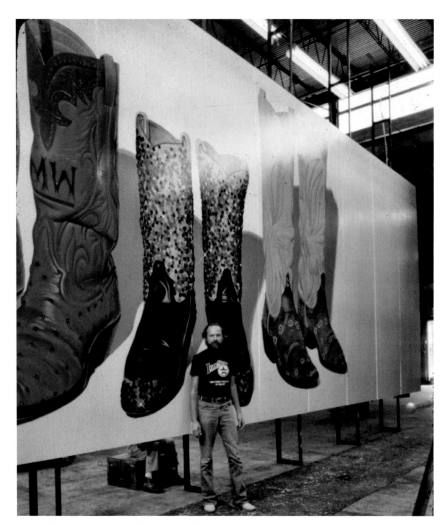

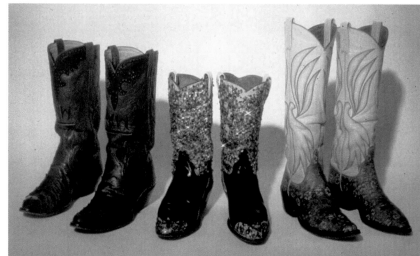

Texas Boots, 1978. Oil on photo linen. 48" × 72". Private collection.

Boots Billboard, 1979. Professionally painted billboard. Rotating temporary installation for Larger Canvas 2. 14' × 48'. Commissioned by Houston National Bank, Houston, Texas.

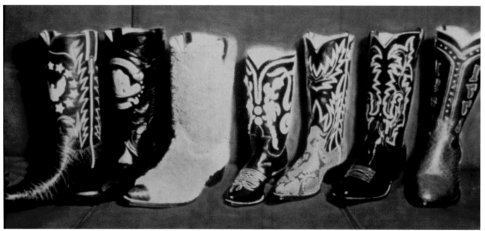

Justin Boots, 1975. Oil on photo linen. 30" × 48". Collection of the San Antonio Museum of Art, San Antonio, Texas.

DADDY-O'S GALLERY OF GUSHERS

David Marion Wilkinson

Daddy-O struggles to articulate why the oil field captures his imagination. Seems like he was born into it. His father managed the great hotels of the rising oil eras—the Gunter in San Antonio, the Galvez in Galveston , the Driscoll in Corpus Christi, and even Beaumont's Edson (once considered the tallest hotel in Texas), among others, where the tycoons, operators, suppliers, lease brokers, and land men congregated in fevered binges at high tide of the booms. Fast money, high stakes,

big winners, all betting against the inevitable bust. Must have rubbed off some kind of way. The character Daddy-O most identified with in the film, *Giant*, was none other than the rags-to-riches wildcatter, Jett Rink.

But we don't see much of the money or the fame in Wade's oil field art. Wade hunts myth, to depict as pure as he can find it. His eye finds it in a lone derrick of wood or iron, rising from the raw, rutted earth. Usually a plume of crude oil blows through

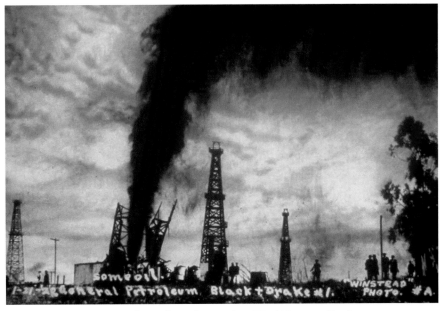

Meeker Gusher, 1980. Oil on photo linen, 48" × 72". Private collection.

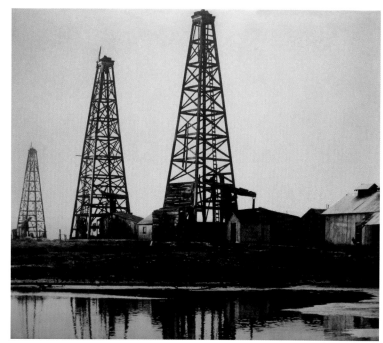

Rig Reflection, 2017. Acrylic on digital canvas, 60"× 52". Private collection.

the crown. In the oil industry's infancy, a gusher meant money—a successful strike. But if you're standing anywhere near it, you're struck by the power of nature that human beings have somehow managed to set free. Whether the few people that inhabit these images are wearing a new store-bought suit or hand-me-down overalls, they seem to share a sense of helplessness and wonder watching oil bellow from the earth. Often we see derricks sprouting up all around them, in close proximity to the boomtowns each big strike dragged in behind it. Wade's images capture a maelstrom of earth and unpainted clapboard humanity—where chaos somehow lends itself to order as we've known it in Texas, with frenzy leaking at the seams. Sure, we've seen plenty of tragedy and loss in Texas. But we laugh a lot, too.

The images Daddy-O loves most are contact prints—which means a photographer shot it on 4×5-inch film, with an old-school bellows camera, perhaps estimating the exposure time based on experience and skill. He then pressed the negative (often made of glass) against the photographic emulsion and a blink of light, resulting in a detailed mirror image of negative and print. There was a little bit of the wildcatter in those old photographers, too. Decades later, Daddy-O would hunt down their now-tawny prints and postcards at roadside antique fairs or estate sales. For him, holding an original Spindletop print in his hand is like holding a piece of history. You stare long enough, dream just a little, and you can almost smell the crude oil in the wind. Or maybe sense the fear deep within some roughneck, wondering how high and how wild this son of a bitch's going to blow. It's all there if you look hard enough, rescued by Daddy-O Wade.

But then Daddy-O tints these old images, doing for the wildcatters and roughnecks what he's done for the cowgirls of West Texas. He makes them live again. Daddy-O's not bemoaning the end of an era. He's celebrating the magic, thrill, and occasional violence of its birth. He's also given the photographs—and the individualists who inhabit them and the artists who created them—a second chance at life. Thanks to Daddy-O Wade, we can walk amongst them forever in the tints and tenor of their own rowdy but truly remarkable times.

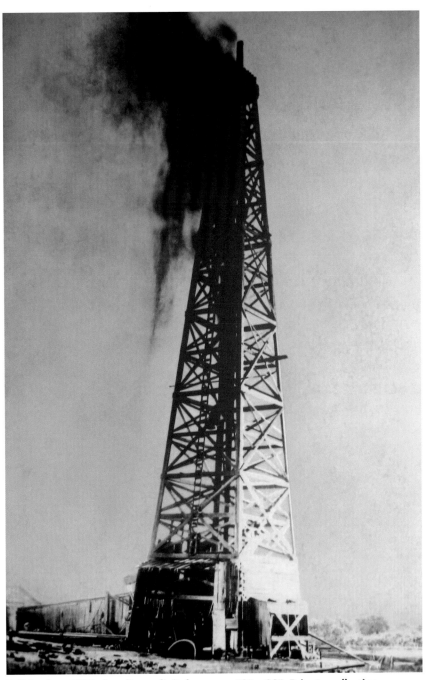

Tall Gusher, 1998. Acrylic on digital canvas, 60" × 39". Private collection.

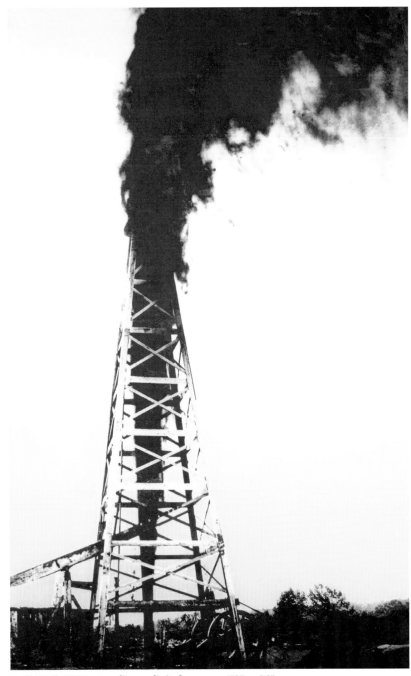

Gulf Well, 2008. Acrylic on digital canvas, 72" × 44".

★

TWIN TORNADOES
Surviving the Storm, Redux
Joanne Leonhardt Cassullo

Twin Tornadoes, 1986. Wood, wire mesh, cotton, miscellaneous objects spray-painted. 15' × variable sizes. Temporary installation at Area nightclub in New York City, New York.

I first wrote about Bob Daddy-O Wade's obsession with tornadoes in a catalogue for an exhibition called Daddy-O's Stuff: An Installation of Bob Wade's Art, Documentation, Oddball Collections, and Offbeat Ephemera at the Art Center of Waco in 1997. My essay, "Surviving the Storm," centered around my firsthand account of personal survival during Daddy-O's installation of Twin Tornadoes in the Area nightclub in downtown Manhattan during the summer of 1986. He was my houseguest—and I got sucked in. On the bright side, while I once suffered a mild case of lilapsophobia (abnormal fear of tornadoes), one most likely caused from watching *The Wizard of Oz* on TV during my childhood, I soon became mesmerized by these violent storms because of my Daddy-O experience. I was not alone. Other New Yorkers were similarly cured of their *Wizard of Oz*–induced tornado phobias after seeing Daddy-O's inventive and amusing installation of one in 1986. As proof of surviving the storm, they kept plucking souvenirs from the twin vortices to use as talismans.

Art, at its best, can cure almost anything.

* * *

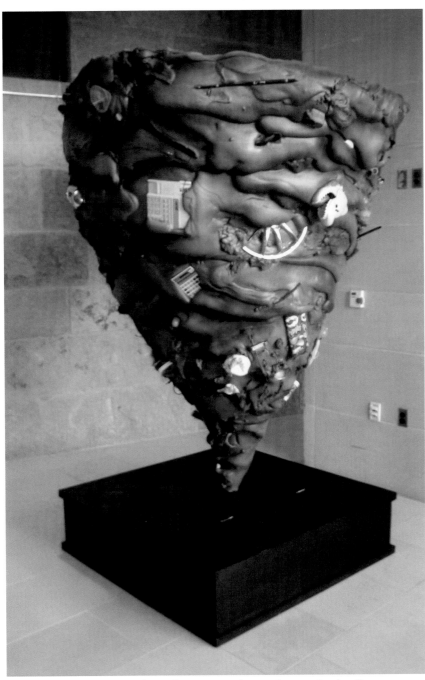

Waco Tornado, 2005. Urethane foam over wire mesh, wood, miscellaneous objects, spray-painted. 8' × 5' × 6'. Created during the Waco Arts Festival, Waco, Texas. Collection of the artist.

1997 article:

If artists are collectors of visual information, then Bob "Daddy-O" Wade is a sociological connoisseur of the most arcane. He is also a sleight-of-hand artist who projects back unto our collective imagination wry souvenir-like snapshots of life through his work. For the most part, the subject of Wade's art is Texas—after all, he lives there. And although his Southwestern roots may have supplied him with iconographic proclivities, Wade manages to make these obsessions engage us all. Wear a T-shirt with his cowgirl portrait emblazoned across it and just see how many people recognize it across a crowded room. Or take for example, his Twin Tornadoes installation in New York City at Area, a lesser-known installation work inside the Tribeca nightspot of the art-hot eighties.

I lived in Texas for fourteen years and never encountered a tornado until the spring of 1986, not long after I had moved back to Manhattan, when Daddy-O arrived on my doorstep as a visiting artist/ houseguest. He was in town for an extended stay, having been invited along with a handful of fellow artists to create installation projects inside the nightclub as part of an exhibition intended to draw in the downtown art crowd.

Unfortunately—perhaps for some, but not for Daddy-O—he was assigned the old textile building's loading dock, which was frozen in the down position, creating a recessed pit. Undaunted, Wade kicked back and began, literally, a cyclonic aesthetic activity, a supernatural creative experience—the hallmark of his creative process—that took on a life of its own. In Daddy-O's mind the unique specifications of the loading dock/pit ideally suited an instal-

lation of a Texas tornado. Tornadoes happen to be one of many obsessions with universal appeal. In fact, Daddy-O has an eccentric's reverence for tornadoes. He grew up partly in Galveston on the Texas coast, where his father was manager of the Galvez Hotel, so most of Wade's meteorological experiences concerned hurricanes, the other kind of Texas storm, and how to prepare for them. But like most boys his age, Wade was lured by the tall tales and adventures found in the illustrated stories about Pecos Bill and their vivid imagery of the legendary Texas cowboy who tamed a cyclone by lassoing it.

The tornado also shows up in Daddy-O's art. Wade's own earthwork, Bicentennial Map of the U.S.A. (1976), located in Dallas, played host to a "tornado visitation" in which extremely high winds knocked down the art observation tower. The following year, Wade included "tornado damage " in his Texas Mobile Home Museum (a sleek refurbished travel trailer furnished with pieces of "Texas phenomena") at the 10th Paris Biennale held at the Musée National d'Art Moderne.

Chronologically, I was the first of a handful of unsuspecting victims of the Daddy-O "creative process," for the Area installation, since he was staying in my home. I speak for Daddy-O's walking wounded when I say we are continually amazed at his ability to garner enthusiasm for any of his given art projects in any conceivable setting at any given point in time. The next victim of Daddy-O's Twin Tornadoes was a former North Texas State University art student he happened to bump into while in a hardware store in SoHo. The now part-time carpenter was enlisted to run errands and help assemble the lumber and chicken wire used as the tornado's skeletal frame.

Next, I unwittingly recruited a Vassar freshman to run errands and help with "tornado research," an activity that ranged from videotaping an episode of 20/20 (which featured tornadoes) to photocopying spectacular cyclonic images from books in the science branch of the New York Public Library for Daddy-O's collection. She in turn enlisted another unsuspecting freshman, this one from Brown University, to run errands and help paint the tornado pit.

It seemed as if everybody knew somebody who knew how to run errands as well as complete a particular task for Daddy-O, and so on. By week's end, Daddy-O had turned my Park Avenue apartment into a cross between an artist's atelier and the Weather Channel. He also managed to set up a studio in my butler pantry and complete a portrait commission for a friend in Fort Worth. All the while, my telephone never seemed to stop ringing and the flurry of activity (not to mention the bagel debris) in the kitchen alone mimicked the disasters visually researched for Daddy-O. He had everyone voluntarily running around in circles. Some liked it better than others.

Memorial Day weekend arrived amid all the frenetic tornado preparations. Still, Daddy-O and some of his workers managed to spend a foggy weekend in the Hamptons, where he fashioned a "beach tornado," an impromptu maquette for his Area installation, from driftwood, seaweed, and errant plastic grocery bags at the shore. In contrast, Wade's Area construction was a man-made wooden structure wrapped in chicken wire over which first cut linter (mattress stuffing) was pulled and stapled into place. Its unique formation was inspired by 20/20's coverage of twin tornadoes in Sweetwater, Texas.

Two long funnel clouds spiraled out of the pit and dramatically rose to the rafters, giving the viewer a voyeur's perspective into the belly of the tornado's vortex. It provided an ideal surface for the artist's tableau. Daddy-O punctuated the cotton surface with "debris," the funky merchandise he purchased along Canal Street: miniature plastic houses and brightly colored farm animals, cheap sunglasses, a rubber boot, a child's cowboy hat. When I previewed the work in progress the night before the opening, I also noticed a specimen fish (mounted and stuffed) that once belonged to my own father. Apparently prone to petty theft, Daddy-O appropriated it from under my very nose.

Luckily, I rescued it before he spray-painted the entire tornado a bright orange to more accurately resemble true soil color. I grabbed the fish and the freshman girls and we taxied home.

The tornado won instant approval with the Area crowd, although people kept stealing the sunglasses. Things in my life returned to normal after Daddy-O left town. Now that Area's Twin Tornadoes are long past, I've come to think of them with an almost nostalgic affection. To this day, one of the freshman girls (the one from Vassar) still refers to his installation as "those tonsils." Just last winter I introduced Daddy-O to a fan from Tribeca who remembers his Area piece as wildly imaginative. That Daddy-O fan kept watch over his Lone Star Iguana (perched at Pier 25 in lower Manhattan), furnishing evidence, once again, that Daddy-O's creative obsessions eventually become our own.

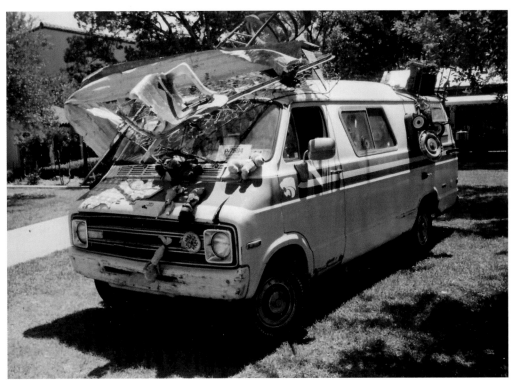

Tornado Van, 2003. 1970s extended Dodge Van, miscellaneous debris. 17' long. Temporary installation at the Waco Art Center, Waco, Texas.

TITO'S VODKA BOTTLE

Bert "Tito" Beveridge

I knew Bob Wade had done some pretty big and well-known sculptures: the Boots, the Frogs, the Sax, and so forth, and since my vodka was getting big and well advertised, I thought a Giant Vodka Bottle would be great. Bob suggested we do it at Carl's Corner truck stop near Hillsboro, Texas, where the

Frogs had made a splash. It would be a great "roadside attraction," with the base housing a fire truck to service Carl's Corner, Texas.

The truck stop got sold, so we had to put the bottle on hold. But Bob had another fun idea for the Tito's office in Austin. "Tito, how about one of

Cowgirl Ridin' a Tito's Bottle, 2011. Acrylic on digital canvas. 5' × 7'. Collection of Tito's Handmade Vodka corporate office, Austin, Texas.

my hand-colored photo canvases showing a cowgirl riding a bucking Tito's bottle?" As it turns out, the Daddy-O had used this vintage cowgirl photo he found, years ago in a big painting. It ended up on the cover of his cowgirl book as well.

So from riding on the hood of a car to riding a Tito's bottle was an easy jump for Brother Wade's cowgirl. "All you gotta do, Tito, is give me a bunch of money and I'll make it six feet wide to perfectly fit the reception area of Tito's world headquarters," Wade told me.

So Daddy-O cranked it out, and it looked so great we made T-shirts from it. I wonder what that giant bottle sculpture will cost?

Tecate Icehouse, 2006. Tecate beer can, plastic figures, metal cars, wood. 5" × 7". Created for Austin Museum of Art 5×7 fundraiser. Private collection, Austin, Texas.

Tecate Can Chair, 2009. Altered beer can. 7" × 2.5". Temporary exhibit at the Austin Museum of Art. Collection of the estate of Damian Priour, Austin, Texas.

Beer Critter, Puerto Vallarta. Collection of the artist.

Bob poses with *Beerguana*, Puerto Vallarta, 2011. Collection of the artist.

Beer Critter, Puerto Vallarta. Collection of the artist.

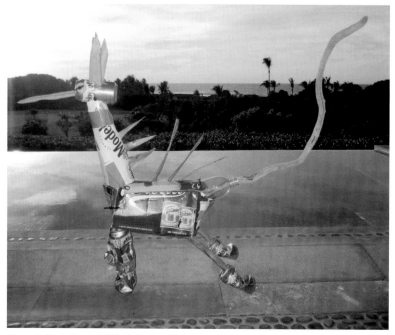

Beer Critter, Puerto Vallarta. Collection of the artist.

TOTEM

Claudia Alarcón

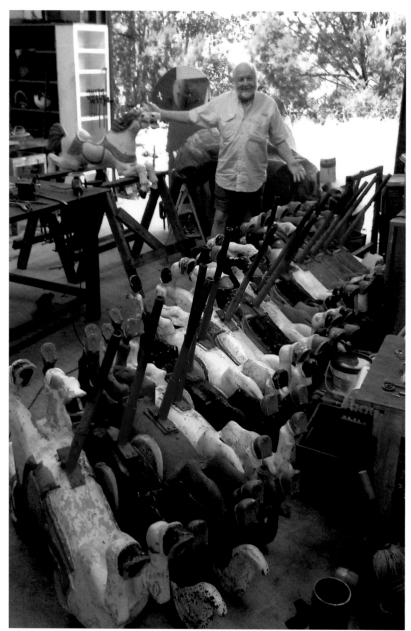

Bob at fabrication shop with carousel horses and other components of Totem, 2017. Collection of the artist.

When I married Austin artist Will Larson in 1999, I had no idea I was also marrying the wacky world of Daddy-O Wade. Through our years together, I often came home to the weirdest things in our backyard. *What is this Volkswagen carcass doing here? What are you doing with all those motorcycle parts? Can we get those empty beer kegs off my flowerbeds?* I must admit that after some time I looked forward to seeing whatever Daddy-O was cooking up with Will, especially after I saw them turn that VW into the iconic Saints Helmet at Shoal Creek Saloon. Plus, it's impossible not to succumb to Daddy-O's charm.

The last time, I came home to find dozens of items from a 1950s amusement park lined up in the backyard. What in the world now? Another dog and pony show with the Daddy-O. Turns out he'd gotten a call from art consultant Kenneth Turner in Fort Worth about a project at Trademark Property's Waterside, a community and mixed-use development. The idea was to repurpose amusement rides and playground equipment from the defunct Lockheed Martin Recreation Association that had occupied the site in order to make the project a reflection of the community in which it was to be built.

Daddy-O took the Amtrak to Fort Worth, where he discovered containers and storage units full of carousel horses, kiddie-ride warplanes and bombs, pieces of a jungle gym, heaps of twisted steel shapes, and other ephemera. His heart skipped a beat—he

had found a gold mine of materials. "The site was so under construction you couldn't visualize jack shit," he says. So he took photos and careful measurements of the objects, drew outlines to scale onto heavy paper, cut them out, and started arranging them, like a puzzle, to spark ideas. "Daddy-O is old-school. He does lots of drawings and cut-and-paste."

Alongside his trusted buddies Dan O'Hara and Dunton Taylor, Daddy-O made trips back and forth to Fort Worth, bringing trailers full of crazy stuff back to Will's shop in the backyard. "I call these guys the Daddy-O Team. Without the Daddy-O Team, there's no art," he said. For weeks, Daddy-O and Will scraped, cleaned, and altered the objects so they could go on a pole, then finished them with clear automotive coating. "When we get to the nitty-gritty, Will and I just swing through. It's a collaborative thing. Being an artist himself, Will gets the aesthetic of the thing, not just the welding. He understands that when I make the drawings, the piece is going to look just like that, not kinda like that." Stylle Read, another member of the Daddy-O Team, delivered the finished pieces back to the site to be assembled onto the totem by the Turner Sign Co. as previously agreed. "When the crane guys show up, it's like, *Here we go. The show is on!* With Will, we have it all theoretically figured out, but when it's time to assemble, things get really exciting."

The result is another one of Daddy-O's homages to roadside America. In his unconventional and inimitable style, he brings new life to old discarded objects that he feels need to be preserved, giving them a whole new purpose. "These old-timey rides have finally found their forever home," he said.

I love the man. He is truly a wacky treasure himself.

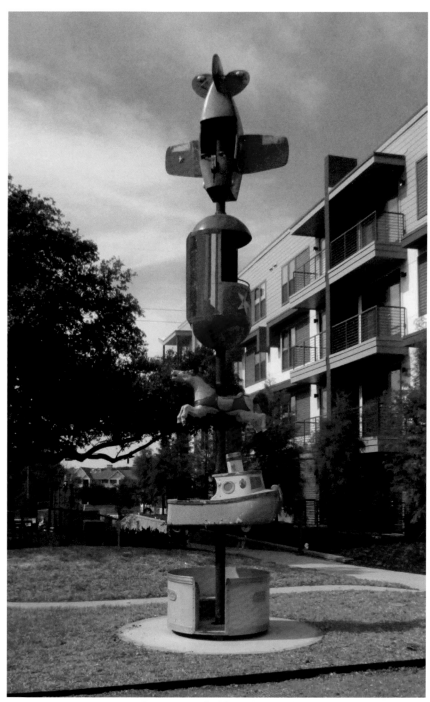

Totem, 2016. Components from 1950s kiddie rides, steel pipe. 25′ × variable sizes. Commissioned by Trademark, Waterside, Fort Worth, Texas.

AFTERWORD:
THE EYES OF DADDY-O ARE UPON YOU

Joe Nick Patoski

The Eyes of Texas and Daddy-O have lots in common. Both are bigger than all get-out, and both follow you around everywhere. Do not think you can escape them.

No matter where I go, there is Daddy-O.

My first time (and everyone has a Daddy-O first time) was 1976, when the giant living map of the United States was unveiled for the United States bicentennial celebration. The cat who did this is smart and imaginative, and somewhat goofy, I figured.

The second, third, and fourth times kinda dominoed together so quickly and so serendipitously, I started looking over my shoulder and wondering if I was being followed. Somewhere along the line, the googly-eyed presence of Daddy-O, formally introduced as Bob Wade, passed before my eyes. I haven't been able to get his manic fevered visage out of my head ever since.

I didn't always put together the wild man I'd met with the art that he created. I just assumed the giant forty-foot tall pair of boots installed in 1980 at North Star Mall, the biggest shopping mall in San Antonio, were part of the suburban Loop 410 landscape, just another high-visibility icon along the frontage road, blending in with the tall signage for Whataburger and Don's & Ben's and the inflatable gorillas identifying automobile dealerships.

I met the iguana a year earlier, in the fall of 1979, when I accompanied the band I was about to start managing, Joe "King" Carrasco and the Crowns, to a shitty-pay opening gig slot at the Lone Star Café in New York City. The Lone Star was hyped as a real Texas honky-tonk on Fifth Avenue, but the room was laid out more like a nice, semi-fancy New York restaurant. The acoustics were terrible and the sight lines lousy. In that respect, it really was like an authentic Texas honky-tonk.

More significantly, the Lone Star was wide open, I quickly learned while leaning into the sink of the

men's room with a rolled-up dollar bill handed to me by Margaux Hemingway's South American boyfriend. In a matter of minutes, after passing Sam—or was it Dave?—upstairs hanging out in the dressing room, I was up on the roof, smoking weed under the asshole of the giant iguana imagined by Bob Wade. I was neither the first nor the last. Smoking weed under Iggy's asshole is what some Texans did when they were in New York, although no one around me called him by name. It was just Daddy-O's big-ass iguana. What else did one need to know?

Six months later, Joe "King" Carrasco and the Crowns played the formal opening of the 8.0 Bar in Dallas and there it was: the Giant Dragonfly. Reptiles and insects, boots and maps. If there was a theme running through them, it was their large size.

Stuffed and well-lacquered dancing frogs that were the staples of every border-town tourist shop got the Daddy-O treatment of Miracle-Gro steroids when six ginormous amphibians were placed on the roof of Tango, Shannon Wynne's zoomy new club in Lower Greenville in Dallas. Two frogs danced. One played a trumpet.

It was around that time that I learned about Daddy-O's El Paso roots, and heard stories of quality time spent at the Kentucky Club, El Submarino, Fred's Rainbow, the Cave, Irma's, and Martino's across the river in Juárez. Daddy-O's twistedness was better understood knowing he had border-hopping desert-rat roots.

My favorite Tango memory was watching the end of a sold-out Joe "King" show from the balcony and marveling over the smoke effect at the foot of the stage during the encore. Only it wasn't a stage

effect. Some OU frat rat joy boy from Fort Worth set off a tear gas bomb, clearing out the entire room in a matter of minutes. Out on the street, trashed-out party people coughed, wheezed, hacked, and comforted one another on the otherwise empty street. Joe "King" ministered to María Elena Santiago-Holly—Buddy Holly's widow—whom he carried out of the backstage dressing room.

The frogs never flinched.

But they did move in 1984, when Tango closed. They moved sixty miles south to become glorified highway signage dancing on the roof of Carl's Corner truck stop on I-35E just north of Hillsboro, where they greeted fans making Willie Nelson pilgrimages. Willie grew up a few miles south of the truck stop and enjoyed playing poker with truck stop czar Carl Cornelius and other buddies there. For a few years, Willie operated a museum, music performance space, radio station, and restaurant at Carl's Corner, until Cornelius went bust.

Willie came and got all his collectibles, three frogs returned to the Tango site in Dallas, which turned into a Taco Cabana, three frogs went to a Chuy's in Nashville, and the Carl's Corner truck stop became a Flying J. I didn't know about the three frogs being in Nashville until I happened to be there at the same time Daddy-O was. He showed me a photo he'd taken earlier that day of his creations at their new location to make sure I didn't miss them.

I finally learned the big iguana had a name, Iggy, when I saw him at his new perch at the Fort Worth Zoo while paying a visit to Ramona Bass. I had no idea.

Daddy-O talks about putting something big on top of the South Austin Museum of Popular Culture,

his main artistic hang in Austin, but the roof can't take the weight. At an opening there, I suggested constructing his next Big Thing out of ultralight carbon or some material the roof could support. Maybe one of the tech companies or Lance Armstrong could help him out. I don't think he was listening; Daddy-O was busy thinking big. And like everything else he's done, I know that whatever it is he is thinking about, it, too, will be part of my life.

Do not think you can escape him.

DADDY-O

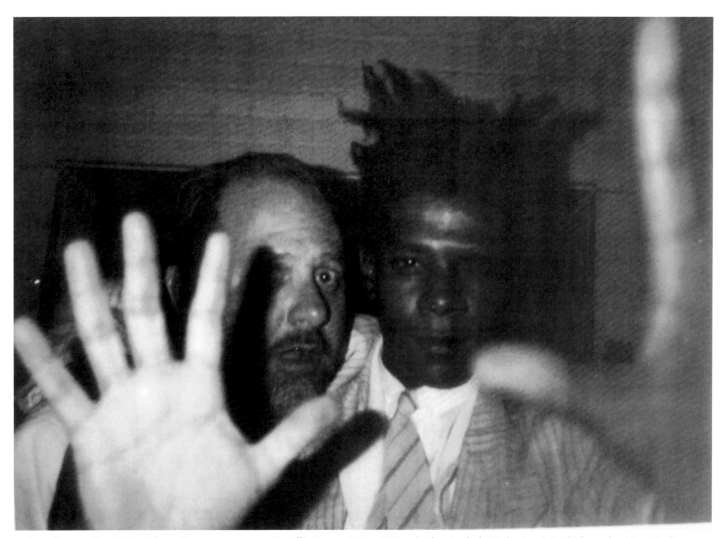

Bob and Basquiat, 2015. Photo Transparency on Metallic Paper, 22" x 29", print by Rachel Wade & original photo by Lisa Wade, Dallas 1985.

THANK-YOUS AND ACKNOWLEDGMENTS

I'm not sure who to thank first for helping me get this book done, and I don't want to fumble along like the Academy Awards people with the "get off the stage" music, but I'll start with production. Thank you, Pam Harte, for steering me to Texas A&M Press and their terrific editor Thom Lemmons. Thom, along with Katie Duelm, Mary Ann Jacob, and Nancy Inglis, did a great job with a lot of "stuff" to assemble and make an informative and fun publication. Helping me get the stuff to Thom's team were my team: hundreds of emails received and resent by my patient wife, Lisa, who also served as adviser and researcher; typist extraordinaire Rachel Wade, who has known my all-caps writing style since her childhood; Will Larson, the Photoshop whiz who cleaned and perked up my photos; and my coauthor, Kip Stratton, who kept the stuff organized as we went along. Many, many thanks, team.

From front to back, thanks to the Kinkster for his foreword, Kip Stratton and Jason Mellard for their essays, all the worldly contributors who made this more than a photo book, and Joe Nick Patoski for the afterword. I am truly grateful for your helping make this book happen.

Aside from my hundreds of friends over the years, there are many who were involved one way or another in helping my career; mentors, assistants, major patrons, galleries, advisers, bar owners, museum professionals and art related folks. And thanks to all the photographers who agreed to the use of their images.

If I spaced out and left your name out or you think you should be on this list, please write your name in here: _____.

Otherwise, here goes:

Adair Margo Fine Art
Lou Adler
Elaine Agather
Prince Albert of Monaco
Boyd Allen
John Anders
Scottie Anderson
Katherine Armstrong
Leigh Arnold
Asel Art Supply, Austin
Atelier Chapman Kelly
Austin Photo Imaging
Victor Ayad
Michael Barnes
Lynn Barnett
Ed Bass
Ramona and Lee Bass
John Paul Batiste
Clint Bell
David Bell

Ray Benson

Lionel Bevan

Lori and Tito Beveridge

Eugene Binder

Bill Bittles

Black & White Lab

Betty Blake

Bill Bostleman

Jack Boynton

Ben Brendel

Benton Brown

Frank Brown

Bruce Kapson Gallery

J. P. Bryan

Helen Bryant

Dan Bullock

Laura Bush

Jan Butterfield

Carol Carden

Annette Carlozzi

Bill Carman

Laura Carpenter

Francine Carraro

Oakes Carson

Preston Carter

Joanne Leonhardt Cassullo

Richard Chase

Rodger Chieffalo

Clement of St. Croix

Judy and Jamey Clement

Mark Coats

Mary and Bobby Cocke

Christine Codelli

Alberto Collie

J. R. Compton

Contessa Gallery

Mort Cooperman

Carl Cornelius

Sophie and Matt Crommett

County Line

Cowboys & Indians magazine

The Crockett Hotel—The Brendel
 Family

Carol Crosthwait

Ralph Curton

Beverly Dale

David Segal Gallery

Davis Gallery

Mary Dean

Janie and Dick DeGuerin

Delahunty Gallery

Denise Jacobs Gallery

Gilbert Denman

Dennis Hopper Works of Art

Beth Rudin DeWoody

Karen Dinitz

Mac Doty

Franklin Drake

Mary Dritschel

Dubbie

El Arroyo

Dale Eldred

Carla Ellard

Linda Ellerbee

Etherton Gallery

Carolyn Farb

Gary Ferguson

Jim Ferguson

Louisa and Brendan Fikes

Jim Fitzgerald

Bill Fitzgibbons

Fix A Wreck

John Fleming

Fonda San Miguel

Virginia Ford

Leslie Fossler

Alice Foultz

Cindy and Glenn Frey

Clare Frost

Bill Gallagher

Jim Ganzer

Analisa Garcia

General Growth Properties

Peter Gill

Tom Garrison

Olivia Georgia

Charlie Geren

Peter Gershon

Gibbs Smith Publisher

Dan Goddard

Henry Gonzalez

Susie Grace

Michael Graves

Ty Grimes

Vaughn and Tex Gross

Madeline Haenggi

Becky Hannum

J. Allen Hansley

Ann and Jim Harithas

Paul Harris

Ken Harrison

Michael Harrison

Shannon and Mark Hart III

Pam and Will Harte

Cleve Hattersley

Marcia Hayslip
Rick Hernandez
Tommy Hicks
Dave Hickey
Jayne Hickey
R. A. Hilder
Barbara Hill
Jim Hill
Richard Hill
Joe Hobbs
Michael Hoinski
Dick Holland
Julianna Holt
Peter Holt
Henry Hopkins
Seth Hopkins
Walter Hopps
Elaine Horwitch
Charles Husbands
Tommy Husbands
Maurice Ingram
Cheryl Jamison
Janie Beggs Gallery
Jan Turner Gallery
Jill Kornblee Gallery
Patricia Johnson
Howdy Kabrins—La Salsa
Susie Kalil
Kansas City Art Institute
Peter Kaplan
Kappa Sigma Fraternity
Molly Kemp
John Kelso
Ed Kienholz
Cassie King

James King
Bob Kjorlien
Michael Kleinman
George Kline
Stu Kraft
Nick Kralj
Janet Kutner
Evelyn Lambert
Christi Lane
John Langdon
Will Larson
Mon Levinson
Richard Linklater
Melvin Lipsitz
Ann Livet
Sarah Logan
Joe Longley
Lost Horse Saloon
Gene Lucas—Gal-Tex
Amy Lukken
Meredith and Stephen Luskey
Lyons Matrix Gallery
Lynn Goode Gallery
John Malmberg
Dian and Don Malouf
Anne and John Marion
Russ Martin
Bill Marvel
Marvin Seline Gallery
Jeanne Massey
Jack Massing
Michael McCall
Juli and Mac McGinnis
Mark McKinnon
McLennan Community College

Susan and Hagen McMahon
Parnell and Mike McNamara
Mark Meador
Leea Mechling
Jim Meeker
Anita Meeks
Andrea Mellard
Jason Mellard
Donald Meyer
Marcia Milam
Mill Street Gallery
Jan Miller
Dee Mitchell
Pat Molak—Down on Grayson
Kit and Charlie Moncrief
BB Moncrief
Dan Moody
Bob Moor
Ardon Moore
Jeff Morehouse
Whitney Hyder More
Lance Avery Morgan
Morgan Gallery
Rosalea Murphy
Melinda and Henry Musselman
Patty and Bobby Nail
Jim Napierala
National Cowgirl Museum and Hall
 of Fame
National Endowment for the Arts
Al Nodal
North Star Mall
Northwood Institute
Dan O'Hara
Eric O'Keefe

Oak Cliff Four

Robert Oliver

Kym Olson

Orange Show Art Car Parade

Marilyn Oshman

Parchman Stremmel Gallery

Pasadena Town Square Mall

Alan Peppard

Governor Rick Perry

Bob Pettit

Bob Phillips

Ron Phillips

Mike Powers

George Prater

Shannon Province

Stylle Read

Becky Duval Reese

Jeff Rentschler

Governor Ann Richards

Ken Robinson

Dede Rogers

Roy Rogers

Susan Romans

Candace Rubin

Jerry Rubin

Ed Ruscha

James Rutherford

Todd Sanders

Julie Sasse

Italo Scanga

Eric Scheffey

Faith Schexnayder

Julian Schnable

Lilly Serna

Sam Shepard

Shoal Creek Saloon

Mike Shropshire

David Smith

Nancy Smith

Roberta Smith

Murray Smither

Robert Smithson

South Austin Museum of Popular
 Culture

Southern Sign

Penelope Speier

St. Martin's Press

Earl Staley

Henry Steinmann

Stephen L. Clark Gallery

D. J. Stout

Aubrey Stringer

Robert Summers

Jim Swift

Dunton Taylor

Texas Hatters

Dick Thompson

John Tinker

Tito's Vodka

Connie Todd

Chip Tompkins

Bob Townley

Trademark Property

Reggie Tuck

Keith Turman

Kenneth Turner

Janet Tyson

University of California Berkeley Art
 Department

University of North Texas Art
 Department

University of Texas Austin Art
 Department

Jay Ungerman

Chuck Varga

Judy Vetter

Evan Voyles

Waco Art Center

Pattie and Chaffin Wade

Lisa Wade

Rachel Wade

Renee and Howard Walsh

Jane Walshe

Matt Wayne and 78704 Gallery

Senator Kirk Watson

Willard "Texas Kid" Watson

Roxane West

Barry Whistler

Pam and Monk White

Larry Sr. and Larry Jr. White

William Campbell Contemporary
 Art

Kevin Williamson—Ranch 616

Tucker Willis

Alexis Wilson

Laura and Robert Wilson

Vance Wingate

Sally and Bill Wittliff

David Wynne

Shannon Wynne

Mike Young—Chuy's, Hula Hut

Keith and Kent Zimmerman

As Billy Joe Shaver

sang in 1973:

"Too much ain't enough!"

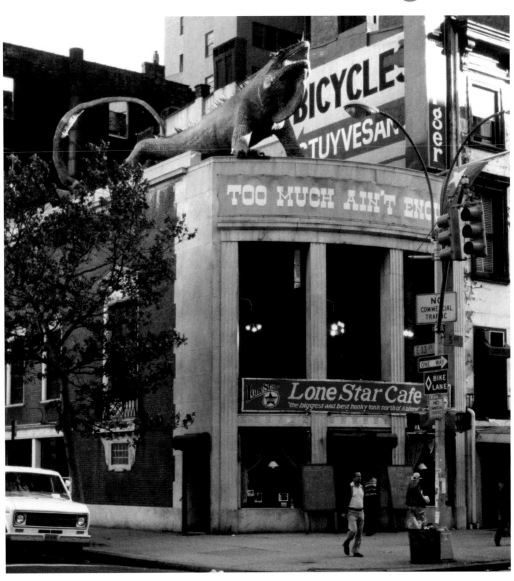

We gratefully acknowledge

the generous support of those who assisted

in the publication of this book:

Ramona and Lee Bass

Cina Alexander Forgason

Will and Pam Harte

Whitney Hyder

Castle Hill Partners—Victor Ayad

Tito's Handmade Vodka, Fifth Generation Inc.

Trademark Property Co.

Waterside Commercial LLC

APPENDIX
Chronology

The following is not an exhibition list, but rather a few important things that occurred in my seventy-six years on the planet.

January 6, 1943: Robert Schrope Wade born at St. David's Hospital in Austin, Texas. Parents: Pattie and Chaffin Wade. Second cousin Roy Rogers visits two months later on movie tour.

1944: Family moves to Corpus Christi, Texas, for hotel management.

1946: Family moves to Waco, Texas, for hotel management.

1948: Family moves to Galveston, Texas, for hotel management. Robert shows signs of drawing skills.

1950: Family moves to Beaumont, Texas, for hotel management. Robert is the class artist. He listens to *The Lone Ranger* on the radio.

1952: Family moves to San Antonio for hotel management. Robert takes art lessons at the Witte Museum.

1953: Family moves to Marfa, Texas, for hotel management and lives at the Hotel Paisano. The filming of the movie *Giant* is about to begin.

1954: Family moves to El Paso, Texas, for non-hotel life. Robert has good art teachers, Jeanne Massey and Jane Walshe, in grade school. Goes to Juárez with Dad for shoeshine and views velvet paintings. Paints flames on childhood toy car. Wins yo-yo contests. Joins Boy Scouts.

1957: Family gets first black-and-white television set. Robert gets Vespa scooter and adds flames. Reads *Mad* magazine. Enters El Paso High as an eighth grader.

1959: Robert gets his first car, a 1951 Ford hardtop. He reads hot-rod magazines and loves artwork by Ed "Big Daddy" Roth. Robert customizes his car inside and out and wins trophies at local drag strip. He is a member of the Roadrunners car club.

1960: Robert has a solo show in the hallway of his high school.

1961: Robert designs the cover of the high school yearbook. He graduates and moves to Austin, Texas, to live with cousin Virginia while a freshman at the University of Texas College of Fine Arts. Joins Kappa Sigma fraternity and gets nicknamed Daddy-O.

1963: Studies with Charles Umlauf, William Lester, and Everett Spruce. Makes abstract paintings.

1964: Meets Kinky Friedman.

1965: Graduates from the University of Texas with a BFA in painting. Enrolls in a master's program at the University of California at Berkeley. Studies with Elmer Bischoff, William Allan, Jim Melchert, and Hayao Miyazaki. Visits exhibits in San Francisco by Peter Voulkos, Robert Arneson, Robert Hudson, and William T. Wiley. Sets up live-in studio in both sides of duplex in Berkeley. Meets Sue Immel.

1966: Graduates from Berkeley with a master's degree in painting. Marries Sue Immel. Sends all graduate work to La Villita gallery in San Antonio for first solo show. Joins original faculty at McLennan Community College in Waco, Texas (only art instructor).

1967: Solo show (the "weenie" paintings) at Atelier Chapman Kelley in Dallas, Texas. Reconnects with Dave Hickey.

1968: Makes first outdoor public sculpture (Funny Farm Family) for San Antonio world's fair (Hemisfair). First trip to New York City. Meets Italo Scanga.

1969: Included in Whitney Museum Annual, New York City. Grows beard. Meets Alberto Collie (director of Northwood Institute).

1970: Becomes artist in residence at Northwood Institute in Cedar Hill (Dallas suburb). Meets Robert Smithson, Nancy Holt, Keith Sonnier, William Wegman, and patron Jim Meeker. Also Fort Worth Museum director Henry T. Hopkins, who calls Robert "Bob."

1971: Becomes director of Northwood "experimental" art institute. Moves to Oak Cliff (Dallas suburb) loft and helps form Oak Cliff Four with Jim Roche, Jack Mims, and George Green. Meets Walter Hopps at Corcoran Gallery of Art in Washington, D.C. Has first NYC solo show at Kornblee Gallery.

1972: Solo show at Smither Gallery in Dallas. Meets Julian Schnabel.

1973: Daughter Christine is born in Dallas. Included in the first Whitney "Biennial." Meets Dennis Hopper in Taos, New Mexico. Gets first National Endowment for the Arts grant to travel Texas. Joins faculty at North Texas State University as an assistant professor of art.

1974: Gets second NEA grant. Meets Jim Harithas (director of the Contemporary Arts Museum in Houston) in El Paso to view Bob's "installation" at the University of Texas at El Paso and goes on Texas tour to see Luis Jiménez in Hondo, New Mexico, and Stanley Marsh 3 in Amarillo.

1975: Sets up photo darkroom in underground Nike missile silo courtesy of North Texas State. Begins Bicentennial Map of the U.S.A.; meets outsider artist Willard "Texas Kid" Watson. Included in art documentary *Jackelope* by Ken Harrison (with James Surls, George Green, Mel Casas).

1976: Bicentennial Map of the U.S.A. is featured in two-page spread in *People* magazine. Meets outsider artist Clarence Schmidt in Woodstock, New York, courtesy of artist Franklin Drake. Makes *Bob Wade's Texas* leather book.

1977: Included in 10th Paris Biennale in Paris, France (ships Texas Mobile Home Museum). Gets divorced from Susie Wade; resigns from North Texas State. Moves to Dallas to an empty Mexican bakery, then to an old church.

1978: Moves into an old wooden building owned by Monk White, which becomes a hangout: Daddy-O's Patios. Goes to Art Park near Niagara Falls, New York, to build Giant Iguana. Sells the Iguana sculpture to the Lone Star Café in Manhattan and installs it on the roof. Sublets Julian Schnabel's loft while doing final touches. Meets Mayor Ed Koch and numerous celebrities up on the roof.

1979: Does first Cowgirl photo work. Mother dies. Builds forty-foot-tall cowboy boots at Washington Project for the Arts art site. Iguana wins court case in New York City (see the Iguana chronology). Boots are bought by Rouse Company and trucked to North Star Mall in San Antonio, Texas.

1980: Boots erected in San Antonio. Mariachis play.

1981: Texas group show in Charles Cowles Gallery, New York City.

1982: Drives machine-gunned Bonnie and Clyde Mobile in New Orleans Mardi Gras art car parade. Meets Lisa Sherman in Santa Fe, New Mexico.

1983: Joins Elaine Horwitch gallery in Santa Fe. Makes Six Frogs Over Tango for Tango club in Dallas, Texas.

1984: Moves Dallas studio to Deep Ellum in Dallas. Meets Sam Shepard and Jessica Lange in Santa Fe. Gets third National Endowment for the Arts grant.

1985: Meets Jean-Michel Basquiat in Dallas. Creates hundred-foot-long eighteen-wheeler flat billboard for Carl's Corner truck stop near Hillsboro, Texas. Six Frogs from Tango soon follow. Marries Lisa Sherman in Santa Fe.

1986: Moves to Santa Fe and then to Tesuque, New Mexico (outside Santa Fe), and builds large studio.

1987: Transforms fiberglass soda jerk in Malibu, California, to Mexican waiter.

1989: Daughter Rachel is born in Santa Fe, New Mexico. Solo show at William Campbell Fine Art, Fort Worth, Texas. Takes prints to Monaco, meets Prince Albert, and does solo show at Le Texan.

1990: Solo show at Janie Beggs Gallery, Beverly Hills, California. Meets Ed Ruscha. Father dies.

1991: Solo show at Etherton/Stern Gallery, Tucson, Arizona.

1992: Bob's Cowgirl T-shirt is worn by Woody Harrelson in the movie *White Men Can't Jump.*

1993: Builds seventy-foot-tall saxophone for Billy Blues Club, Houston, Texas.

1994: Bigmouth Bass sculpture arrives at the lake at the Hula Hut, Austin, Texas.

1995: Works with Kent and Keith Zimmerman on Bob's book *Daddy-O: Iguana Heads & Texas Tales* (St. Martin's Press). Creates the Iguanamobile (1956 Airstream) to promote the book on a tour of Texas. Karen Dinitz follows with film crew.

1996: Moves to Austin, Texas, and sets up large studio at new house.

1997: Group show The Painted Photograph, 1939–Present, University of Wyoming Art Museum.

1998: Indoor and outdoor commissions for Ranch 616 restaurant, Austin, Texas.

1999: *Too High, Too Wide and Too Long: A Texas Style Road Trip,* Karen Dinitz documentary about the Iguanamobile, premieres in Austin. Meets Richard Linklater.

2002: Six large photo-canvases for the SBC Center (now AT&T), San Antonio, Texas.

2003: Installation at the Austin Museum of Art, Austin, Texas, with an appearance by Clarence Swensen (a little person), who is remembered for his role as one of the Munchkin soldiers from *The Wizard of Oz* film.

2004: Makes Saints Helmet from a Volkswagen for the roof of Shoal Creek Saloon, Austin, Texas.

2005: Solo show Cowgirl Photoworks at Booth Western Art Museum in Cartersville, Georgia.

2006: Creates the Guv Bug teardrop trailer for Kinky Friedman's Texas Tour for Governor race.

2009: Solo show Retrospectical at the South Austin Museum of Popular Culture in Austin, Texas.

2010: Lone Star Iguana arrives by helicopter to the roof of the Fort Worth Zoo.

2013: Three Tango Frogs move from Chuy's restaurant in Houston to Chuy's restaurant in Nashville.

2014: Three Frogs move from Carl's Corner in Hillsboro, Texas, to Taco Cabana in Dallas (their original location).

2016: Bonnie and Clyde Mobile moves from Langdon farm in Granbury, Texas, to the Lost Horse Saloon in Marfa, Texas. *Guinness Book of World Records* includes Wade's Boots sculpture.

2017: Installs Pride Dillo in a public interior space at Facebook, Austin, Texas.

2019: Receives two separate resolutions congratulating him on his art career from the Texas Legislature's House and Senate. Receives "outstanding ex" award from El Paso High School, El Paso, Texas.

2020: Texas A&M University Press publishes *Daddy-O's Book of Big-Ass Art.* Selected as Texas Book Festival Poster artist. Included in the exhibit Southwest Rising: Contemporary Art and the Legacy of Elaine Horwitch at the Tuscon Museum of Art. Receives official congratulations from the City of San Antonio for the 40th anniversary of the World's Largest Boots. January 5 declared "Bob 'Daddy-O' Wade Day" in Austin by Mayor Steve Adler.

CONTRIBUTORS

Claudia Alarcón was born in Mexico City but got to Austin as fast as she could. Over the last thirty-five years she has gained an appreciation for all things Texas, including a special fondness for Airstream trailers disguised as iguanas. Her writing spans subjects from gastronomy and Mexican culture to art cars and home design. She lives in South Austin with her two rescue doggies, Benji and Eddie.

Michael Barnes is a native Texan who holds a PhD from the University of Texas at Austin. As the social columnist of the *Austin American-Statesman*, he writes about the city's people, places, culture, and history. He is also the author of *Indelible Austin: Selected Histories*.

Lynn Barnett has been executive director of the Abilene Cultural Affairs Council since 1980, where she launched and implemented Abilene's Outdoor Sculpture Exhibition, National Center for Children's Illustrated Literature, Center for Contemporary Arts, Children's Art & Literacy Festival, Storybook Sculpture Project, and Abilene's Cultural District.

Bert "Tito" Beveridge is from San Antonio and graduated from the University of Texas in Austin. In 1995, Tito obtained the first legal permit to distill in Texas and created Tito's Handmade Vodka (distilled and bottled in Austin). "We're a philanthropic events company that sells vodka on the side," he said. Beveridge lives in Austin.

Temple Boon was a draft dodger, marijuana smuggler, and federal fugitive for twenty-two years. The elusive actor/writer is the author of *Temple Boon and the Free Mexican Airforce*.

Carlene Brady was one of the original art directors of the *Austin Sun*, an influential biweekly alternative newspaper published in the 1970s, for which she wrote about Wade's "Texas Formal Garden."

Roy Bragg worked as a newspaper journalist in Texas for more than thirty years, mostly at the *Houston Chronicle* and the *San Antonio Express-News*. He's currently focused on writing a book and launching podcasts.

Michael Brick was an American journalist and songwriter. Born in Maryland, he moved to Dallas as a teenager, graduating from R. L. Turner High School in Carrollton. He then attended the University of Texas, where he wrote for *The Daily Texan*. After graduating from UT, he worked as a freelance writer and as a staff writer for *The New York Times*. He also wrote the book *Saving the School: The True Story of a Principal, a Teacher, a Coach, a Bunch of Kids, and a Year in the Crosshairs of Education Reform*, published in 2012. Brick was a columnist at the *Houston Chronicle* at the time of his death from colon cancer in 2016. He was forty-one.

From West Texas cowboy to Colorado folk blues singer to Austin corporate executive, **Dan R. Bullock** is a seasoned community leader who writes, speaks, and consults on leadership and civic engagement. He was director of the Governor's Office of Community Leadership and Volunteer Services and has been

recognized by *Southwest: The Magazine* and *Texas Monthly*.

Joanne Leonhardt Cassullo is a nationally recognized arts leader. She is the president and founder of the Dorothea L. Leonhardt Foundation Inc. and serves on the boards of multiple arts organizations across the country, including the Whitney Museum of Art, where thirty-five years ago, she was tapped to become the youngest board member in its history, a distinction she still holds today.

Dick DeGuerin is an internationally respected defense attorney with offices in Houston who has many high-profile cases to his credit. He is also an adjunct professor at the University of Texas School of Law in Austin. DeGuerin, a longtime friend of the Daddy-O's, is a familiar figure in Marfa, where he has a home.

Karen Dinitz is the director of the documentary *Too High, Too Wide, and Too Long*. Traveling with Bob "Daddy-O" Wade and the Iguanamobile in the late nineties fueled her lifelong love of the intersection of people and art. She currently lives in New York City with her son. Dinitz is a graduate of the University of Pennsylvania.

Dr. Katie Robinson Edwards is curator at the Umlauf Sculpture Garden & Museum in Austin, where she organizes exhibitions and manages a vast collection of Charles Umlauf's work and archives. Her MA and PhD are from the University of Texas at Austin; she previously taught art history at the Allbritton Art Institute at Baylor University. In addition to developing exhibitions on Umlauf's milieu, she has organized shows on Farrah Fawcett, Margo Sawyer, Luis Jiménez, and Jesús Moroles. Her award-winning book on abstract art in Texas from

1930 to 1960 is *Midcentury Modern Art in Texas*. She has written on Jackson Pollock, Andrew Wyeth, Chuck Close, and others and is proud to be part of this Daddy-O volume.

Carla Ellard is the photography archivist and curator of the Southwestern & Mexican Photography Collection at the Wittliff Collections at Texas State University. She began as the assistant curator in 2000. She has curated several exhibitions for the Wittliff and also served as a juror for local community photography contests. She received her master's degree in library and information science from the University of Texas at Austin and a bachelor of science in photography at East Texas State University (now Texas A&M University–Commerce).

Marc English is by, his own description, a "design shaman." The longtime Austinite has created distinct looks for the Criterion Collection, the Harry Ransom Center, the Austin Film Society, the Salvage Vanguard Theater, Girlstart, Troublemaker Studios, and Sun Microsystems, among many others. He holds a BFA in design from the Massachusetts College of Art and Design and has taught as adjunct faculty at Texas State University and other colleges. He's also a painter who showed his work at the Lewis Carnegie Gallery in East Austin in a 2018 show, Frontiers Are Where You Find Them: The Road to Hope.

Robert Faires is arts editor for *The Austin Chronicle*, where he's been covering the local arts scene for more than thirty years. He's a member of the American Theatre Critics Association, and in 2011, *American Theatre* magazine named him to a list of twelve of the nation's most influential theater critics. He's also been active in local theater since 1980, having worked on more than seventy-five theatrical pro-

ductions across the city as an actor, a director, and a writer.

Jim Ferguson is a lover of all things Daddy-O. He lives in Hico, Texas.

Artist **Bill FitzGibbons** has been creating sculpture for over thirty years. During his career he has completed more than twenty-five public art projects and performances in six countries including Reykjavík, Iceland; Helsinki, Finland; Braunschweig, Germany; and Stockholm, Sweden. FitzGibbons embraces an environmentally conscious approach to public art through his work with computerized LED lighting systems. His honors include being appointed as a Fulbright Artist for the Hungarian Art Academy in Budapest, receiving a USIA Artist Fellowship to Kuvataideakatemia (Academy of Fine Arts) in Helsinki, Finland, and being selected by the Texas State Legislature as the Official State Artist in 2012.

Kinky Friedman is, by his own reckoning, the most famous Jew from Texas. He is also a defender of strays.

Pete Gershon is the author of *Painting the Town Orange: The Stories Behind Houston's Visionary Art Environments* and *Collision: The Contemporary Art Scene in Houston, 1972–1985*, the winner of the 2019 Ron Tyler Award for Best Illustrated Book on Texas Arts and Culture. From 1997 to 2013, he was the publisher and editor of *Signal to Noise: The Journal of Improvised & Experimental Music*. He has a BA in literary nonfiction from Hampshire College (1995) and a master's in library and information science from the University of North Texas (2015).

Will Harte describes himself as a "big fan of Bob Wade."

Cleve Hattersley is the founder of the seminal Austin band Greezy Wheels; an ex-con who has also managed legendary clubs like the Lone Star Café and the Blue Note Jazz Club in New York City; and one-time executive buttboy (official title) for Kinky Friedman. Cleve currently writes, edits, and publishes his works and those of others for YES Publishing, including his upcoming book *Life Is a Butt Dial—Tales of a Life Among the Tragically Hip*. Greezy Wheels will be releasing its final CD in 2020, the band's fiftieth anniversary.

Ricardo "Rick" Hernandez is a ceramist, painter, and art administrator. From 1973 to 1977, he worked on several of Daddy-O's projects, including the Bicentennial Map of the U.S.A. and the now-renowned Giant Iguana. The former executive director of the Texas Commission on the Arts, he served the agency for thirty years and retired in 2007.

Michael Hoinski is a journalist and museum educator living in Austin. He has written about the arts and culture for *The New York Times*, *Texas Highways*, and *Texas Monthly*. As curator of the O. Henry Museum, he develops exhibits and produces the Pun-Off World Championships, and has published as a fine press book a "lost" O. Henry short story, "As Others See Us." Hoinski has presented at the Texas Book Festival and appeared on C-SPAN Book TV.

Richard A. Holland is the editor of Larry L. King's selected letters and the editor of and contributor to *The Texas Book*. He and Daddy-O met in San Marcos when Holland was curator of the Wittliff Collections at Texas State University, and have been fast pork chop friends ever since. Since retiring from being a rare books librarian and a stint of teaching at UT, Holland has been working on a modest project titled *Bewitched: An Autobiography with Musical Examples*.

Carl Hoover has covered arts and entertainment for more than thirty years for the *Waco Tribune-Herald* and has won eight Texas Associated Press Managing Editors awards for comment and criticism. "Meeting free-thinking, creative people like Bob Wade has been part of the fun," Hoover says.

John Kelso was a popular humor columnist for the *Austin American-Statesman* and the author of three books. He wrote for the *Statesman* for more than forty years. He was known as the Bard of South Austin—a reference to a mostly working-class yet eccentric section of the Texas capital that frequently provided source material for his columns. He died in 2017 after suffering from cancer for several years.

Jack Massing has been interested in arts and crafts since an early age. Growing up in a loving family, he was encouraged to express his creativity in many ways. After graduating from Kenmore East Senior High School in Tonawanda, New York, he found employment at Artpark in Lewiston, New York, where he was exposed to contemporary art in new and exciting ways. Massing met Michael Galbreth at the University of Houston and formed the Art Guys in Houston in 1983. Massing enjoys cooking, learning new languages, and long walks on the beach.

Leea Mechling has been involved in Austin's counterculture since her days as a staff member at the Armadillo World Headquarters. Retired from UT-Austin, she is the executive director of the South Austin Museum of Popular Culture (SouthPop), exploring Austin's alternate route to peace, love, and happiness. She lives in Buda, Texas, on the Rockin' G Ranch with her posse of three pugs.

Jason Mellard is a cultural historian of the modern South and Southwest. He received his PhD in American studies at the University of Texas at Austin in 2009. At Texas State University, he works with the Center for Texas Music History on the publication of *The Journal of Texas Music History*, the weekly radio program *This Week in Texas Music History*, coursework, and other projects. His first book, *Progressive Country: How the 1970s Transformed the Texan in Popular Culture*, explores the intersections of political change and popular culture in the Sunbelt South's largest state. Research on that book led to public collaborations on the arts with various institutions and artists, including Bob "Daddy-O" Wade.

After a successful career in media, public relations, and entertainment in Austin during which she cofounded the Austin Film Festival and created free music series in cities across Texas, **Marsha Milam** decided to dive headlong into the spirits industry. Specifically, she is the founder of the Ben Milam Distillery, producer of the Double Gold award-winning Ben Milam Bourbon.

Chris O'Connell is a writer and editor who lives in Austin with his wife, Julia, and two children, Mira and Shane.

Dan O'Hara is "a friend of the arts, a friend of the Wades, a Texan at heart." He lives in San Antonio.

Riding shotgun with the Daddy-O ranks as a career high for author, editor, and journalist **Eric O'Keefe.** Whether it was cutting up with Willie Nelson backstage at Carl's Corner, breaking bread with Ann Richards at Ranch 616, or up to no good with Monk White, Dick DeGuerin, and Bob's other Kappa Sig buddies, the laughter and mayhem will always endure.

Edmond Ortiz is the managing editor of the *North Central News*, a Prime Time community weekly of the *San Antonio Express-News*. A San Antonio native, Ortiz has been with Prime Time Newspapers since 1999, when he began writing for the *Northeast/Metrocom Herald*. Prior to that, he briefly owned/operated the *San Antonio Scene*, an alternative news monthly.

Joe Nick Patoski writes about Texas and Texans, particularly those who qualify as Crazy from the Heat. His books about Stevie Ray Vaughan, Selena, Willie Nelson, the Dallas Cowboys, and alternative Austin have afforded him the luxury of buying baby a new pair of shoes and avoiding skip chasers. He hosts the *Texas Music Hour of Power* Saturday nights on Marfa Public Radio.

Anne Rapp is a screenwriter, filmmaker, playwright, fiction writer, poet (in theory), math major, old jock, cotton farmer from the Texas Panhandle who now lives in Austin and draws, walks long distances, aspires to compete on *Chopped*, and has kept her accent. She still has her first car.

In the past decade, **Jan Reid** has produced three award-winning books: his novels *Sins of the Younger Sons* and *Comanche Sundown* and his biography of Ann Richards, *Let the People In*. His ten prior books include a memoir of misadventure in Mexico, *The Bullet Meant for Me*, and his 1974 debut, *The Improbable Rise of Redneck Rock*. He has been a major contributor to *Texas Monthly, Esquire,* and *Men's Journal.* A native of Wichita Falls, Reid lives in Austin with his collie, Biscuit.

Dr. Julie Sasse is chief curator and curator of modern and contemporary art at the Tucson Museum of Art, serving as a curator there since 2000. Over the last four decades, she has curated hundreds of solo and group exhibitions about art from Southwest and has written more than fifty publications about diverse artists and subjects.

Andi Scull is an Asian American art director/producer specializing in nontraditional branding, creative program development, and taste-maker communications for twenty plus years. She is the founder and executive producer of HOPE Events—the nonprofit producing the HOPE (Helping Other People Everywhere) Campaign and the Austin-based HOPE Farmers Market and HOPE Outdoor Gallery.

Lisa Sherman was an archaeologist at the American Museum of Natural History in New York and worked as an art and music critic for *Rolling Stone, Art News,* and *Art in America*. She serves on numerous boards and advisory committees for art organizations and children's charities in Santa Fe, New Mexico, and Austin, Texas. She is the vice president of Prolink Sports & Entertainment and has worked with the world's top professional tennis players for twenty years.

Journalist-author **Mike Shropshire** has been writing about Texas topics for nearly six decades. He lives in Dallas.

DJ Stout is a sixth-generation Texan, born in the small West Texas town of Alpine. He studied graphic design at Texas Tech University, where he has been honored as a distinguished alumnus. DJ began his graphic design career in 1981 working for Wilson Associates in Dallas. In 1987, he moved to Austin, where he was the award-winning art director of *Texas Monthly*. In January 2000 DJ joined Pentagram as a partner in the Austin office.

W. K. (Kip) Stratton is the *Los Angeles Times* best-

selling author of *The Wild Bunch: Sam Peckinpah, a Revolution in Hollywood, and the Making of a Legendary Film* and eight other books. He's also written for *Texas Monthly*, *Outside*, *GQ*, and *Sports Illustrated*. He's a fellow of the Texas Institute of Letters. He and Daddy-O met long ago in Belton, Texas. Neither can recall the circumstances.

Jesse Sublett is an author, a musician, and a painter in Austin, Texas. He's the author of thirteen published books. A legend in the Austin music scene, he was the founder in 1977 of the Skunks, the band that established the punk/new wave scene at Raul's Club and blazed the trail for Austin's coronation as the Music Capital of the World. Jesse's published books ranged from crime fiction to nonfiction history works such as *Armadillo World Headquarters: A Memoir* (with Eddie Wilson) and *1960s Austin Gangsters: Organized Crime That Rocked the Capital*.

Historian, curator, and author **Lonn Taylor** received his bachelor's degree in history and government from Texas Christian University in 1961 and held a Woodrow Wilson Fellowship in government at New York University during 1961–1962. Between 1965 and 1969 he did graduate work at the University of Texas in history, museology, and historic preservation. From 1970 to 1977, Taylor worked at the University of Texas at Austin's Winedale Historical Complex in Round Top as director and curator of collections. He later served as a curator for the Dallas Historical Society and the American Folklife Center. In 1984 Taylor joined the staff of the Smithsonian Institution's National Museum of American History, where he served for eighteen years. He has written books on American cowboys, New Mexican furniture, and Southwestern history. Lonn Taylor retired

from the Smithsonian in 2002. He lived in Fort Davis and contributed regularly to the *Big Bend Sentinel* as well as to the Marfa NPR station. Taylor died in 2019.

John Tinker has maintained a studio practice in New Mexico for more than forty years. He holds a BFA from the University of Wisconsin. His sculpture is represented in public collections including the New Mexico Museum of Art, the Albuquerque Museum, and the Scottsdale Museum of Contemporary Art. Tinker's work is also included in private collections, both national and international. He simultaneously maintained a twenty-five-year museum career as both a preparator and exhibition designer.

Diana Vela, PhD, is the associate executive director for the National Cowgirl Museum and Hall of Fame in Fort Worth and is responsible for narrative content, education efforts, and artifact acquisition. The National Cowgirl Museum is the only museum in the world dedicated to honoring women, past and present, whose lives exemplify the courage, resilience, and independence that shaped the American West.

Evan Voyles is an artist and sign maker (not necessarily in that order) in Austin, Texas, where he was born and raised. A graduate of both Yale and the back roads and junk stores of America, he has devoted most of his waking adult life to the acquisition and/or production of amazing objects, all of which he considers to be folk art, if not high art. He is married to Gail Chovan, who is an artist, clothing designer, and professor, and they have twin children together. Evan first met Bob Wade somewhere north of Santa Fe around 1990, in the undefined area that lies between a pueblo and a flea market.

Gary Webernick is a longtime friend of Bob "Daddy-O" Wade and a fellow "imagineer." He's the vice

president and exhibits chair of the Texas Sculpture Group, as well as a professor and chair of the art department at Austin Community College.

David Marion Wilkinson is an Austin novelist, author, and screenwriter.

Bon vivant **Kevin Williamson** is the head chef and owner of Ranch 616, the Pistol Patio, the Wiggle Room, and the Star Bar in Austin, Texas, where he also lives.

Shannon Wynne is a tall skinny restaurant guy from Dallas, Texas. Father to six and husband (and ex- to two), he has heard it all, which is why he gets along fairly well with Daddy-O.

Kent Zimmerman is half of a twin-brother writing team. He and his brother, Keith, have coauthored or contributed to more than sixteen books, including the bestsellers *Hell's Angel* with Ralph "Sonny" Barger and *Rotten* with John Lydon, aka Johnny Rotten, lead singer of the Sex Pistols. In the mid-1990s, they collaborated with Bob Wade on his autobiography, *Daddy-O: Iguana Heads & Texas Tales*, published by St. Martin's Press in New York.

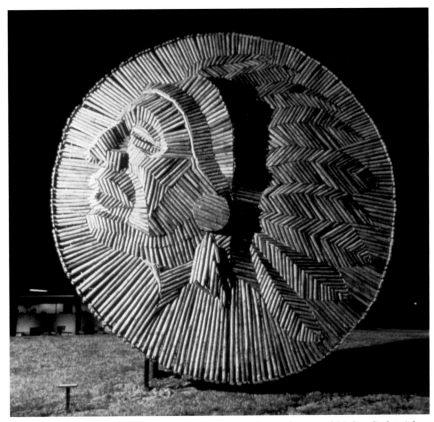

Big Indian Head, 1985. Treated landscape wood wired to steel high-relief "nickel." Originally installed against telephone poles at Texas Commerce Bank, Dallas, Texas. 20' diameter × 18'. On loan to Carl's Corner, Texas—collection of Monk White and the artist. Photo: Clinton Bell.

INDEX

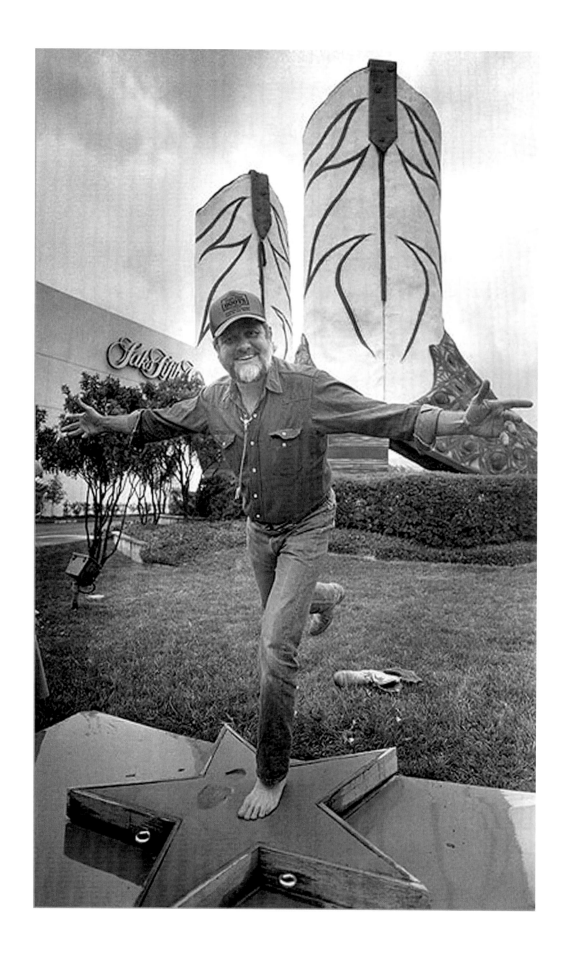

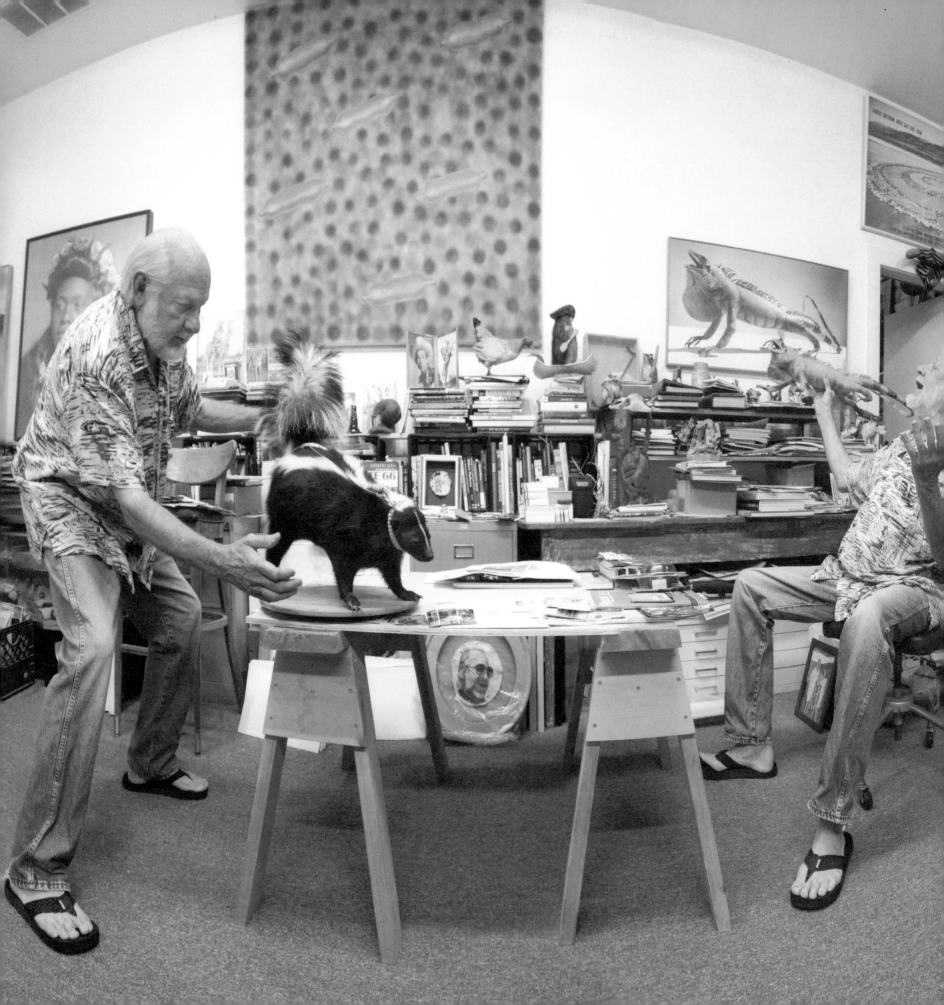